MW00852838

clap your hands and stomp your feet, let's get moving to the

PANSY BEAT

premiere issue
AUTUMN 89

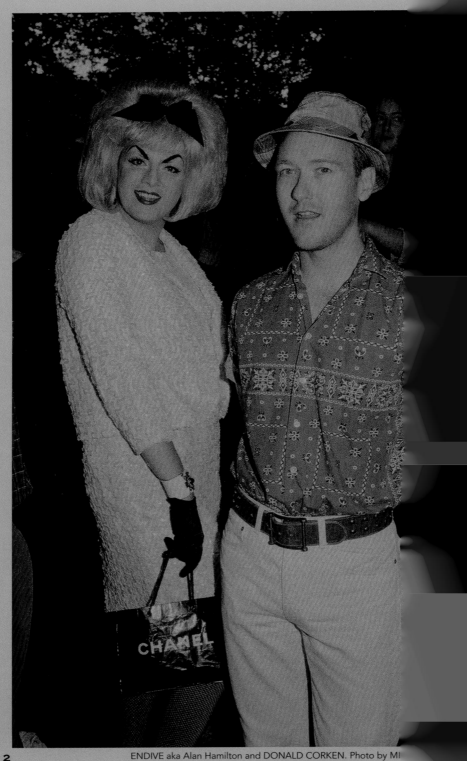

ENDIVE aka Alan Hamilton and DONALD CORKEN. Photo by MI

FOR ENDIVE AND DONALD.

PREFACE

SOMETIMES IT FELT LIKE THE MOST REASONABLE WAY TO FIGHT THE ANXIETY WAS JUST TO GO OUT DANCING ALL NIGHT.

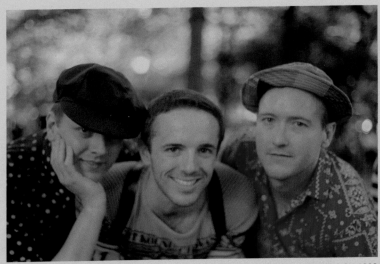

ENDIVE, MICHAEL ECONOMY & DONALD CORKEN at WIGSTOCK 1989

IN LATE JUNE OF 1989, I came back to New York after a six-month gig with a production company in Tokyo, where I'd been paid to do almost nothing but go to clubs at night. All that was fun for a while but ultimately unfulfilling. The gay scene in Tokyo had been frustratingly closeted. One night after my return, I was hanging out with my good friends Donald Corken and Endive. We were flipping through magazines, one of which was Linda Simpson's *My Comrade*. As I described my time in Japan, Donald asked "Well, what are you going to do NOW?" and then Endive stood up and shouted: "I know! You're going to make a magazine and put ME on the cover." Donald exclaimed "PANSY BEAT!" And that was the beginning.

It sounds insane now but somehow it wasn't. I had worked for two years at *Paper* magazine with Kim Hastreiter and Richard Pandiscio. I thought I had an idea of what it took to put a magazine together.

Why not? We were trying to figure out who we were then, in the post-disco, peak-AIDS years of the late 80s. Many of our friends were drag queens. We loved Lady Bunny. ACT-UP had ignited an angry urgent sensibility. The time felt mixed-up and in-between. Friends were dead or dying and we all assumed that we would be next. Sometimes it felt like the most reasonable way to fight the anxiety was just to go out dancing all night.

Anyway, the wheels were set in motion. We leapt into action, literally the next day. In a flurry of activity over the next few weeks, we began to define what became our brand of "unashamed sissy shit". We sold $10 ads, shot Lady Bunny's centerfold, interviewed Deee-Lite, and documented the fifth annual Wigstock. We made a magazine.

Donald Corken, my co-editor, was the fanzine's brain. Our shared sensibilities, too many to list here, boiled down to a deep love of Blondie, Barbies and cutting a rug. Endive, aka Alan Hamilton, our main talent and house muse, had been Corken's friend in Cincinnati and followed him to NYC. Michael Fazakerley was staff photographer with whom I had collaborated on countless late night photoshoots throughout the 80s. Contributing writer Josiah Schumann, now known as Josiah Howard, was Corken's colleague in styling mannequins at Canal Jeans on lower Broadway. The ever-enchanting Endive introduced me to the young political activist Glenn Belverio. Terry Lawson, aka Cole Slaw, an old friend I'd met working at the Limelight in Atlanta, was our secretary.

Over the course of the year, other contributors popped in and out. By *Pansy Beat*'s third issue, we were joined by Chip Wass, who was introduced to me by our mutual friend and fellow illustrator Sachio Kamia. Chip's trenchant wit and illustration style embodied the *Pansy Beat* point of view. To this day, he remains my steadfast champion and friend.

It was all an accident, basically. At least that's the way I remember it now.

BY M.E.

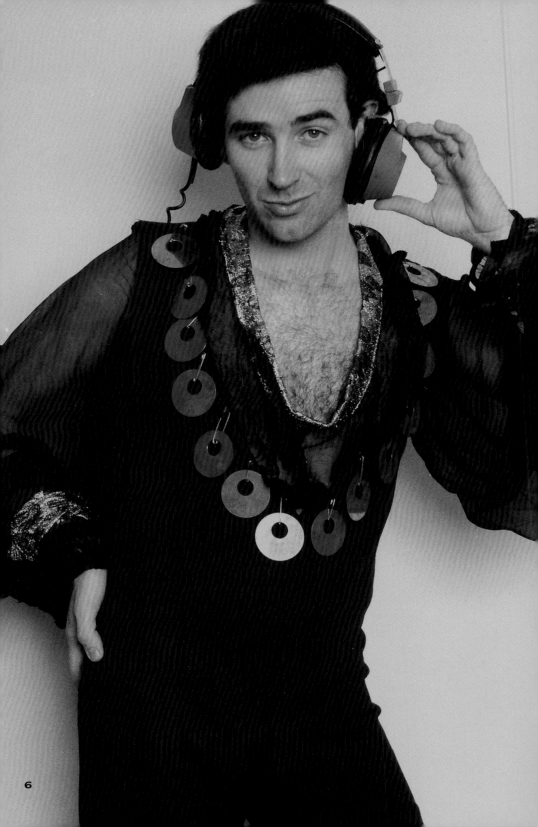

◆ T ◆ O ◆ C ◆

Cover photos of BILLY ERB, ENDIVE, JAVIER FIGUEROA, KENNY KENNY & QUENTIN CRISP
and photo of LARRY TEE on P6 by MICHAEL FAZAKERLEY

FOREWORD

FAR FROM A THOUGHTFUL, ORGANIZED HISTORY, PANSY BEAT EXISTED AS CHAOTIC, NEAR-IMPROVISATION.

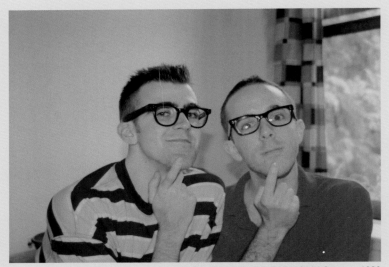

CHIP WASS & MICHAEL ECONOMY, Summer 1990

THE NAME was an attention-getting tease. Was it a 60s teen fan magazine or a history of the Greenwich Village "Pansy Craze" of 1930? I was standing in a magazine shop in the East Village looking at something called *Pansy Beat*. The "twinkling premiere issue" of the fanzine offered a "whimsical journey down a pansy strewn lane." It was early Fall, the end of the 80s. I had just moved to the city, without a plan, hoping to be free. The party days were over, of course. These were the darkest days of the plague. A *Village Voice* cover had recently declared the Death of Downtown. My adolescent fantasy of

New York nights at Danceteria (closed, 1986) and afternoons shopping at Fiorucci (closed,1988) was turning out more anxious and threadbare than planned. The stock market crashed on Friday the 13th. The streets were a mess. But even then, New York summoned its wellspring of pleasure: the Pyramid Club and Lady Bunny, Wigstock, Love Machine, Pat Fields on 8th Street, Boy Bar. And here was this little magazine. On the cover, the drag performer Endive smiled inscrutably, her eyes filled with stars.

What are the smallest moves you made that changed your life? Opening the first issue of *Pansy Beat* was one of mine. The contents hit me like a flaming arrow from 1930s Hollywood soaring through a Saturday morning cartoon utopia on its way to a 70s disco intercepted by a street punk. Across its pages, a parade of cute homeboys, faded movie stars, lunatic drag queens, and cartoon club kids unveiled the path to a fantastic world (one free condom included). *Pansy Beat* wasn't planning a revolution, because it presumed (from some gender-fluid, multicultural space colony from which it came) that we were already there. It was confident, stupid, and joyfully inappropriate. It was anachronistic and completely of-the-moment. And its spirit was most vivid in the cornucopia of one-of-a-kind, big-eyed illustrations drawn by *Pansy Beat*'s creator and editor-in-chief, the improbably named Michael Economy.

Throughout the next year, I was swept into the *Pansy Beat* universe to help with its hectic creation. Five issues total were published, documenting a groundbreaking, transitional time in New York nightlife. Interviews and subjects included downtown personalities on the verge of global stardom: artists like Lady Bunny, Deee-Lite, Billy Erb, Connie Girl, Lypsinka, and Kenny Kenny. Here is proof that Sister Dimension, one of the most singularly exotic of the East Village's legendary performers, was not a hallucination. During its brief span, *Pansy Beat* was written about glowingly in the *Advocate* and the *Voice*. And then it vanished as quickly as it had appeared. In the end, that was part of what made it special: far from a thoughtful, organized history, *Pansy Beat* existed as chaotic near-improvisation. It was a blur of delirious fun, like an ecstatic moment on the dance floor. You closed your eyes and it was gone, fading into everything yet-to-be.

BY CHIP WASS

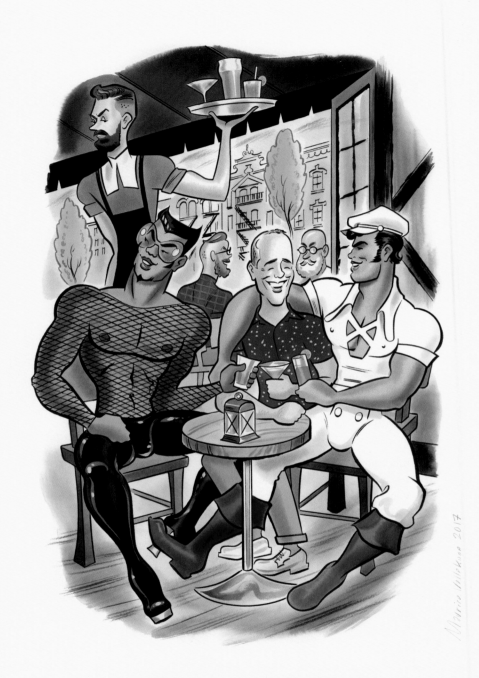

MESH AND LEE, OF PANSY BEAT ISSUE #4,
TIME TRAVEL FROM 1990 TO THE PRESENT TO INTERVIEW
THE ARTIST WHO CREATED THEM.

Illustration by MAURICE VELLEKOOP

A MAKE-BELIEVE INTERVIEW

LATE AFTERNOON SUNLIGHT winked seductively off the ambitious r
of The Wimple's mock-rough-planked back patio. Beneath a golden a
hour had just commenced and already the seats were mostly filled. Le
riends—had after some confusion located the bar at the agreed-upon
he last table for three. Tipping down Avenue A, nothing had looked
he'd last seen it… could it really have been decades ago? The bodega
make clandestine late-night purchases was now Bowdega, a gift wrap
bookstore that he'd once frequented regularly now actually sold book
Gabay's Outlet was somehow still in its correct spot, and he'd been able

He caught the waiter's eye, ordered a Powhatan from the pilgrim-then
and while pondering at what hour pilgrims took their cocktails—vesp
three of cerulean-Naugahyde-wrapped Mesh strode onto the pati
hadn't seen one another since the previous century, but maintained a
of promissory text messages. Now here they both were. After gree
appraising gazes, they were descending into their seats when Lee
you're looking fit. And is that your Vespa of old that I heard revving a

"The one, papi. Repainted and refurbished, but with cowhide on the
No getting fine pleather these days. Thank gunya my old riding naug

"Oh, don't I know. And I see you've dislodged your fixation with aqu
black. I recall how difficult it was matching nail polish to both upholst

"You'll be pleased to know that my OCS is in the past, Lee. I've been se
and he does wonders. Well, these do wonders." He reached into his
shook a plastic bottle like a maraca before pausing and peering aroun
know, walking in here I didn't recognize one face. And I think I even w
t was a…"

"A...?"

"A..."

They burst into laughter. Who could remember?

Mesh ordered a Rueful Nathan from a passing buckle-shoed waiter and cocked his head expectantly at Lee.

"I finally found all my copies of *Pansy Beat* last night," the latter grinned, moving on to the reason for their meeting. "They were rather capriciously tucked into this T&V shopping bag. Along with a crunchy pair of L'Eggs and two BoyBar drink tickets." All five issues of the magazine spilled onto the table.

"Ooh, these covers!" enthused Mesh. "Dazzle! I searched last night too, but I'm afraid mine are lost in space."

"No surprise. It's been a long time, Mesh. The final issue was Autumn 1990." They began poring through the magazines, tsking in delight.

"It really was a film idol mag for the Downtown stars. The films in our heads, at any rate. Look at them all—The Connie Girl! Lypsinka! Sister Dimension! Gawd—Lady Bunny interviewing Leigh Bowery. That's insane!"

"Do you remember this Edwige Q & A? And here's Frieda being grilled by Tom Rubnitz. 'I've been in the laboratory working on the scent for my new perfume, Gruyere.' You're so right, Mesh. It was the world as only we knew it. Queer downtown dreaming of itself in high-res toner. *My Comrade* was our *New York Post*, but *Pansy Beat* was our..."

"...*After Dark*. Crossed with Archie and *The Rabbitville Gazette*. Do these copies still have the free condoms glued in?"

"Except for one of them. I remember peeling it off in an emergency."

"Here's Endive's recipe column, 'Cooking with Endive'! I recently had a dream about Endive."

Lee's expression froze, but pleasantly, as his mind went whirling backwards through a spiraling vermillion time tunnel to when he was much younger. He had idolized Endive. Just as colorfully his mind came whirling back. "I made her yule log recipe one year," he murmured, almost to himself.

"Loved her, hated him," Mesh sniffed. "Where's that waiter? And I wonder what's keeping Michael."

As if on cue, the lissome figure of Michael Economy appeared in the gold-streaked sunlight.

"Sorry I'm late. I got a little lost trying to... oh, you know." He sat down and flipped opened a *Pansy Beat*. "I think this issue with the Billy Beyond cover is when we really got it right."

"Hi Michael!" Mesh and Lee cried in unison. "We were just gagging over them all," said Mesh. "Are you ready for your interview?"

"Ready as I'll ever be, believe me." A few minutes later, a Marblehead Mule in hand, he leaned forward in his chair as Lee pressed the record button.

SO, TELL US THE STORY OF A COUNTRY BOY COMING TO NEW YORK CITY.

MESH: *So, tell us the story of a country boy coming to New York City.*

MICHAEL: Well, I moved to New York from Atlanta in 1981. I remember begging all my friends to come with me, but none would. I'd wanted to be in New York since I was a young teenager, and I'd even gotten accepted to Parsons when I was 17. But it wasn't a possibility that I could afford to go there. Then I got a scholarship to the Art Institute of Atlanta, and that was the deciding factor of where I went to school. When I was 19 I was recruited right from a student show by the Limelight disco in Atlanta, to be their one-man art department. I worked there for a year, but I hung out at a New Wave club called 688. I met Lawrence there—Larry Tee. He didn't have his band the Now Explosion yet, and he wasn't DJing. We were dance floor buddies. We danced to live bands like the Method Actors, Pylon, the Plastics from Japan, the Rockats. And there was Love Tractor, a really brilliant band. It was a funny era in Atlanta. I saw Bow Wow Wow at Six Flags!

LEE: *What a scene! When did you make your way up north?*

Michael: I had already taken my first trip to New York in 1980, and on that three-day visit I met Michael Fazakerley, the photographer who later did all the pictures in *Pansy Beat*. I saved my money that whole next summer and moved up. The only people I really knew there were a couple from Atlanta, Terry Lawson and his lover Vince, who had a small railroad apartment in Chelsea. They said, yes, you can come and sleep in the living room for a month or two.

Mesh: Was there a master plan?

Michael: I went with the intention to get into fashion, but I didn't know how. I ended up at Macy's in window display. I met this really punk girl named Claire DeLong and her friend Tim Goslin, who worked on the trendy junior's floor there. I somehow convinced Claire to have a cup of coffee with me. And like a good artist I always had my sketch book of drawings with me. She was impressed and said, "You have to meet the head of the department, Vinnie. He'll give you a job for sure." And that's what happened! Claire was really hardcore, with a mohawk, dressed in head-to-toe black, and Tim was a little condescending to me because of the way I looked.

Lee: I've always said, until the moment that Larry Tee, RuPaul, Lady Bunny and Lahoma Van Zandt—the Atlanta crowd—moved to the East Village, New York was all people dressed in black.

Michael: It seemed that way. I can remember in my mind's eye coming up those wooden escalators at Macy's and Claire and Tim standing at the top looking down on me as I ascended. I was kind of B-52s Atlanta New Wave. I had on a child's sweater vest that was really short-waisted and had colorful hearts going across in different basic colors. Under that I had a button-down Fifties shirt or something, a pair of second-hand women's baggy jeans, and 99-cent store shoes. I had no idea how to dress for the cold in New York, so on top of that an old trench coat that I thought was going to keep me warm! And probably a bad haircut. I got to the top of the escalator, and they were looking me up and down.

Tim said really pointedly, "Are there other people in Atlanta that dress like you?" (laughs) No, New York was not a colorful, welcoming, upbeat place then. It was freezing cold, with dirty snow, and everywhere it was… grownups.

Mesh: 1981 was still the late Seventies style-wise.

Michael: I quickly found out that I wasn't going to make enough money to stay in New York that way, so I started finding freelance window accounts. I was doing this punk vintage store called Flip, and their ads for *The Village Voice*. I did a couple of windows and ads for Pat Field, and for an uptown place called Il Makiage. I freelanced for Barneys and Zoe Coste, a French jewelry designer. I had clients uptown and downtown. Then in '83 I got a full-time job doing the windows at Suzuya, across the street from Fiorucci. Those got me attention and I somehow landed a freelance illustration job at Penthouse Forum, and it paid really well! My boyfriend and I were kind of in shock, and he said, "You should just do this all the time!" I do remember I liked getting that check, the most money ever, for drawing. But I didn't want to draw for money. I really liked doing windows! It was more creative and more people saw what you were doing.

Mesh: I remember the manager at Flip… Marty.

Michael: Yes! Very hardcore New York. People were mean in 1981! (laughs)

Lee: Let's fast-forward a few years. Where did the idea come from to do Pansy Beat?

Michael: We were at Donald Corken's colorful, well-curated apartment on 7th street off Avenue B. It was July 4th weekend, 1989. Endive was there and I'm pretty sure Josiah Schumann was too. I had been working in Tokyo for a year, and just moved back and was looking for something to do. So Donald was catching me up on East Village news. I'd missed the riots in Tompkins Square Park, for instance. And then he said, "Oh, and Linda Simpson made this magazine called *My Comrade/Sister.*" I was looking at it and Endive grabbed it out of my hand and waved it in my face. "I'll tell you what you're going to do. You're going to make a magazine too, and put me on the cover." I laughed and said, "What are we going to call it?" Donald coined the name *Pansy Beat*. "We love Twenties things and you love teen idol magazines." So there it was, a cross between "pansy" and *Tiger Beat*. At the time the only other zine I'd been exposed to was *Straight To Hell*, and I had two copies of *Physique Pictorial*. But I was 29 and I thought this was a way to have a voice, and to put together everything I loved in one place.

Lee: Was it hard to get people to do things for it?

Michael: No. In fact I started cracking the whip and said that if anyone wanted something printed in the first issue they had to sell at least one ad. They were only ten dollars, but it was hard getting them paid for. Some people stepped right up, like Pat Field and also people that I'd freelanced for, like Tom Oatman who owned New Republic.

Mesh: You lived in Tokyo?

Michael: For two six-month stints, around '88-'89.

Lee: Is your graphic work influenced by Japanese manga?

Michael: Sure, but it's also from much earlier than that. I grew up in the mountains of

Virginia, and when I was a child we would go up to D.C. to visit my grandmother. On her TV they had a station that played "Astro Boy". I really loved that. Cut to 1978 with Japanese New Wave, like the Plastics from Tokyo. I got into Tadanori Yokoo and Osamu Tezuka, and fashion designers like Kansai Yamamoto and Issey Miyake were very influential on me. I even used to sign my projects and then underneath write 'Made In Japan'.

Lee: I ask because I own a Japanese book of your illustration work. A catalog.

Michael: Yes, in 1999 I had an exhibition in the art gallery at Parco department store in Tokyo. So it all came full circle.

Mesh: Speaking of influences, did you ever see Star *magazine from the early Seventies?*

Lee: I still have my Star *magazines from when I was 13. They're my most treasured possessions.*

Mesh: Really? The illustrations in Star *remind me so much of your line.*

Michael: I have to almost one-hundred-percent say that that came from a cartoonist in *Star* magazine. His name was Joe Petagno. He did a comic strip in there called The Groupies. I had been drawing since before kindergarten, but when I was 12 I got my hands on that first issue of *Star*. Until then I would trace Betty Boop and was drawing very cartoony. But when I saw his work I immediately switched to drawing like that. That line that was just so flowing, with a Seventies twist.

Lee: There are a lot of Boy Bar connections in Pansy Beat. *Did you go out a lot?*

Michael: Well, it was always the main goal to go out dancing. To Pyramid and Boy Bar, to Paradise Garage. I attended every one of Larry Tee's Love Machine parties. Also to shows at King Tut's Wah Wah Hut. I distinctly remember Endive performing in the basement there, with maybe six of us in attendance. She sang Doris Day's "Everybody Loves Me" and we all kept screaming and cheering like it was a sold-out crowd.

Lee: I used to love her shows. That tight blonde bubble, and a stage presence like Patsy Cline by way of a plump Doris Day.

Michael: Bunny called her, "Everyone's swingin' auntie". She was a boozy, loony broad, a bit like Karen a decade later on *Will and Grace*. One time I was at her apartment while she was packing to move. It was a tiny room with a window that overlooked the garbage cans. There was stuff piled all over and she was just throwing things out the window. Dish rack with plates still in it, framed pictures, bedspreads, clothes, wigs, tennis shoes. She had one suitcase open on the bed. Whatever fit in the suitcase was what she was taking with her. I looked out the window and said, "Endive, the lids are still on those trash cans." She said "So?" and just kept throwing. She finally moved out of New York, soon after that period.

Lee: Michael, to me Pansy Beat *was as a kind of twisted tourist guide. I lived on the west coast in that era. But my friends and I would consult it like a crystal ball for clues as to what was going down in the mythical East Village. When I'd visit New York, I knew precisely where to go and what to do, but in a through-the-looking-glass kind of way. I only knew Lypsinka as a coloring book drawing in* Pansy Beat *before I ever saw*

Illustration by MICHAEL ECONOMY

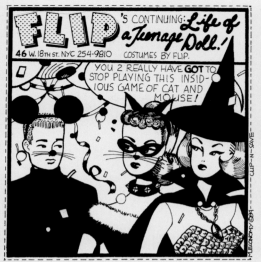

her in the flesh. She was even skinnier than the drawing! And then I actually met you and got featured in Issue 4, with Mesh here!

Mesh: One of my favorites from those days, who contributed Christmas jokes to Pansy Beat, was Barbara Patterson-Lloyd, the librarian-comedian-poetess.

Michael: Genius! I remember seeing her perform many times, and just doubling over and crying in hilarity. Especially when Barbara Patterson-Lloyd and Bunny were onstage at the same time. And that Christmas piece that she submitted to Pansy Beat! I re-read it recently and was laughing so hard. Anyone reading that now will be dumbstruck as to why it would be considered even remotely funny. (laughs)

Mesh: It was in the telling and the timing, which was so much a part of the Pyramid's rarified aesthetic.

Lee: You know, until the Atlanta kids hit the Pyramid, I don't think I'd even been there.

Mesh: Tom Rubnitz so captured the Pyramid's freak family in his videos.

Michael: I just flipped when I saw those. I loved them so much. I mean, I don't want to put all of these people into one lump, but there were so many talented people that were extracted from the equation because of AIDS. And all of that exact ilk, who would have changed things so much had they lived. The density of talent per square foot in this city at that point in history… I mean, there's no telling what kind of place this would have become. I was one of those people who at that time thought that New York really was the center of the universe. So, for me, everything that ever happened culturally at that time emanated from between 14th Street and Canal Street. Then all of those people, literally one after the other, started dropping like flies.

Lee: It kind of startled me to see Michael Alig in the last issue. Things on the club scene were starting to shift that direction.

Illustration by MICHAEL ECONOMY

Michael: You know, I never thought about the club kids much. Even up until the last issue of *Pansy Beat*, I referred to them as the munchkins. I had known Michael Alig since the mid-Eighties. One day Marty at Flip said to me, "Oh, I really think you're going to like this one. He's going to be your assistant from now on." It's Michael Alig and he hands me out of his lunchbox an invite to one of his parties. We did work together on a couple of windows, and I remember saying to him, "Oh, Michael. You're too talented. Go out dancing and have fun, but don't get involved working in the club scene!" (everyone laughing) Cut to Autumn 1990, the last issue of *Pansy Beat*, bought and paid for by Michael Alig via Peter Gatien, my former boss from a decade earlier in Atlanta. Michael wanted the back cover and an ad inside. We were able to print a thousand of that issue, instead of just the 500. But that's when Donald Corken was like, "The club kids? No. I'm out."

Lee: Pansy Beat *was such a relief from the harsh reality of bashings and AIDS surrounding us at that time. But it also had political articles and interviews by Glen Belverio and a condom glued by hand into each issue.*

Michael: I felt like we were just a little bit of everything. I wasn't indifferent to the bootstompers of ACT-UP. I knew what it represented. I had lost friends to AIDS. But we were also young and trying to live our lives, and we were surrounded by this thing that was so big, so all-encompassing. It was terrifying. It was such a different world at that time. One day Terry Lawson—Cole Slaw—said, "You know, the New York State Department of Health offered to give us these boxes of condoms if we agree to distribute them." And I thought, let's put them in the magazine. Like a free toy in a box of cereal. Like the Sixties. Like everything I like.

As the dusk deepened, fairy lights along the patio walls cast a twinkling glow over their table. More drinks, more chortles, more *Pansy Beat* memories: Tea with Quentin Crisp, Celebrity Faves with Deee-Lite and Larry Tee, the Connie Girl Doll, Sister Dimension's poetry, Lady Bunny's Christmas miracle, interviews with Edwige, Michael Alig, Mel Odom, Frieda…

Finally Mesh snapped off the recorder and jumped to his feet. "Oh gunya. I'm so late." A flurry of boozy kisses and parting salutations and in an instant he'd swung through the restaurant and out onto the street. Through a gap in the hedge Lee and Michael could see him hopping onto the Vespa. He turned for a moment, smiled back at them and then made a "come on" gesture. Before Michael knew what was happening, Lee had scooped up his things, given him a perfunctory hug and in a flash was out the door too and climbing onto the back of Mesh's scooter. With a loud rip the two of them zipped off down the street into the blue evening light back to 1990.

Michael ordered one last Marblehead Mule and sat smiling hazily to himself for a few minutes, before a look of realization came over his face. "Those shady hustlers just stuck me with the bill," he snorted out loud. "Well, well. I guess some things never change." But his passing waiter assured him it wasn't so—Mesh has tossed him two large bills on the way out. "Ah, well then…" Michael brightened. "In that case make the Mule a double." He leaned back contentedly in his chair, gazing up into the faintly sparkling sky. The stars were just coming out over Avenue A.

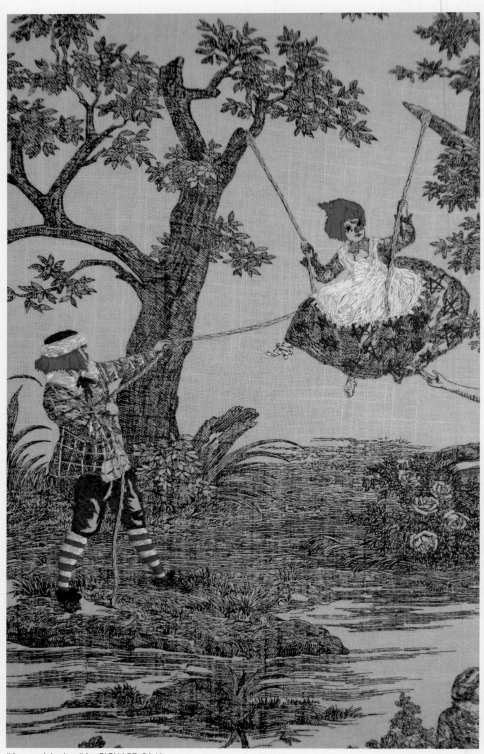

"Ann and Andrea" by RICHARD SAJA

× 2017 ×

NEW INTERVIEWS + ARTWORK
FROM SOME OF PANSY BEAT'S
× ORIGINAL CONTRIBUTORS ×

WIG PARTY

ENTERTAINER, ACTIVIST, HAIR DON'T, CONSPICUOUS PINKBERRY CONSUMER

LADY BUNNY × BY LEE KIMBLE × AKA BARBARA PATTERSON-LLOYD ×

Imagine, if you can, *I Dream of Jeannie* Barbara Eden divided by H.R. Pufnstuf and multiplied by the voice of Bobbie Gentry. Then carry the Sylvester. The result of this arithmetic is Lady Bunny. Her mega-wigs, her icy blue eyes peeking through greasy black lashes, her shimmer-tight sealed legs teetering on clear plastic mules, her scintillating dance moves, and her raunchy humor have shocked and thrilled gleeful audiences to tears of laughter for decades. An alum of the 80's Pyramid Club and the co-creator of Wigstock, an authentic show biz professional and self-described hardest working drag queen in the entertainment industry, Lady Bunny these days find herself booked with back-to-back DJ and performance gigs across the globe. And with her latest show, *Trans-Jester!*, the lashy Lady has added a bounty of political barbs to her quiver of "talents". Below, Bunny's one time stage cohort, **BARBARA PATTERSON-LLOYD** (aka Lee Kimble) tries to make sense of the senselessness that is **LADY BUNNY**…

Photo by MISS GUY

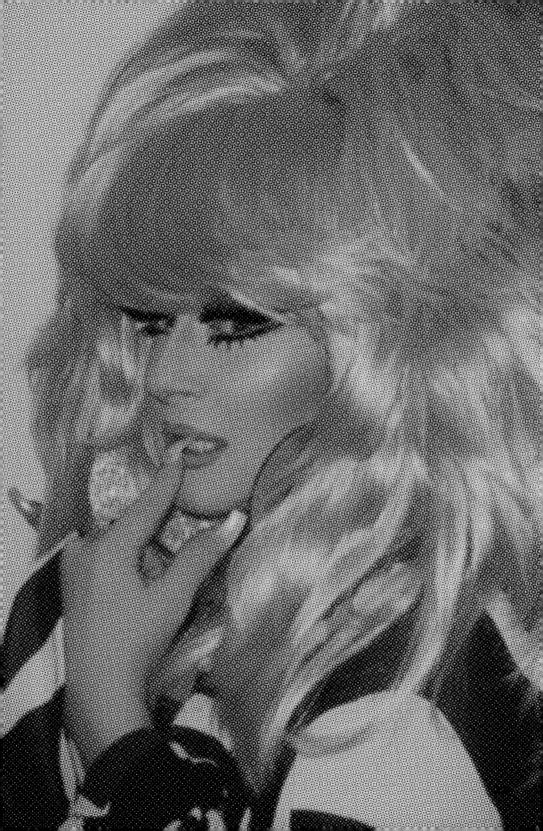

THE FIRST TIME I encountered Lady Bunny in the mid-1980s I wasn't sure if she was something I should run toward or from. She was go-go dancing on the sagging bar of the Pyramid Club wearing a mini-skirt made of plastic room divider beads that was both endearing for its hand-made novelty and yet shockingly debauched. Later that night at an after hours club called Nickel Bag I watched her fall from the top of a steep set of steps that led to a loft where illicit activity was purportedly under way. She had just executed a haughtily made gesture as if to announce her descent when she lost her footing and literally slid step after step to the floor, landing inches from my feet. In a flash she leapt to her heels, squealed 'pleased to meet you,' and grandly swept herself away.

It's been 30 some years since that night and I can say with conviction, I should have run the other way.

L. K: *Do you remember falling down those stairs?*

L. B: Yes! Even though I was blacked out drunk. I was later told I smoked opium in that upstairs room—which is something I never even wanted to try. I'm naturally clumsy, so adding high heels, a steep staircase, unlimited booze and possibly opium would've definitely heightened the mess factor. After decades of similar falls, I finally quit drinking completely. I eventually found that the alcohol interferes with my use of hard drugs.

Do you remember the mini-skirt?

I don't, but I've always been fascinated by room divider beads, which were a hippie thing from my youth. They have a middle eastern or gypsy feeling to them. I also made earrings from the kind with clear plastic hoops because of their large scale. Everything I wore in my early days was either from a thrift store or homemade because I was penniless. I'm sure I was also wearing only one wig at a time back then, too! As I've grown both in terms of waist size and size of paychecks, I now wear at least 5 wigs at once and have my costumes custom made. But I still design them myself, which is one of my favorite things about my job.

When you began your career Ronald Reagan was president, the AIDS epidemic was taking its toll, and The New York Times didn't allow for use of the term 'gay'. Was there a component to your early career that was responding to an unfriendly culture and did you feel you were being transgressive or political?

My father was an activist and we didn't get along in my teens. So I grew up seeing politics as something I needed to shun in an effort to shun my dad himself. Many on the club scene joined ACT UP to combat the government's slow response to AIDS, but I didn't feel I had much to offer the group. I'd do whatever benefits I was asked to, but I was in my twenties and more interested in boys and booze than activism. Many did claim that Wigstock was inherently political since an annual, outdoor drag concert was being "in your face." I only saw it as an entertaining show.

It took a little courage to be ourselves at an outdoor drag festival, but the fact that the festival continued for so long confirmed that NYC was the wacky home for many of us who had migrated to the city from duller parts of the country. I also felt that the serious activists needed a jester like myself to provide some levity by throwing a costume bash to connect with nonsense, community and celebration. That was about all I had to offer in my early twenties. Now I'm so transgressive and political that I'm sure many wish I'd revert to my former silly-all-of-time self! But during the last election many of the same passionate activists spearheading ACT UP instantly forgave Hillary Clinton after she inexplicably thanked Nancy Reagan for starting a conversation on AIDS—which neither she nor her husband ever did. Funny how those raging activists have now mellowed and I'm now sometimes viewed as the seditious, anti-establishment one as I hit my mid-50s.

Does your penchant for the subversive and filthy just come naturally?

What I do on stage or video stems from what makes me laugh amongst friends. And my friends are very sick! I try to bring that kind of humor to my act so that I can enjoy performing it and so that it's authentic. And coming up through the AIDS crisis, some of us used gallows humor just to cope with our friends dropping and fears about our own HIV status. One silly thing I've done for years is to pretend to masturbate when I'm at the movies and there's a death scene or a bomb—just to act a fool for my friends in a totally inappropriate way. I enjoy some polite humor, but I cut my drag teeth performing for very drunk and high club crowds at 1AM who encouraged raunchy and twisted stuff. I can literally say

that pulling out a crack pipe to the tune of Whitney Houston's version of "I Will Always Love You" got such tremendous cheers and laughs that it payed my rent for over a decade. I don't enjoy forcing sick humor on those who are prudish or PC, but there is a large audience for it and my goal is to reach them.

Have you ever in any way gone too far?

I'm on youtube doing blackface at the Pyramid. I wouldn't do it today because I understand why it's offensive after my interactions with black friends. But I'd found a comedy album by a black drag queen named Mr. Jerry Walker, The Fairy Godmother in a thrift shop. I fell in love with it. My goal was to impersonate Jerry out of respect for his character, comedy and delivery. In my mind it was a lip-synch tribute to something I enjoyed. It's also very easy to do a flawless impersonation of someone who no one had ever seen or heard of!

But I'm not keen on this idea of going too far, since we all have different tolerance levels to things which annoy/offend us. While my humor can be rough, I work regularly so it can't be that offensive. However, everyone is so easily offended nowadays that they seek to shut down whatever they dislike. Why censor it? Just avoid it! Just change the channel or go to a different venue which books the type of shows which you enjoy. I'm an atheist who's offended by the president getting sworn in on the Bible, a book of old fairy tales which has been used as a weapon to bash gays, justify slavery, prosecute "witches", set up a system for child abuse, etc, for centuries. But I have bigger battles to fight than changing what book the president is sworn in on. As if the Bible keeps any of them from bamboozling us once they're in office!

In recent years you have become more politically vocal. Can you in a few sentences describe your political viewpoint?

We have only two political parties. Republicans denounce even the science of global warming and that enables them do nothing. If there is no problem, no fix is required. Democrats pretend to care, but still work for the oil companies. As I type this, we've just experienced Hurricanes Harvey and Irma and one third of Bangladesh is under water after a catastrophe there. It's so dry in California that years of draughts have led to raging forest fires which they don't have enough water to put out. How are you going to argue about immigration, abortion, insurance, gay rights or anything else when your city is under water? Both major parties are too corrupt to care about anything but their donors, which include fossil fuels. The mainstream media mocks proponents of global warming as out of touch—as if ISIS or US military interests abroad were much greater threats. It turns out that the Pentagon agrees that global warming is the main threat and has been quietly making plans for the oncoming catastrophic climate changes which do trump all other threats to our nation's safety. I don't like the term "fake news", but if you're ranting about Russia, the fall-out from Charlottesville protests or trans in the military non-stop, you are completely ignoring the #1 issue: climate change. Try charging your cellphone under water which you can't drink!

Of course, our mainstream media takes ad dollars from oil companies so they downplay global warming in our "news". During the recent election, our news completely turned into TMZ. The sensational format is devoid of in-depth analysis. How will any of that drivel translate into policies which affect working Americans—the bulk of us? They won't, yet this is presented as news. Corporate media has a corporate agenda. Along with not questioning or regularly bringing up wars we are currently in, not connecting the dots between fossil fuels and climate change, establishment media fails to point out that the two parties have become too similar. Establishment Democrats and Republicans both seek to engage in perpetual warfare, ignore climate change, refuse to support the state-run insurance which works in most other Western countries, and cozy up next to corporate interests like big finance, despite the fact that they crashed the economy and housing market. I'm a life-long Democrat who has campaigned, donated and blogged extensively in their defense. But centrists drove the Dems so close to the middle that my former party no longer represents progressives. Therefore, we need new parties. Too bad that both parties aren't stressing education either. Is it such a stretch to think that if we're uninformed enough, the hot button "trending" issues overshadow discussion of policy?

Whew! That was long-winded. But I guess, you could sum up my political views like this. Fifty per cent of our tax dollars goes to defense. Who is attacking us? No one can even explain the missions in Syria, Yemen, Iran and Afghanistan—the longest war in US history. The military-industrial complex is making banks with troops stationed in 30 countries. But if we trimmed the defense budget, we would not even have to pay much more in taxes to create state-run health care with no more monthly premiums. The elites in both parties have decided that spending a fortune bombing people in countries which never attacked us is more important than the health of US citizens. I'm so glad I could cheer you up!

Illustration by MICHAEL ECONOMY

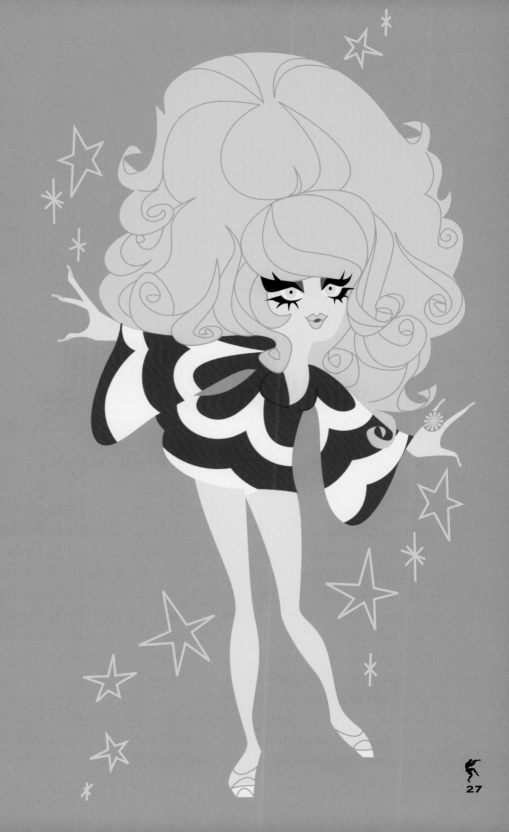

POLE MODEL

◆ CONNIE FLEMING ◆ BY MISS GUY ◆

With appearances in the opening credit montage of NBC's Saturday Night Live as well as George Michael's music video "Too Funky", **CONNIE FLEMING** was probably the most visible trans woman on the planet in the early '90s. Already a seasoned performer as one of the East Village's Boy Bar Beauties, Connie was favored by Parisian haute couturier Thierry Mugler and ruled the catwalk during the legendary era of the Supermodel. More recently Connie gives a revealing performance in *Turning*, the 2014 Antony and the Johnsons concert documentary by Charles Atlas where she joins 13 other remarkable women including Kembra Pfahler, Joie Iacono, Honey Dijon and Joey Gabriel. Currently focused on fashion illustration, her first love, Ms. Fleming also designs a clothing line and assists artist friends Patricia Field and Kevin Mchugh, with whom she is active in the Lower East Side Girls Club. She continues, as well, to make appearances as New York's most notoriously frosty club door-person.

I REMEMBER the very first time I heard about The Connie Girl. A friend said "Connie is incredible. Wait till you see her" and it wasn't long before I did. It was at Boy Bar on a crowded Thursday night in late 1985. The show started and my somewhat innocent eyes watched Miss Shannon and Glamamore perform one after the other. I'd seen a few drag shows in Los Angeles before moving to New York but I wasn't prepared for what I saw that night. It was beyond camp. LA queens at the time were doing a sort of Sunset stripper real girl look but Glamamore and Miss Shannon were doing cartoon glamour that was shocking and beautiful. I was drawn into what they were doing like a moth to a flame. And then The Connie Girl hit the stage doing a mind-blowing lip sync to Yoko Ono's Walking On Thin Ice. She was a mannequin come to life dancing and high kicking all over the stage. I'd had a similar feeling when I first saw Bowie and Debbie Harry. I was excited but slightly threatened because I'd never seen anything like them before. Connie was a combination of New York and LA, mixing the cartoonish glamour and beauty with the sexiness of the Sunset stripper look. She was a downtown superstar. She brought down the house that night and every time she stepped on that stage. She still brings down the house whenever she's on stage performing or modeling. I got to meet Connie after the show and she was super sweet. I met all the people involved in the show that night and eventually was asked to do a show with them. Connie and I got to know each other well and are friends to this day. I've watched her wow audiences all over NYC and even in Tokyo. I've seen her walk in numerous fashion shows. I've seen her influence on models like Naomi Campbell as well as other super models of the late eighties and early nineties. Recently I had the pleasure of photographing Connie and again was blown away by her genius-ness! She is brilliant in front of the camera but even more brilliant in real life. The way she moves has to be seen to be believed. And by the way, I'm not only a spokesmodel for the Boy Bar Beauties of 1985, I'm also a member.

MISS GUY

M.G: *What is your involvement with the Lower East Side Girls Club?*

C.F: After my dear friend/sister Codie Leone's passing, her dogs Luigi & Hefner went to our great friend Kevin McHugh. One day while walking the boys we ran into co-founder Jenny Dembrow with a gorgeous posse of girls following behind her. While Luigi & Hefner charmed the girls Jenny invited us to come by and check out the LESGC. We did, and we fell in love. It's love in action. A 30,000 square foot oasis of possibilities built on the vision, passion and determination of a handful of East Village kick-ass women. I am a community spokesperson and evangelize to anyone who will listen and hopefully get involved or donate. Also planning an art class with Jenny and a runway class focusing on Deportment, Style, Posture and Confidence, DARLING!!!

Are you doing the door at any clubs at the moment?

Yes, I'm doing LadyFag's Battle Hymn Sunday nights BITCHZZZ.

What are a few of your funniest moments working a door?

There is nothing funny about working the door except YOU thinking you are getting in the club tonight.
(Just kidding.)

Do you have the issue of Pansy Beat *that features you as Barbie?*

I did but lost it along the way and really missed it. Michael was so gracious to send me a copy.

What do you remember from the shoot? Was this the first time a fashion editorial was created around you?

I remember lots of laughter. Billy Beyond did my make-up that day and was in rare form. I do remember being so excited that it was a Barbie story as I am a collector and all around Barbie freak myself! I was over the moon. She has been such a large part of my childhood, my view of style and Girl Power. And yes I think it was my first fashion editorial feature focus fantasy!

Your cover and spread in Candy *magazine from 2012 was genius! How did that come about?*

The incomparable Sophia Lamar told me that Luis Venegas the editor / creative director of *Candy* mag was a fan and wanted to meet me. I was to be at Susanne Bartsch's On Top at midnight looking as P. R. E. T. T. Y. as humanly possible. We met that night and chatted about being in *Candy* and he said he'd be in touch soon. About a year or so later there was an email from Luis about

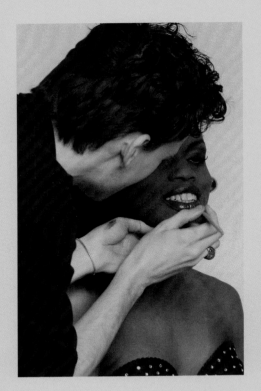
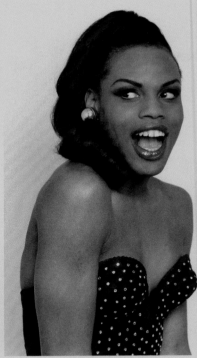
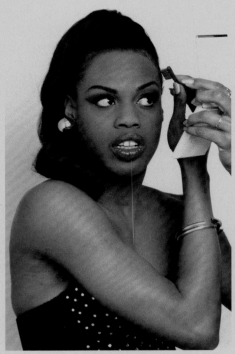
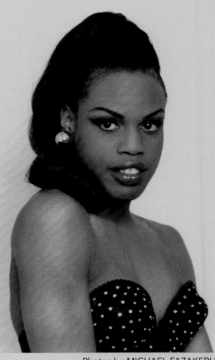

Photos by MICHAEL FAZAKERLEY

a story idea. We spoke later that day about his inspirations and the times we were in. He mentioned the '90s iconic Rosemary McGrotha for Donna Karen presidential ads--which was all I needed to know! A couple of months later he emailed again about shooting in L.A. and the photoshoot being filmed for Brad Goreski's show *It's a Brad, Brad World*--okay? At this point it was meant to be editorial not a cover story. After the shoot, talk started about it being the cover. Billy B. Brasfield (makeup artist to the stars) called it first on set--which had me petrified!

What was the first magazine or zine that you were ever in?

Paper magazine shoot by David LaChapelle. The year of our lord 1685.

What photographers have you been photographed by?

David LaChapelle, Tina Paul, Steven Meisel, Francesco Scavullo, Tony Viramontez, Doris Kloster, Steven Klein, Thierry Mugler, Simone Bocanegra, Nan Goldin, Paul Steinitz, Danielle Levitt, Mario Testino.

Do you like modeling?

No! As Audrey Hepburn said in *Funny Face*, about fashion magazines and modeling, "It's chichi and an unrealistic approach to self-impressions as well as economics". The best part, again, Audrey in *Funny Face* "Take the picture, take the picture!" The worst, shooting furs in August.

What was it like walking the runway for Thierry Mugler?

It was insane! It was something others said would be genius and that I'd be perfect for. But it was something I'd never

◆◆◆◆◆◆◆◆◆◆◆◆◆◆◆◆

I, OF COURSE, HAD THE PIVOTAL ROLE THAT BROUGHT THE MORAL OF THE STORY TOGETHER.

◆◆◆◆◆◆◆◆◆◆◆◆◆◆◆◆

let myself dream about or hope for. So when it actually happened, I had no time to think about anything but doing a great job--not only for myself but for everyone that believed in me.

You're an incredible model as well as a performer. Which do you prefer, modeling or performing and why?

I don't really prefer one over the other. I think it's because it's all performance to me.

Tell me about the first time you performed on stage and in front of an audience. Did you have stage fright?

The first or second grade in the play *Stone Soup*. I, of course, had the pivotal role that brought the moral of the story together.

Do you have stage fright? Do you still get nervous before a show?

Yes, I do get stage fright. At the beginning I, sort of, expected it. As time went along it got better but any time away kills it all, and I am back to square one. So there's a lot of psyching myself out before.

I WAS ONE OF THE ORIGINAL BOY BAR BEAUTIES. NEVER MISS BOY BAR, BUT WE WON'T GO INTO THAT. IT'S STILL VERY PAINFUL!

What memories do you have of legendary 80s clubs like Pyramid and Boy Bar?

It was a special, daunting, magical time from which we all feel the reverberations today. It's filled with earth shaping Art, Music, Dance and Fashion that for the most part germinated in the downtown East Village scene. My fondest memory of Boy Bar, the red light on the dance floor. If that light went on it meant the cops where in da house, so stop dancing and start cruising MARY!

You were one of the original Boy Bar Beauties with Glamamore and Shannon. What affect did that have on you as a young artist?

Yes, I was one of the original Boy Bar Beauties. Never Miss Boy Bar, but we won't go into that. It's still very painful!

What was it that attracted you to the performing arts?

Expression.

What do you consider to be some of your career highlights?

The opening credits of *SNL*, Mugler couture, *Candy* cover, being a black trans woman in heavy rotation on MTV and living in New York MotherF*ckin Titty.

You've been known to do cartwheels and the splits. Can you still do the splits?

Why yes I can, just give-a-bitch a yoga class and I'm ready to go.

When did you get into illustration? Who are some of your influences?

My first memories are drawing on the wall of our house when I was 3 and it became my saving grace throughout my school years. My plan was to attend Parsons or FIT to study but then The Connie Girl was born--and let's not go into it. You know how Miss Connie is. My influences are Henri de Toulouse-Lautrec. Erté. René Gruau. Alberto Vargas. George Petty. Antonio Lopez. Tony Viramontes. Robert W. Richards. George Stavrinos.

You still live in New York. Are you a native? Do you ever think about living in another city?

A native-ish. We moved here from Jamaica when I was 5 and I grew up in Brooklyn. The only other city is Paris. I thought of moving there in the '90s for work-- but, c'est la vie.

What was your favorite era in NYC?

The years I was privileged to attend The Paradise Garage--it was perfection, a religious experience that shaped my life in many ways.

What type of men are you attracted to?

I like them tall. Dark. Rich. And well versed in the art of spoiling a girl with jewelry, real estate and mixed securities.

I AUDITIONED FOR THE ROLE OF LEGOLAS IN THE LORD OF THE RINGS. FOUR CALL BACKS. I WAS FINALLY GOING TO HAVE A PAYCHECK AND BUY A HOUSE AND BE DONE.

Four call backs. I was finally going to have a paycheck and buy a house and be done. Cut to Orlando Bloom! That was another almost.

As a DJ in the 90s, you co-curated the legendary party Beige, NYC's longest running gay weekly event, and on a Tuesday night no less! How did Beige start?

Beige was the concept of Eric Conrad, who came to me and said, "Let's do this party together." He came up with the name Beige because we were aiming for the middle. He had just had a couple of successes with Club Soda, which I named for him after opening his refrigerator. And also the big stink he caused in midtown with Poop. At one time it was possible to make a big Splash in the Men's Room and then go to Poop, those were the clubs. Anyway, so Beige was Eric's concept, all we had was a photo of Kim Novak and we wanted to start something without a dance floor that wasn't playing house music and could I play the music? "Yes, I would love to!" The only records I had were an old box that belonged to my dad. I used my dad's Air Force headphones. Now the good news was that my dad had very great musical

taste, super swanky. Enoch Light, Sergio Mendez, Martin Denny, classic upbeat happy lounge music. And so that's what I played.

Uh-huh, Bossa nova and Cha-cha-cha?

Yeah, somewhat borderline kooky. The Harmonicats. Fifty Guitars, Tommy Garret, the Three Sons, of course Chris Montez. Claudine Longet. It was very A&M playlist. There wasn't anything like that happening at the time. The first week, lots of celebrities showed up and no one else, like Tim Burton, Parker Posey, the New York celebs of the minute. There was no dance floor, so it was more about listening, and appreciation and cocktails and that whole thing, which was just starting out as a big trend. And so we moved quickly to the Bowery Bar and it lasted there 17 years. And that was my first DJ gig!

What were some of your most memorable DJ gigs?

One of the most thrilling moments was for Tim Burton's birthday and it was at a Frank Lloyd Wright house in Los Feliz. The house is just stunning. Lisa Marie decorated this house with hundreds of thousands of long stem red roses. Armloads of them dumped along the walls on the floor, everywhere, in every hallway. It was wild and it was really beautiful excess to do that with so many flowers. So I'm deejaying in the garden, and I'm playing my classic lounge look and suddenly coming towards me from across the garden, is Tim Burton with Ann-Margaret. She was wearing all beige, she had beige nails, and her hair was a shade of beige. She came right over to me with that smile, holding a Champagne glass and nods and it's sunset. She grabs my arm, and all the hair on my body stood up. She had an electrical charge around her body.

I have actually read that about her after this meeting. It terrified me because I had never experienced that. She grabbed my arm and she said, "I could tell you're an entertainer too". Okay, besides shooting myself, I said, "I was just about to play 'C'est Si Bon.'" She said, "You have that record? Well if you think they'll like it." She still has her claws embedded in my arm, and the minute the song starts to play, she had a full personality flip and became completely like a scared kitten: huge eyes and looking out over the lawn, going, "Do they like it?" At that moment Cherry Vanilla comes running across the yard, screaming, "I love this track, oh my God it's you." As soon as Ann saw that, she flipped right back into the tesla-coil-zapping-electric-superstar, let go of my arm and put her hand out to shake Cherry Vanilla's hand, "Thank you. Thank you." And I just thought, what just happened?

Who is Billy Erb and who is Billy Beyond?

Billy Beyond is a name that was given to me by Body Map designer David Holah in 1985. Josh introduced me and David came over and looked at me and said, "Beyond, Billy Beyond," and that was it, done.

INCREASE EMPATHY: THAT'S REALLY THE ONLY RULE YOU NEED.

I'VE ALWAYS BEEN SERIOUS ABOUT FUN TOO... FUN IS IMPORTANT.

It's so funny because Erb seems like such a unique name anyway.

Nobody believes that Billy Erb is my real name. Most people think it's made up but that's my family name.

HA! Tell ME about it! Now besides Antonio Lopez, another inspiration is your exploration of the Greek myth Narcissus.

The Narcissus myth has been a rich vein for gay artists through history. I guess this is because same-sex love has been seen as or misunderstood as being related to traits of vanity or obsessive self love. Perhaps personal redemption is the impetus for this project? I don't know, but like many of those who were equally cursed and blessed with a type of beauty in their youth, I was sometimes blinded by it. I mistakenly believed it to be an advantage. Artistically I have always felt obliged to create beauty, if only for its own sake. Beauty for me exists as many different things, some of which are unremarkable, underwhelming or even ugly. The beautiful part exists as a sense of peace that can inspire. Beauty has a sacred quality.

Beautifully said. I can't wait to see what you create next. Finally, do you have any personal mantras you want to share?

Increase empathy: that's really the only rule you need. I've always been serious about fun too...fun is important.

"Lucca, Homage Antonio" by BILLY ERB

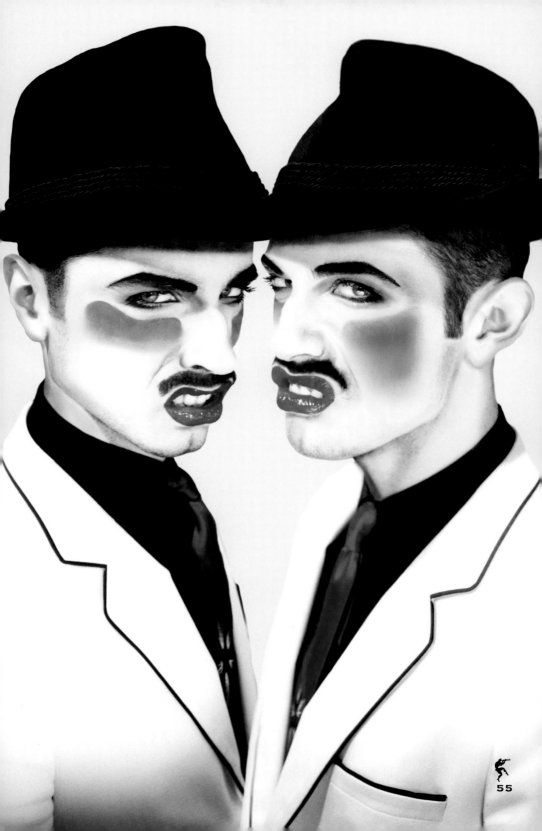

55

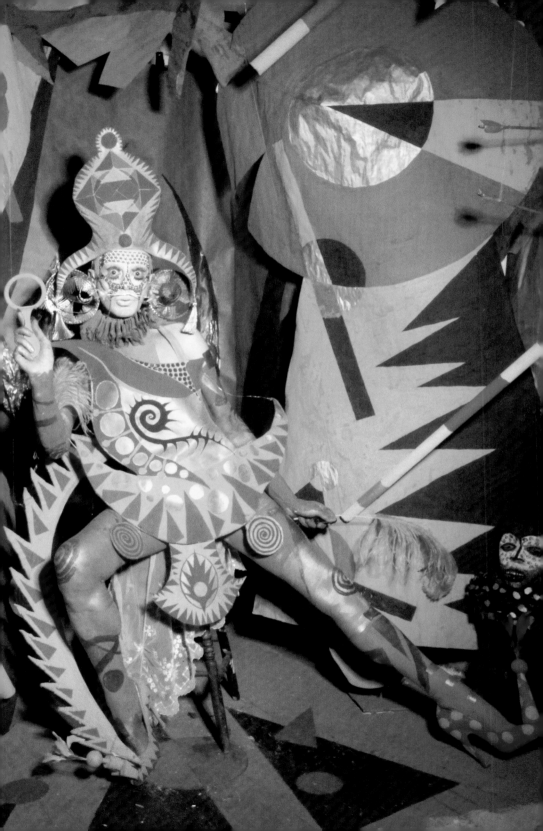

MICHAEL

★ BY MICHAEL ECONOMY ★

★ KENNY ★
★ KENNY ★

NIGHT CLUB ROYALTY

EXHIBITIONIST EXTRAORDINAIRE

RIDER OF WHITE SWANS

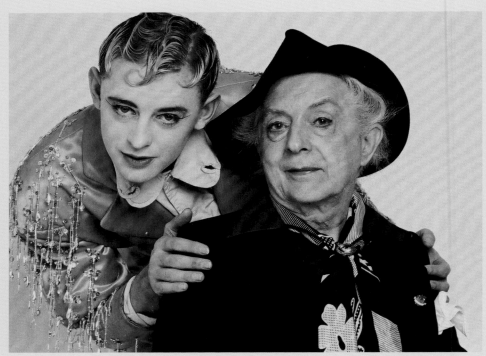

KENNY KENNY and QUENTIN CRISP for PANSY BEAT, Spring 1990

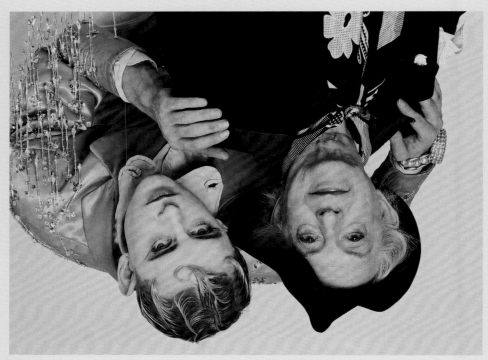

★ ★

For over twenty-five years, **KENNY KENNY** was the gate-keeper of New York nightlife, the premier door person to the city's hottest nightclubs and events. His memorable, ever-changing looks delighted clubland's constituents and prompted writer Michael Musto to describe him as "Dietrich via space alien." Now retired from the scene, Kenny Kenny devotes his nights to creating elaborately costumed self-portraits without ever leaving home.

★ ★

M. E: *What made you decide to take on the task of self portraiture, when did you start?*

K. K: I started about 5 years ago. I was always wrapped up in the world of dressing up, but because I'm not very technically minded I was reluctant to start into photography but then digital came along and made it easier. I wanted to find the creative side of this person that I am, underneath the layers and tell a story, a visual poem, by creating mysterious characters who hide behind veils, masks, and costumes. I am that person in many ways.

Where and what were you doing just before you moved to New York?

I was working in London in the early 80s when it was all about fashion and costume. I was working for Rachel Auburn as a studio assistant. Every morning she gave me a glass of orange juice with a little bit of speed in it but I didn't know it. I was still quite shy and sensitive back then. One day I freaked out and ended up sewing sleeves onto the back of skirts and one of the seamstresses pulled me aside and told me about the speed and I got very upset. But people like Trojan, Leigh Bowery and Michael Clark were always dropping in and Pearl lived downstairs and Dean Bright lived on the same street, so I put up with it. Even though I was intimidated by her, I was in awe as well. She was a strong, enigmatic, sensual, gorgeous woman. It was heaven and hell at the same time with all the amazing, brilliant people in and out of the studio.

P56: Self-portratit by KENNY KENNY. P58: Photos by MICHAEL FAZAKERLEY.

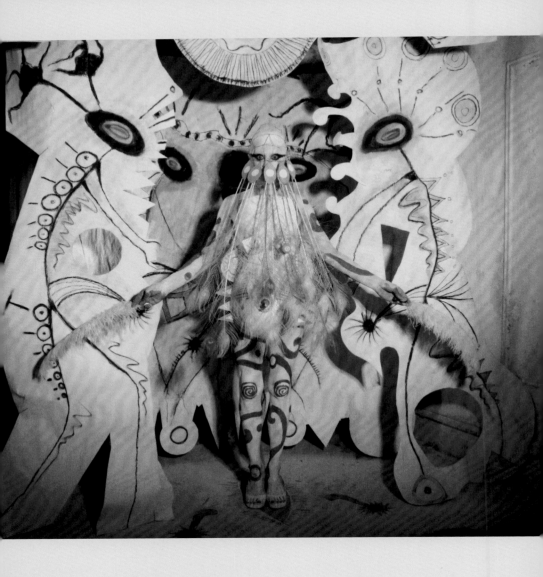

I REALIZED I HAD A DRINKING PROBLEM.
I HAD TO HAVE A JOB TO SUPPORT IT.

So you left Ireland for London with a degree in Fashion & Textile?

Yes. And Rachel was the DJ at Tabboo where we all were every Thursday night, hanging out with Leigh, getting wasted drunk and living in a really rough area of London. Then my Mom calls from the small town in Ireland where I grew up. The College had offered me a styling job in Dublin. I was living in a squat, drunk and high on speed all the time. I decided it would be a good time to move to New York for a new start, although it was much more of a do or die situation. So I did the job in Dublin, took the money and was off to New York. It was my first time on an airplane and it felt like Alice in Wonderland.

And when was this?

In 1986, I was 23. After the airline ticket I ended up with almost no money. I met a guy at The Bar in the East Village who said he'd let me sleep on his floor for $150 a month, nothing sexual. He smoked pot all the time. At some point after that I tried the gay roommate service in *The Village Voice*. Remember? $50 a month. But it was sad. I'd go to see these apartments and all these people were dying of AIDS and I didn't know how to handle that. Eventually I got a sublet in a SRO. Having my own room and sharing the bathroom with a bunch of junkies—ugh! But it was my own room. I still felt like just being in New York was a really important thing to be doing. The second day, I realized I had a drinking problem. I had to have a job to support it so I went into every single shop on Bleecker street and ended up working at a shop called Magic Shoes. It was a nightmare so I left there and got a job at a costume jewelery design store where all these queens worked and started going to the Pyramid with them and meeting a lot of the London kids like Sticky Vicky. Right off, Suzanne Barstch saw me and she was like "I LOVE YOU!" She said she'd call but you know how people in clubs are, and then she called the very next day and that was it. I started working the door at Savage and it never stopped.

What do you remember about the Quentin Crisp interview for Pansy Beat *back in Spring of 1990?*

I remember I couldn't believe it was happening. I knew him from the movie *The Naked Civil Servant*. I remember being a bit aloof although I was super excited and nervous. The next day, thinking about it, I almost fell out of my seat. He was really sweet. He really is my ultimate gay icon, his flamboyance and his elegance and his genius! And he was kind to me on top of it.

That was a special day for me too. I was meeting Mister Crisp for the first time, and I was very excited you had agreed to do the interview for us. In Quentin Crisp's autobiographical book, he says "Exhibitionism is like a drug. Hooked in adolescence I was now taking doses so massive they would have killed a novice." Do you agree?

I would say it was probably true for me too. Because in my formative years, I wasn't allowed to develop because of the way I was mistreated. Once I was out in the world of London and working club doors in NYC, I naturally developed a craving for attention and status and a fake sense of self-esteem. However, it was the only self esteem I had

Self-portratit by KENNY KENNY

ONCE I WAS OUT IN THE WORLD OF LONDON AND WORKING CLUB DOORS IN NYC, I NATURALLY DEVELOPED A CRAVING FOR ATTENTION AND STATUS AND A FAKE SENSE OF SELF-ESTEEM.

ever known. The rush is believing that you are special. Looking back, maybe I thought I was special but underneath I was very insecure. After it was all over, that bubble really burst and I realized I was just covering up trauma. I stayed in the club world so long that I had to give up that identity. It's all ego in the end. For so long it meant so much to me. I had believed in Kenny Kenny the club personality and all that goes with it, but it meant nothing to anybody.

I don't agree with that. You, or that flamboyant club personality you presented to the world, certainly meant something. You inspired and delighted people, but go on...

Well later, I realized it did mean as much as I had hoped, although I do think people feed into it. But it's all an illusion for the most part. Nightlife gave me a sense of self esteem that was not real. It became a crutch. And when I gave that up I saw the real me. What I have discovered since dropping out of the nightlife business is that I have talent. Leaving all that after more than two decades is still a process and I'm in that process. Through my art and therapy, I'm beginning to find out who I am. It's a bit shaky now because when you give up your identity, what you thought you were, you slowly begin to see who you really are and it's a very different thing.

As a 70's teen, were you a fan of David Bowie?

Yes. I remember all of the kids in my neighborhood had just seen Bowie on *Top Of The Pops* and I was the only one who had missed it. All they could talk about was whether or not he was an alien. I remember sensing that something extraordinary was happening. But I really didn't get into to him until *Scary Monsters*. I have to say that at the time I was really into Marc Bolan because to me he was much more sexual. I loved his feminine and mysterious style. You know he had a children's TV Show. It was a really naff-looking show but he had all these 10-year-old kids on it, dancing around him with his feather boa. For me at 11, seeing him like that, I thought, "THAT'S ME! That's what I'm going to be!" So I left home at 12 with an old man who owned a construction company in London, plus he had a gold Rolls Royce. He would take me to London and we would go shopping. I had him take me where Marc Bolan shopped. He bought me these white platform shoes and a deep blue crushed velvet blazer. When I came back home with that whole look, to my small town in Ireland, everyone was just screaming and shouting like the circus was in town!

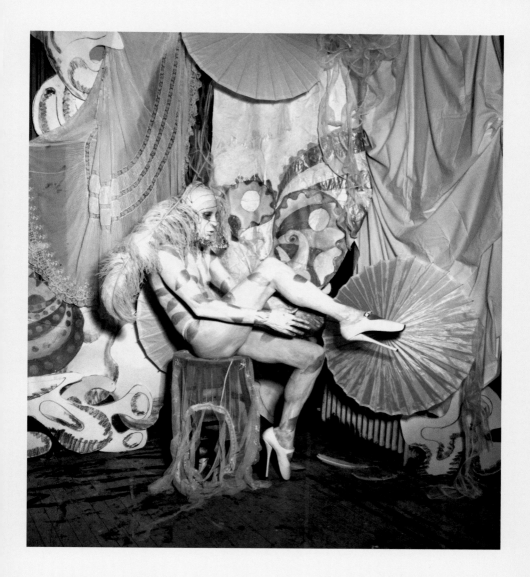

Did your Mom know what was going on?

She knew. The whole thing was really fucked up. I wanted to run away from home and not come back, but I didn't have the courage at 12. I mean we would go driving around at night in this car and go to these neighborhoods where prostitutes would come up to the car. He liked having me sitting with him dressed up.

WOW!

So if you could say anything to your younger self what would it be?

Don't be scared. Your destiny is in the cards. You are worthy and good enough. There's nothing to fear.

Self-portratit by KENNY KENNY

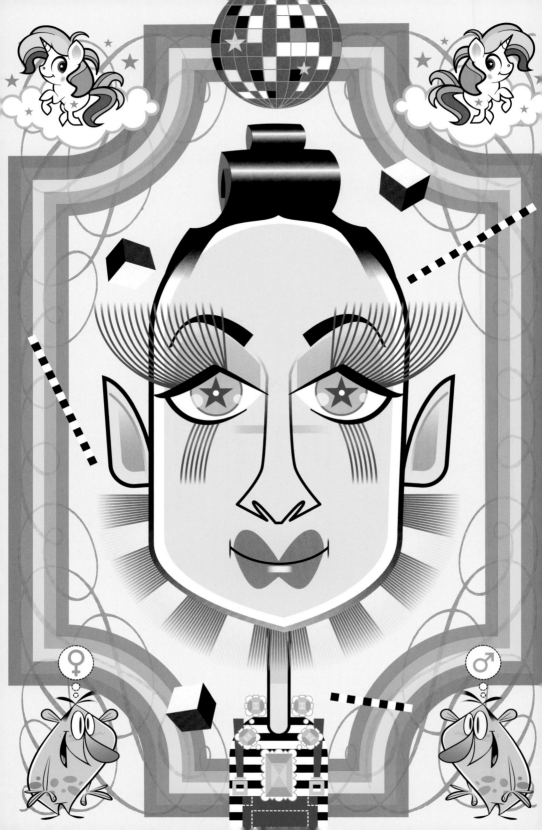

+ BY

+ SISTER DIMENSION +

+ BY CHIP WASS +

SISTER TWISTED

SISTER

MOLI PAMECULA

DE LA TASSLES BLONDIE

DESTINY DARLING

TINKLE POOSNACKER

POMPOM VON PUFF-N-STUFF

SHASTA DEL MAR

NEBULA FERGIE

MENTOR MERLIN

GRAMPA HOOFPYNPOEIERS

DIMENSION

Illustration by CHIP WASS

Sister
Dimension brought
shape-shifting creativity to late 80s
New York club culture as a DJ, poet, and drag
performer. At Wigstock, Pyramid Club, and Larry
Tee's Love Machine, as well as her own weekly Palladium
party, Panty Girdles, Sister baffled delighted audiences
with a singularly erudite insanity. Perhaps no one performance
perfectly epitomized the era, but for many, **SISTER DIMENSION**'s
star turn as the eponymous character in Tom Rubnitz's 1989
short video masterpiece "Pickle Surprise" stands tallest in
a cornfield of lunatic colossi. Here, Chip Wass shares a few
words with the creature listed in 1989's Wigstock program as
"Sister Moli Pamecula de la Tassles Blondie Destiny
Darling Tinkle Poosnacker Pompom von Puff-n-
stuff Shasta Del Mar Nebula Fergie Mentor
Merlin Grampa Hoofpynpoeiers
Dimension".

Epipsychidion's
Adjunct and Obtuse Journey Continues

In Cupidon,
the heartbeat of the itinerant wayfarer's souls
hasten to match the beat of Fates' lyre string
strumming
With one broken oar, our boat makes steady progress
on the Unknown Sea towards the Isle of 3 Sisters Voices
Humming
Starlit, celestial tunes
fill the empty spaces in our minds,
future drumming

Our approach signals mythic trumpet fanfares
Yet to be described winged creatures rise a-sudden
In solemn, gay salute to We
Heralding the Infinite She

Notes, in Time, standing still, move forward, maybe not
Perfect Chords in balance are We
As friendship beckons us into the Cave of Forgetfulness
Where all is still, warm, safe, forgotten, eternal

As 3 goddesses rise in the sea foam
Lift their shells and blast one long harmonious
silent yet loud, frothy, salty, note
We freeze in their beauty and know we must paddle onward
Towards the beckoning pastures of Elysium

BY
SISTER DIMENSION

ON EDWIGE BELMORE ★

★ HAYLEY MOSS ★ BY MICHAEL ECONOMY ★

a RÉPONDS:

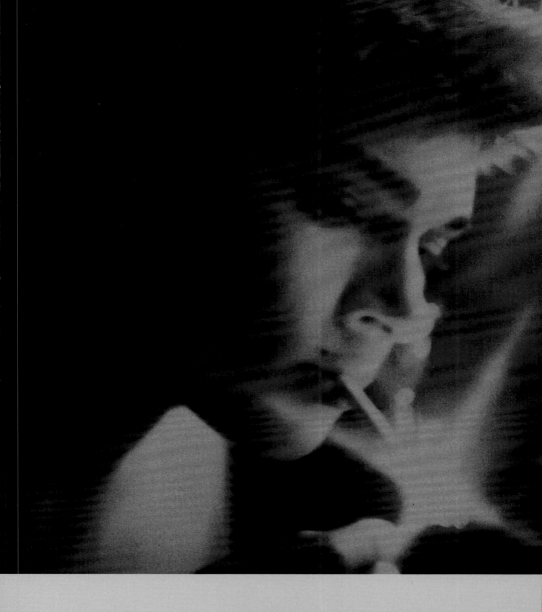

COMPOSER
NATIVE NEW YORKER
CAT PEOPLE
EX-GIRLFRIEND

Paris/New York nightlife legend, singer and dyke icon **EDWIGE BELMORE** (1957-2015) was an early inspiration to artist duo Pierre & Gilles and model/muse for fashion superstars Thierry Mugler and Jean Paul Gaultier. *Pansy Beat* profiled her in our fifth issue (page 350), just after her two year strech at an ashram upstate. Today, two years after her death, we've discovered recently-released tracks featuring Edwige's unique vocal stylings. This led us to the song's composer, Edwige's former lover **HAYLEY MOSS**. Miss Moss is a self-taught composer and was born and bred on New York's Upper West Side. By combining her lush film and TV soundtrack style with early-90's vocal tracks made with Edwige, Moss has created a potent mix of mysterious and meditative melodies.

M.E: *How did you meet Edwige?*

H.M: I met Eddie in the summer of 1983. She was the Bartender at this small bar in the 20s off Park Avenue, called Evelyn's. We were lovers off and on for 3 years. As soon as I saw her, I was mesmerized. A good friend, Joel Virgel, introduced us. I had just come back from Quogue, on Long Island, where I lived next to a golf course and there were golf balls everywhere. I was always picking them up and I had one in my pocket when I met Edwige. She started talking about how she loved golf and golf shoes. So next week I came back with another golf ball and rolled it down the bar... I captured her attention with that golf ball every week. We then fell into this extremely passionate experience, which transformed into a great friendship and creative partnership. It was most definitely something very deep and very immediate. It was a recognition of something ancient, a profoundly spiritual connection. We used to have the same dream at night. We were in each others dreams as we slept, and they were the same dreams. It was extremely unusual. We remained very close friends until she passed. We were very much in each other's lives as family until the end.

Did you know who she was when you met?

I had heard of her through a mutual friend of ours who lived in Paris, a designer named Bertrand Marechal. I did not know of her career as a model and I learned about her band, *Mathématiques Modernes*, after we met.

I still love their song "Disco Rough" and the Pierre & Gilles artwork on the 45. It was the first thing I bought when I moved to NYC, seeing it in the window of a record store on Bleecker street. But now, when I listen to the album, I love the song "Réponds Moi" so much. Do you like the music on Les Vistors Du Soir*?*

Yes! Me too...I love that one. I have the *Mathématiques Modernes* album and the "Disco Rough" 45...love it. Still holds up today.

In 2016, you released "History of a Disappearance," "Guru" and "Sea of Compassion" with Edwige's vocals. When and where did you make those recordings of Edwige?

In my loft in Tribeca in the early 90's. We have other recordings that are not released yet. "Guru" and "Sea of Compassion" were created when Edwige was studying at the Ashram. They came out of the studying

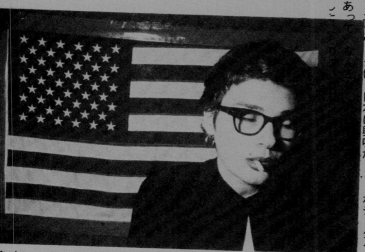

女王

場。

出たりもするし、レスビアンという噂もあるし……。
エドヴィジは「日本に興味があって、

ボディタイツ姿で〝牛〟の役を

クロア風の服の雰

登場のエドヴィジ。

dwige at her popular Beat Cocktail Lounge at the American

of Vedanta. They were done when Edwige was at her happiest I believe. Those tracks flowed out like liquid love. These still had the theme of longing..but now instead of longing for a lover, it was the longing for universal love. For bliss in the "Sea of Compassion" it was part of a group of songs called "The Mermaid's Tales."

Did you create the lyrics together? What was the process?

We had an interesting process for creating music. I would start out with a scratch track that she would sing to. A really simple track, to give her ambience and mood. Her words would flow as if one were floating through water. She was a masterful poet. Then she would leave and I would cut up all the vocals, rearrange the original structure and recreate something utterly different. Rewriting the lyrics by cutting and rearranging her voice. And then orchestrating around the main edit. Kind of how Bowie and Eno worked on the album *Low*.

"History of a Disappearance" is so mysterious and big, like an entire film soundtrack in 4 minutes and fifty-nine seconds. What is the song about?

That song didn't start that way… it was about lost love and losing someone; a theme that haunted not only Edwige, but myself as well. It's about the end of a painful love, about being torn apart and bruised by love. It's about loneliness and pain. It's like *Wuthering Heights* gone wrong. I created the drama with editing and orchestration and, of course, Edwige's sexy voice. I am a film composer, so I pretended I was scoring a French film. Mystery is something I inject into all of my music and film and TV scores. I have always been obsessed with French film scores and the great pathos they evoke. It's a theme that runs through a lot of my work. Edwige and I both had a deep understanding of passionate love and the

THE
KEY

82年は、何かを起こす年、ウフッ。

ラーさんという人が、日本は"第三の波"に生き残れない
と、イヤなことを言っております。ねぇ、そろそろ何か起こそうよ、
さん。頑固にポジティブにチャレンジしよう、面白いこと探
今年の合言葉は、これ。"We make the future!"

2

77

1982 Febr

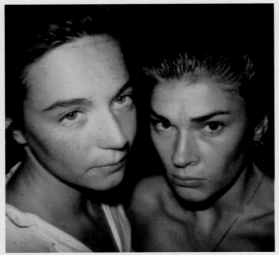

FRAGILE AND FILLED WITH THE SOUL OF A TRUE POET WITH SOME CASANOVA FIRE RUNNING THROUGH HER VEINS.

HALEY MOSS & EDWIGE BELMORE

concept of loss. We shared the same inner language of that longing for profound, haunting love, as well as longing for union with the endless light of spirit. We put those emotions into our work together. We were on the same page and it was effortless for us to create together. There are more unreleased songs. We were working on two new songs when she died. I have not been able to finish them…it hurts too much. She was such a creative being. We inspired each other, and we had a lot fun doing it. We laughed a lot when we were working together, even when we were creating deep stuff. She had a wicked sense of fun.

Do you remember Edwige's Beat Cocktail Lounge back in 1985?*

I was part of starting the Beat Cocktail Lounge with Edwige. I was the bartender. Her brother Eric Busch was the doorman and Jack Walls was the coat check. We had so much fun doing it!

Do you know anything about Edwige's last couple of years?

She was living at the Vagabond Hotel as it belonged to her friend. She might not have been the official gardener but she loved to create and make things beautiful. To be honest it was not good, she was lost. I don't think she had any place else to go. I had the belief that she was on the mend. It was terribly sad and complicated. She wrestled with demons. She broke our hearts, and in the end she slipped away from sheer exhaustion, heartbreak and longing. Edwige was a powerful warrior with a tremendous heart, a sensitive heart. Fragile and filled with the soul of a true poet with some Casanova fire running through her veins. Everyone loved her, yet she never could figure out how to rest and exist in it. She escaped into heaven from a painful lonely place. Perhaps there is peace now. "History of a Disappearance," in some strange way, is her requiem.

**Beat Cocktail Lounge was a weekly party at changing venues--from an Irish bar with sawdust-covered floors to Carmelita's, an East 14th street Hispanic social club with vinyl seats and candelabras. Edwige would perform with Bowie's sax man Robert Aaron, and James Chance of James White and the Blacks.*

This page photo by HAYLEY MOSS. Page 76: WALTER CESSNA's THE KEY magazine, 1984, Photo by W.C. Page 77: RYUKO TSUSHIN magazine 1982, Photo: UNKNOWN

★ HISTORY OF A DISAPPEARANCE ★

FEATURING EDWIGE BELMORE
MUSIC BY HAYLEY MOSS

TENDERNESS IS GONE, INTOXICATION GONE,
IN OUR DISAPPEARING LOVE, FORGOTTEN CARESS.
WHEN MY FINGERS ON YOUR SKIN
DISCOVERED THE FRENZY
I WAS LETTING MYSELF FALL
I WAS LETTING MYSELF GO.
ALONG YOUR LOWER BACK AND YOUR WAIST SO SLIM
I WAS LOSING MYSELF IN VAIN.

★

FROM MORNING TO NIGHT
I WANDER AIMLESSLY
FOR I HAVE LOST YOUR SOUL
AND HAVE SURRENDERED.

★

BLOOD ON MY LIPS HAS LOST ITS TASTE,
BLOOD ON MY TONGUE BRINGS ME DISGUST.
MY FINGERS IN YOUR HAIR AND ON YOUR SKIN
WERE LEAVING MARKS OF BLUE.

★

RAGS.
I NO LONGER KNOW HOW TO DREAM.
I FEEL TORN.
YOUR NAILS
HAMMERED IN MY HEART
FORGOT THE MEANING OF PAIN.
YOUR NAILS
HAMMERED IN MY HEART
FORGOT THE TERROR IN VAIN.

★

FROM MORNING TO NIGHT
I WANDER AIMLESSLY
FOR I HAVE LOST YOUR SOUL
AND HAVE SURRENDERED.

★

I LOST THE DESIRE
TO TAKE YOU IN MY ARMS
AND MAKE YOU SUFFER.

GUYS 'N DOLLS

ARTIST, DOLL ENTHUSIAST, SILVER FOX,
SYLVIA SIDNEY FAN CLUB PRESIDENT

Like **MAXFIELD PARRISH** and **J.C. LEYENDECKER**, **MEL ODOM** is one of the great American illustrators of the 20th century. But unlike Parrish's frolicsome figures or Leyendecker's hard, Arrow Shirt gentlemen, Odom's heavy-lidded lovers swoon at the edge of ecstasy. Odom's art-deco illustrations nod to classicism but with a new wave twist. Early work for *Viva*, *Blueboy*, and *Paper Moon Graphics* established the lush tone Odom later continued with work for *Playboy*, *Time* and countless book covers of the 1980s. Then in the 90's, Odom created Gene Marshall, a highly collectable fashion doll, that took his career to new heights. Today Odom's passions are focused on his portrait style oil paintings of his favorite dolls.

*** BY M. E. ***

Illustration by MICHAEL ECONOMY

M. E: *You have a deep love of dolls. At one point, you had a large collection of Barbies, most of which you liquidated and replaced with your current collecting of Civil war dolls and mid-century dolls. What is it that you find so inspiring about dolls?*

M. O: Dolls are the first objects I ever desperately wanted, from as far back as I can remember. My earliest childhood memories are about dolls, they've been a constant in my life. It just happened, I had no control over it, it was just who I was. As a small child I believed in fairies

and the supernatural, and pretty much anything else I was told. I think this was in part because of the constant presence of fairies in cartoons and storybooks. Disney was a brilliant source of memorable fairy action. When I was very young, I attributed supernatural powers to dolls. The dolls being small and impossibly beautiful, you know, like fairies. As soon as I found out little boys shouldn't play with dolls, well that just made them even more attractive. Dolls were only the first time I wanted something that I was told boys shouldn't want. That later became a norm in my life.

Your new paintings feature dolls and stylized new wave graphic elements in the mix. Tell me how how they came to be?

I think they came from my seeing a million movie posters and cosmetics ads and cartoons and loving them and wanting them and that somehow becoming these paintings. The china doll paintings were about sadness and goodbyes. I painted them exclusively for ten years. They were my way of saying farewell to all the friends and loved ones I'd lost. I lost 2/3s of my friends to AIDS. That sadness had to go somewhere. The china doll paintings were about feeling fragile and yet surviving.

These new paintings you refer too became much more buoyant and optimistic. The dolls were from the 1940s and the paintings were done as if I were working as a graphic artist in a movie studio and designing posters and signs for movies. I do them as a working studio professional, as fast as I can, keeping it bright and mysterious at the same time.

I did a series of four paintings of a specific make of doll from the early 1940s, "Monica of Hollywood". The four portraits

start with the subject far away and come in for a tight close-up if you hang them in the right order. These are fairly spontaneous images in how they happen. I was working on one of these paintings and saw a wonderful B-picture on TV, "The Falcon in Mexico", liked the way the opening credits looked and included it in the painting. It's a spontaneous, VERY fun, stream of conscience kind of thing, from sketch to finished painting.

In 1995 you created your very own doll, the beloved Gene Marshall. Sales of Gene rivaled Barbie and at a 1997 auction, Gene dolls raised more than $30,000 for the Gay Men's Health Crisis Center. What does it mean to be a man with a doll?

Perhaps, for a man, it means not letting society decide what it is you like or don't like. Occasionally, as a child, I was shamed for playing with dolls. Obviously that didn't stop me. The explosion of AIDS deaths was numbing, the loss of so many loved ones and friends. What I did with my talent became important to me because I really didn't know how much more time I had. I didn't know I'd be left standing after the debacle. If, within sorrow, you can allow yourself to feel joy about something that you think is cool or beautiful, and you're able to find some piece of yourself in it at the same time, that's what real magic is, that ability. Gene Marshall was a gift to me and through me all the people who loved her.

How was creating Gene Marshall meaningful for you?

I started working on Gene because my best friend was dying and I was going to be the one to do the "family thing", and be there for him. I was terrified of watching his decline. I'd already lost my first grownup boyfriend to AIDS ten years before and knew what

was ahead. Gene seemed like a project that would save me from the grim reality that was happening all around me. I threw myself into working with Michael Evert, the sculptor who sculpted Gene, and doing that kept me from despair. Michael is a very sweet and low key guy, and very attuned to the emotional space I needed to go from visiting Brian in the hospital, to coming to the studio and working with him. I would show him sketches and photos of actresses and influences I wanted for Gene. It would be very quiet and the camaraderie between us would gradually bring me out of the funk I was in. When Gene became a success and I would do appearances at stores, people would come up and tell me how Gene got them through a tough time in their life or the loss of someone in their family. The 1940s-50s era of Gene and her fashions and story were based on familiarity. Somehow that connected for Gene collectors with people in their lives, maybe their mother or even their earlier self.

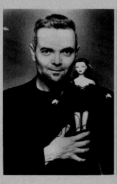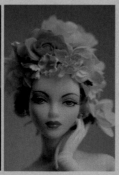

What do dolls mean to your fans?

Dolls mean all kinds of things to people who collect them. They can be a totem for something we desire, a perfect self, a different self, a small enough dream that we can hold it in our hands. They can bring back a sense of who we were as a children. All these things are seductive.

MEL & GENE 1996. Photo by LISA CROSBY.
GENE today. Photo by JAYME THORNTON

You were a contemporary of George Starvinos, Michael Volbrach and Antonio Lopez in the early 80s. They were primarily known as fashion illustrators and re-inventors of the genre. Did you know any of them? Can you share any stories about them?

I knew all of them one way or another. I had a massive crush on Michael Volbrach for the longest time. We met at a party for the contributors to *Blueboy* magazine and he was so madly handsome that my mouth went dry and I couldn't even act normally around him. We saw each other socially a couple of times but I had a really dangerous, drug addict boyfriend at the time and couldn't imagine dragging Michael into that scary world in which I found myself. We're still friends, mostly through Facebook and I still have a huge crush on him. George Stavrinos was the first successful star illustrator to reach out to me to become friends. I was so impressed with his impeccable fashion illustrations for Bergdorf and his total commitment to his work. He was a very sweet man on top of it all. We were neighbors and friends. Antonio was a genius I'd loved since college. He was very complimentary to me about my drawings and we were social at parties and clubs. But every time we tried to get together he'd cancel at the last minute, so a friendship never happened. I just figured he was a very busy guy!

My first boyfriend gave me your book First Eyes *in 1981, and we'd sit and pore over the images together, kindling our romance. Then we were thrilled to actually meet you at an opening of Pater Sato's paintings in a basement on Union Square, I think it was the Union Square Ballroom. Is it possible you remember that night? Did you know Pater Sato? What was he like?*

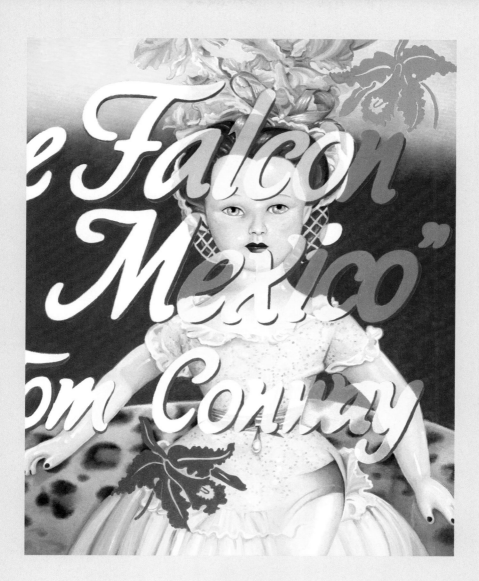

"The Falcon In Mexico" by MEL ODOM

I do remember that night. It was a very fun, sweaty kind of evening and the people there were the real attraction. Once you got over the incredible beauty of Pater's work, and the wild anything can happen vibe, I got to meet Pater and Keith Haring that night or soon before. Pater was a rather enigmatic man, possibly because of the language difference, but kind and spooky-talented. I had a burgeoning career in Japan and he was very helpful and promoted me there. It's difficult to acknowledge their being gone and my still being here. I feel like the survivor of an undeclared war. I'll NEVER complain about getting older. Too many of my friends would have done anything to have another couple of years to live, much less 35 more years. This propels me to want to do something amazing with my life.

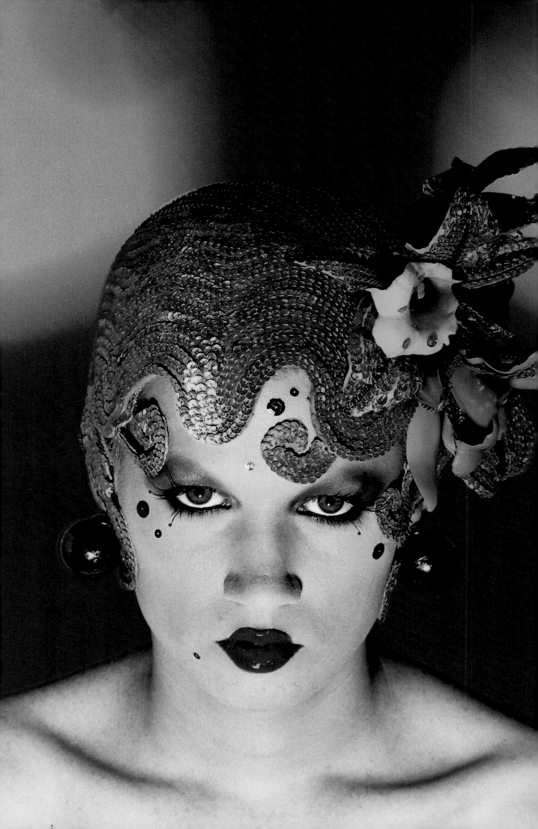

COVER GIRL

The nineteen year old face on the cover of our final issue (page 327) belonged to **CHYNA BLEAU**. In 1990, she had just moved to the city, part of a growing New York club kid scene. I met her at Larry Tee's weekly party, Love Machine*, when she jumped down off a sound speaker in high heels and a platinum bob wig. When she said her name was Chyna Bleu, I said, "Like in the Ken Russell movie *Crimes of Passion*?" She said "Yes! I love that character". After our cover shoot, I saw her only one other time, momentarily, at the Limelight party that Michael Alig threw for the issue's release. I can only remember that Amanda Lepore was there by Michael's side and handing Chyna some copies of *Pansy Beat*. Then suddenly she danced off into the crowd and I never saw her again. I've often wondered: who was Chyna Bleau? Recently, we discovered her on facebook when her friend José Luis Garay commemorated the 10th anniversary of Chyna's death. Here, José shares some memories of his dearest friend.

1971-2006 ★ BY MICHAEL ECONOMY

WITH JOSÉ LUIS GARAY ★

Illustration by MICHAEL ECONOMY. Photo by MICHAEL FAZAKERLEY

José and Chyna met in high school in Miami before she headed to NYC. Four years later when she returned to Miami, she fully transitioned and they became roommates until her death in 2006.

M.E: *What made Chyna Bleau decide to move to NYC?*

J.L.G: Chyna was very close with her grandmother, who was always very supportive of her and even bought her her first make-up kit at the Navarro Pharmacy. But the day after her Grandmother passed away, Chyna's mother and step father told her that she had to stop with the girl clothes and all of it, but she wouldn't, so they put all her stuff in a plastic garbage bag and put her out of the house. And that was it. She decided right then to go to New York City.

Wow, that's rough, and yet still a common story for so many LGBT kids today. Would you say she was tough?

Because of how she lived her life so openly and stayed true to who she was she had a hard time. People gave her a hard time, so she had to be tough. But everybody that knew her loved her and if she loved you, she really loved you, but if she didn't like you, she would let you know it. People gravitated to her because she had a lot of pride in who she was and when people disrespected her she called them out on it.

She felt like Miami was not ready for everything she had to offer. She said that in New York she could be her true self and she was absolutely right: New York was ready for someone like her. She spent four years exploring and putting herself out there for the world. She had so much to offer and she learned so much. She also met many friends along the way.

Yes, she seemed very confident to me, especially for someone so young. At the Pansy Beat *photo shoot she looked so cute with her platinum buzzed hair. Not many girls can get away with that look and still be as feminine as she was...*

Chyna told me she started wearing girls clothes in fifth grade at age 11. She knew who she was very early on and then in sixth grade she got kicked out of school for having hair extensions down to her waist. She told me of how the principal of the school called her mother to ask "Do you know what your son was wearing today at school?"and her mother replied "Of course I know what she wore, I live with her so please don't call me to waste my time with this!" I could not stop laughing!!!

People may remember she worked at Patricia Field's boutique on 8th street. How do you think she would like to be remembered?

Everyone that knew her never forgot her. She had a larger-than-life personality. Once you got to know her you realized that this was a her true self. It was not just the make-up and hair. There was a really beautiful soul. She wanted to help everyone she could. Don't

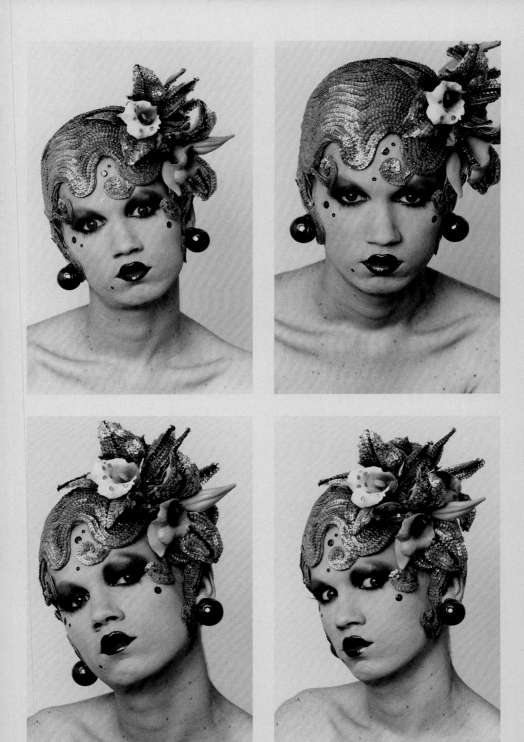

Photos by MICHAEL FAZAKERLEY

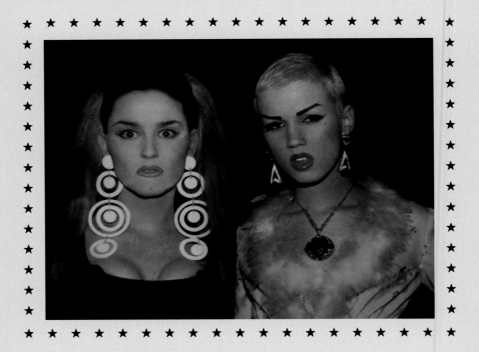

get me wrong, it was not all rainbows and unicorns. She rubbed some people the wrong way and there were people that either didn't like her or were just envious of her. She was so real inside and out and people either loved it or hated it. Bottom line.

What did she love?

She loved love. And she loved to write. She spent all of her extra time writing poems and pieces. There were beautiful writings but there was also a lot of pain. Her journal is full of the good as well as the bad. She struggled a lot when she was younger and that came through in her writings. It was all very real to her.

What type of music did she like? Did she have a favorite singer or song?

She was completely in love with Nine Inch Nails and Azucar Moreno. Two very different artists. She loved that the lead singer of Nine Inch Nails had no filter. She could relate to him so much. Azucar Moreno was her softer love side. She loved a good love song. She also loved Mary J. Blige because she always sung about love and life. I remember she would play the CD of Mary J. Blige "My Life" from beginning to end. She would be blaring the music as she cleaned the house. She also loved to cook, especially Cuban food. She loved making Picadillo, Frijoles Negros Y Arroz Blanco. She always went back to her Cuban roots. She loved being the good house wife and staying home cleaning and cooking. We were like a family and she loved cooking and feeding us. She was the mother and we were all her children.

** Love Machine was DJ Larry Tee's weekly party in 1990 at the Underground located at the top of Union Square.*

CODIE RAVIOLI & CHYNA BLEAU. Photo: UNKNOWN

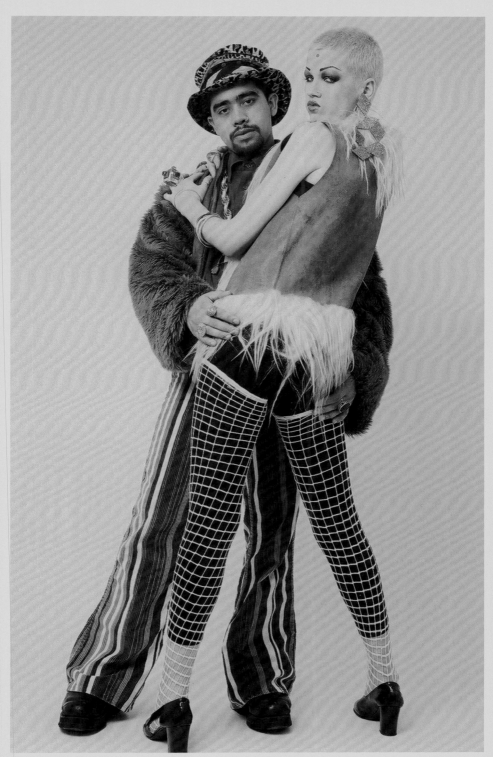

ERGE & CHYNA by MICHAEL FAZAKERLEY

◆ JAVIER FIGUEROA ◆

BY MICHAEL ECONOMY ◆

ENGLISH TEACHER

EX-MALE MODEL

CLASS ACT

STUDENT BODY

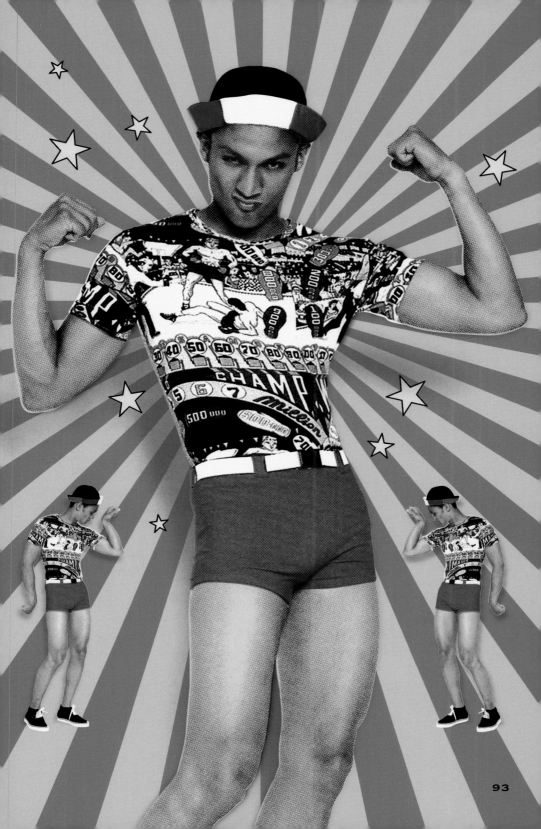

THE PICTURES OF **JAVIER** that appear in the fashion pages of *Pansy Beat* are everyone's favorite. That's because in 1990, Javier Figueroa was the hottest, sweetest guy on the downtown scene. Former model and party boy, Javier also fronted his own electronic dance band Two Be Free with his then partner. But a decade and a half of bartending and the hard living of club culture can take its toll. After a short 28 day stint in rehab, he headed back to school at age 39. Mr. Figueroa got his Bachelor's Degree at Hunter College and now teaches English at the Martin Luther King Jr. Public High School in Manhattan.

How and when did you decide to be a teacher?

I decided to become a teacher in 2007 after an enlightening moment in a rehab. Outside of the "glamorous" New York City bubble I had grown accustomed to, I realized the reality of the larger world I was living in. It was a state run facility in Schenectady, NY and many of the patients there were mandated for run-ins with the law. Part of the rehab program was to write a daily journal. Since a good number of the patients were considered academically illiterate, they struggled with writing their journal entries. Despite growing up in a low income environment, I had received a good education, and I sprang into action –helping with spelling, grammar, and communication. I experienced such a high, ironically, from simply helping someone place commas correctly and articulate their thoughts. In that moment I realized how fortunate I was; I had taken my literacy and education for granted. That's when I had my "calling", so to speak. I realized then that that's what I wanted to do.

This realization gave me the strength and conviction to get through the rest of my program. I couldn't wait to get back to New York City. Shortly after my return I enrolled for the education program at Hunter College.

How do your students refer to you? Mr. Figueroa?

Students usually call me Mr. Figueroa, at first. But most of the school calls me "Mr. Figs" or simply "Fig". This is probably due to the fact that when I first started, I gave out fig bars so that they'd remember me and I guess it stuck.

What is your relationship with your students like?

My relationship with my students is primarily that of a cool older cousin, since I look extremely much younger than my age, thank god, and am a teen-ager at heart (I never grew up), although ultimately I see them as my sons and daughters, all 120 of them.

I fight with them all the time. One boy got up in my face, one time, because I wouldn't let him run amok of the class period. He called me a "faggot", out of frustration. I challenged him by saying "well at least I own it, I've earned that! What have you earned"? He backed down and left the class, as everyone clapped for me. He showed back up a week later, with his tail between his legs, sat quietly and did his work for the rest of the year. At graduation he hugged and thanked me, with tears in both of our eyes.

Are you originally from NYC?

I am originally from New York City, Bushwick specifically. I think this is another reason my students relate well to me, because I grew up just like them, in a low-income environment, as I mentioned earlier.

I've been teaching high school English for four years now, and love what I do. It's tough sometimes, since my students are mostly low-income public-school teenagers. What keeps me getting up at six A.M. every morning is the importance of what I do. My students depend on me and I love being there for them.

How long have you lived in the East Village?

I now live in the East Village and have for almost my entire adult life. I moved here in 1989 and never left. It is part of my identity. That's when I modeled for *Pansy Beat*. I was 21 at the time and just beginning to form my identity. The East Village, with things like *Pansy Beat*, Trash & Vaudeville, The Boy Bar and David LaChapelle, provided an environment where I could be anything I wanted to be. I was young and gay with a punk/alternative attitude. I don't know where else (at the time) I could have planted my roots.

Looking back, I realize now how special that time was. We were young and living with the AIDS epidemic. I get emotional thinking about it. People were dying left and right: friends like Keith Haring and John Sex, to name a few. It was a scary time and we clearly didn't fit into the mainstream (there was no social media). We were angry and fearless. This gave rise to such an incredible culture, which

I gladly embraced and became a part of, like The Club Kids, which included my good friends Michael Alig, James St. James and Amanda Lepore.

All of that made me who I am today. If I had never been a part of that I would have never ended up in the rehab in Schenectady, and would have never become a fulfilled English teacher in the Martin Luther King campus.

Who else did you model for?

Steven Meisel, Steven Klein and Albert Watson. When I modeled for Steven Meisel, Kevyn Aucoin did my make up. I personally felt that he overdid it with the make up, although I looked beautiful. Steven, in the end, did not use me for the campaign, which I believe was the red hot and blue campaign. Kevyn Aucoin was fabulous at making me feel comfortable and trying to inspire the best in me, even though the overdone make up cost me a tear sheet.

In the early 90s you and your partner at the time formed a house music duo, Two Be Free. Any memories?

Two Be Free was an amazing experience. We signed to a demo deal with Chrysalis/Epic records. However my own insecurities and frustrations about not singing enough lead vocals eventually caused our demise. We broke up and never signed a record deal. Something that I still regret to this day. The lesson learned, however, was to never give in to your insecurities and push for your dreams. I try to inspire my students to do the same.

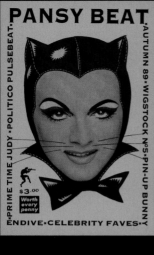

PANSY BEAT

·AUTUMN 89· WIGSTOCK №5·PIN-UP BUNNY·

·PRIME TIME JUDY· POLITICO PULSEBEAT·

$3.00
Worth every penny

·ENDIVE·CELEBRITY FAVES·

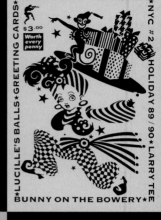

PANSY BEAT

★NYC #2 HOLIDAY 89/'90★LARRY TEE★

★LUCILLE'S BALLS★GREETING CARDS★

$3.00
Worth every penny

BUNNY ON THE BOWERY★

PANSY BEAT

NYC #3 ◆ SPRING/90 ◆ THE CONNIE GIRL ◆

◆MEL ODOM◆K·ZAHARRA◆OH BABY DOLL!

$3.00
Worth every penny

KENNY K. MEETS QUENTIN C.

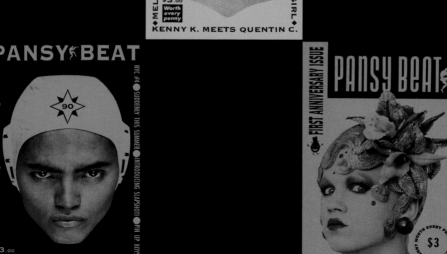

PANSY BEAT

NYC #4 ● SUDDENLY THIS SUMMER ● INTRODUCING SLAPSHOT ● PIN UP BOYS ●

FREE CONDOM! ● DRAG RAGS TO RICHES ● COLE SLAW'S SUMMER SCHOOL ●

$3.00
Worth every penny

LYPSINKA'S COLORING BOOK ● SISTER DIMENSION

PANSY BEAT

FIRST ANNIVERSARY ISSUE

$3

WORTH EVERY PENNY WORTH EVERY PENNY

★ 1989 ★

HERE ARE THE FIVE ISSUES OF PANSY BEAT REPRODUCED IN ★ THEIR ORIGINAL FORMAT ★

1

OUR TWINKLING
× PREMIERE ×
ISSUE

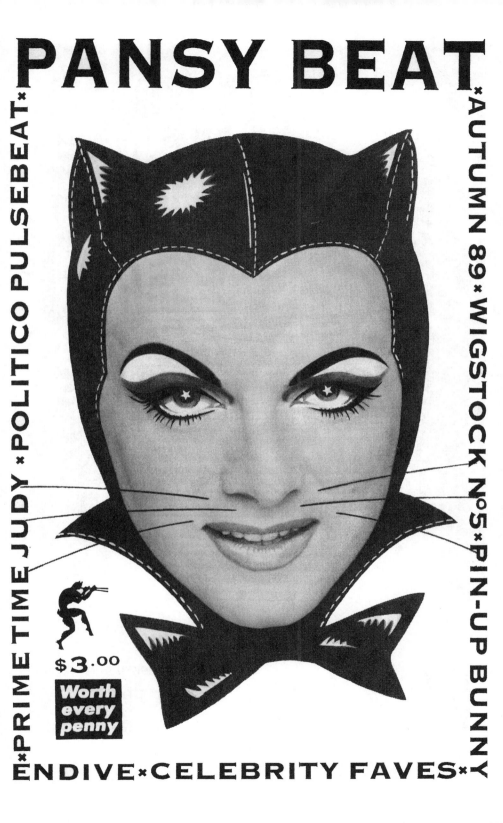

Patricia Field

TEN EAST EIGHTH STREET
NEW YORK CITY 10003

254-1699

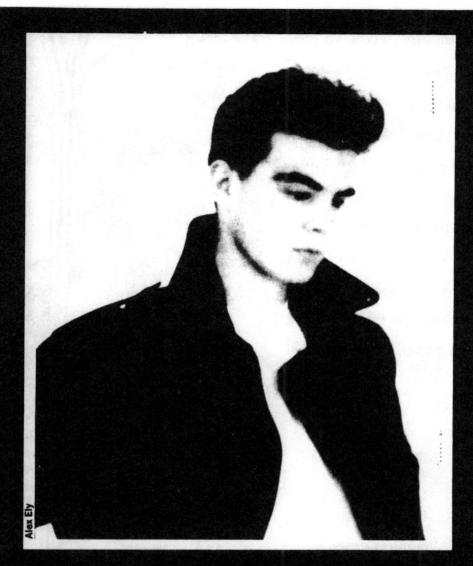

MEN'S CLOTHING

CAMOUFLAGE

141 EIGHTH AVENUE AT 17TH STREET
NEW YORK, NEW YORK (212) 741-9118

Welcome to our twinkling premiere issue featuring our cover kitty, the lovely Endive. We hope to take you on a whimsical journey down a pansy strewn lane, leading to our peculiar brand of offbeat obsessive humor, colorful local celebrities, and sometimes even a lil' bit of social consciousness. There's no stopping once you start, so clap yo' hands and stomp yo' feet, let's get movin' to the PANSY BEAT!

EDITOR-N-CREATIVE DIRECTOR
MICHAEL ECONOMY

ASSOCIATE EDITOR
DONALD CORKEN

CONTRIBUTING EDITORS
GLENN BELVERIO
JOSIAH SCHUMANN

ADVERTISING DIRECTOR
ALAN HAMILTON

STAFF PHOTOGRAPHER
MICHAEL FAZAKERLEY

CONTRIBUTORS
Cole Slaw Deee-Lite
Endive Lady Bunny

COVER PHOTO:FAZAKERLEY

Pansy Beat
237 West 18th Street
NYC 10011

Published by Pansy Beat Productions
All Rights Reserved
Copyright 1989

Cantarella

Hair Stylists

529-4422

S. E. Corner 11th St. & Ave. A

Prime Time Judy

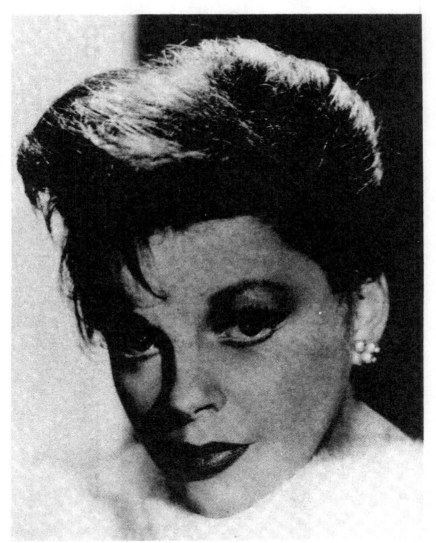

BY DONALD CORKEN

I have to admit that there is little to say about Judy Garland that hasn't already been said; by now the stories of the pills, the booze and the suicide attempts are all too familiar. Her movie triumphs, particularly in The Wizard of Oz, remain untarnished; but the image of her in the end, when her voice was just a memory and her face a ravaged testament to her years of unhappiness, keeps popping up.

A popularly held opinion is that it was all downhill for Judy after her success in 1954 in A STAR IS BORN, and for many her career had peaked way back in 1939 with WIZARD. As far as I'm concerned, though, you can keep most of those musicals she made for MGM in the 30's and 40's. For me, her career didn't really get going until after she was fired from MGM in 1950. Appropriately enough, we get our first glimpse of the Judy to come in the last number she filmed for the last movie she ever did at MGM - the "Get Happy" number in SUMMER STOCK. Dressed in the outfit that would become a trademark - a stylish man's tuxedo jacket, fedora, and black stockings, this new sophisticated Judy was light years away from Dorothy Gale.

This break with MGM marked the beginning of the second phase of her career--the concert years. Judy Garland the singing actress became Garland the singer, and launched a hugely successful schedule of live concerts that continued throughout the 50's and 60's. Based on the strength of the recordings Judy made on the Capitol label during the 50's (ending with her epochal 1961 Carnegie Hall album,) I have to make the claim that Judy was the greatest pop singer of her generation. Ella's voice may be more technically perfect, Peggy Lee may be more stylishly dramatic, and Sarah Vaughan may possess more dazzling virtuosity, but no one sells a song like Judy at her best. I find Judy's singing in her 40's musicals to be entirely pleasant, but there can be a harsh, almost shrill, edge to her voice when she hits the upper registers. In her later recordings, the voice is warmer and more rounded, and her sheer joy in her craft is what catches me the most.

In my opinion, 1963 is truly the peak in Judy Garlands career, for it was the year that saw the release of her last film, I COULD GO ON SINGING,

and the debut of her short-lived television series, THE JUDY GARLAND SHOW. By now the image of Dorothy was dead and buried, and Judy capitalized on her audience's knowledge of her personal problems, which in turn sometimes gave an autobiographical bent to the songs she sang.

I COULD GO ON SINGING, newly available on videocasette, is, for all purposes, the Judy Garland story. Playing a charactor much like herself, a world famous singer who's private life is a mess, the story is a maudlin tale of mother-love, with the Garland character trying to win back the son she had abandoned at birth, as well as recapture the lost love of the boy's father (Dirk Bogarde.) Happily, the story is frequently interrupted by some gorgeous production numbers, filmed in spectacular Panavision, that offers almost a documentary-like look at Garland at work before a London Palladium audiance. A trifle overweight and puffy, Judy still looks good in her smart Edith Head ensembles, particularly a purple beaded cardigan jacket worn over a blue sheath with matching purple pumps.

The musical highpoint is a thrilling rendition of "By Myself," in which Judy looks like a big ripe tomato in a hideous red dress (Head's one turkey,) filmed against a bleeding red backdrop. Nonetheless, it is brilliant performance, with Judy starting out quietly, standing dead still, then building steadily to the climax as she paces the stage, her arms flailing the air extravagantly.

Judy's considerable skill as a dramatic actress makes the material seem better than it is. There is a great "nervous breakdown" scene toward the end of the film, with Garland drunkenly telling Bogarde that she can't possibly perform that night. Filmed in one take by director Ronald Neame, Judy serves up some juicy lines: "I've had enough (drinks) to float Fire Island!...It's not worth all the deaths I have

Prime *Time*

to die...I've hung onto every bit of rubbish there is to in life and I've thrown all the good bits away!" Later, as Judy finally makes it onto the stage, dressed in a mink-trimmed suit, she says to the audience, "Like my furs? I just shot 'em" as she hurls her stole, stripper-style, into the wings.

(Incidentally, this video version is shown using "black bars" on the top and bottom of the screen, so that the entire width of the Panavison image is reproduced.)

I've save the best for last - a video release called JUDY GARLAND IN CONCERT. This is a ninety minute compilation of Judy performing songs culled from her 1963-1964 television series. Here's Judy at her most glamorous-she was very slim at the time, and she is dressed in a succession of beautiful Ray Aghayan outfits. She sings many of her trademark songs - songs from her movies, and songs she had made her own on her Capitol albums. Judy never sounded better than she does here, as she performs each number live before a studio audience with Mort Lindsey conducting a top-notch orchestra.

My favorite parts are two extended segments where Judy sings one song after another in a concert-like format, without stopping between numbers. In the first segment, dressed in a sequined zebra motif floor length sheath, Judy sings several standards, including a lovely version of her "Almost Like Being In Love/This Can't Be Love" medley, and a brilliant version of "Just In Time." Here she starts out softly, accompanied by only a piano, and builds gradually, modulating through several key changes as the orchestra joins in for the big climax. In the other segment, dressed in a spectacular flower motif gown, she sings beatifully controlled versions of "Smile," "I

Can't Give You Anything But Love," "After You've Gone," and "Alone Together," ending with a riveting rendition of "Come Rain or Come Shine." This is an artist in complete control of her craft.

Included in the program are a few segments of "patter," in which Judy shares some anectdotal reminiscences with the audience in a self-effacing, Bankhead-ish manner. She is a bundle of raw nerves, and just this side of incoherent, but in these unscripted moments we can sense the wicked intelligence that fueled her talent.

So now, twenty years after her death, and fifty years sinse THE WIZARD OF OZ, give Dorothy a rest and find out what real glamour is all about-the prime of Judy Garland.

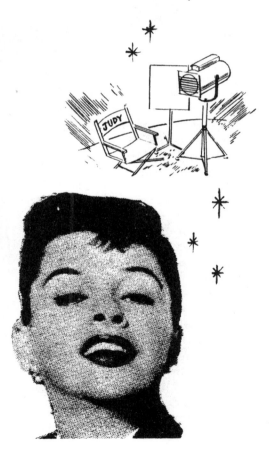

Judy

BOTTOMS R TOPS

BY JOSIAH SCHUMANN

It was the absurdity of gluing a fake eyelash onto the bottom of your eye, as well as the top, that fascinated me. Bottom false eyelashes - what an idea! The first person I remember seeing wearing them was CHER on her 1975 solo variety series. During her melodramatic solo production numbers the camera would zoom into a closeup, and there they would be, glued under her eyes.

Bottom false eyelashes, or "bottoms" as I affectionately call them, were a fashion neccessity during the late 60's and early 70's, and by far the most popular brand of top and bottom false eyelashes were those made by Christina. Specializing in alternating lengths, and with styles like "Showgirl" and "Soft Touch," Christina kept millions, (OK thousands,) of "in the know" women in the latest and finest eyewear available - and I don't mean spectacles! Stars like DIANA ROSS, ANN-MARGARET and LIZA MINNELLI (especially Liza, who gets the lifetime achievement award for continually wearing the longest, spikiest, showiest lashes available,) wouldn't be caught dead without their tops, and most importantly their bottoms!

As far as I'm concerned, no man or women is in comoplete drag unless they are featuring a bottom lash. Why, you have only to look at some of today's biggest stars - LADY BUNNY, TABBOO!, PRINCESS DIANDRA and SISTER DIMENSION (not to mention CHITA RIVERA and DOLLY PARTON,) to see the all-important, larger than life illusion that a bottom lash creates.

Unfortunately, the fact that they are difficult to keep glued on for any length of time made them impractical, and this was their downfall-- literally and figuratively, (the skin underneath the eye, unlike at the base of the lid, is just too mobile.)

Just ask Diana Ross, who's 1977 Rolling Stone cover celebrates not only her new mainstream marketability, but also the fact that her bottom eyelash has come unglued! And pity poor Cher who in the December 1974 issue of Interview, looks beautiful in a completely retouched Bill King photograph; however, they forgot to notice that her unnatural grimace caused her left bottom eyelash to dangle precariously above her fuchsia colored cheek!

To me, seeing a half glued bottom eyelash is like seeing wisps of thinning blonde hair (or knarled knots) peek out of an elaborately coiffed dark wig. It's like that piece of toilet paper that sticks to your shoe even though you're wearing a $10,000 dress.

A high point in my lash fixation came the day that Debbie Sanchez, a high school friend that was always overly made up (at my urging,) lost one of her bottoms while trying to apply it over her desk in homeroom. Always the quick thinker, Debbie simply took out a black eyeliner and drew them on - not unlike Raggedy Ann! I was in heaven, especially since she walked around the entire day looking like this - and this was 1983!

Yes, I must admit that I do own a pair of bottom eyelashes, but they are not CHRISTINA's and they are not " showgirl" length. My lashes give what I call a "light day" look. On nights when I'm feeling particularly adventurous, I secretly glue them on and walk the city streets. No one can really see them--but I know they're there!

CONDOMS
MAKE SAFE SEX FUN!

**THIS THIN RUBBER SHEATH
IS DESIGNED FOR TODAY'S
HIGH VELOCITY LIFESTYLES
AND IS A PANSY BEAT FREEBIE**

deLOVely

Super DJ Dmitry

Upstairs DJ.: Sister Dimension Lights:Capt.¥4tzzo wed oct 4 ▶ Richard Alvarez, Mark Rives, Dooo-lite's Lady Miss Kier and Super DJ Dmitry request your fabulous ass to attend DELOVELY 531 W 19th 10 - 4 Door Diva:Leahle $5-21 I.D.:

COFFY

Black...Exploit...Exploitation...Blaxploitation -

the idea that blacks were knowingly, or unknowingly, exploiting themselves is interesting; but really, the low budget black films that flooded the movie market in the mid 70's were no worse than their white counterparts. In fact, they were arguably better, if only because they showcased, albeit in a distorted way, a culture and a people who have for the most part been ignored in American films.

BREAK

BY JOSIAH SCHUMANN

COFFY is one of these films. Released in 1973 (now available from Orion Home Video,) COFFY was American International Pictures female answer to MGM's wildly successful SHAFT, only with more violence, more nudity, and more foul language. It is this very excess, however, that makes these black adventure films, COFFY in particular, camp classics.

Bosomy, black, and beautiful, Pam Grier stars as Coffy - nurse by day, vigilante-style murderess by night. When her 11 year old sister falls hopelessly into drug addiction, Coffy becomes the "baddest one woman hit-squad that ever hit town." Packed with action, this 90 minute flick whizzes by in what seems like 10. But don't expect the plot to make too much sense. Just sit back and enjoy.

It won't be easy to relax, though, even with it's improbable situations and overacting. COFFY is truly suspenseful, and the violence, thought not particularly convincing, is often shocking. What is surprising and most entertaining is that the violence is not suggested, it is shown. We see a man's head explode as it is blasted by a shotgun, and we watch as a bloody carcass, in a noose, is dragged by a car; yet another man is beaten into a coma by two men wielding baseball bats. What's more, the film plays with the universal fear of being mutilated, which can be many times more frightening than merely being killed. A man rips open a woman's blouse and holds a seven-inch knife to her breast - threatening to cut it off. A woman gets her fingers sliced up by razor blades. In this world anything can happen, no matter how ghastly. Coffy herself bludgeons, shoots and runs over a remarkable seven people in her frenzied search for justice.

The carnage doesn't mean much, though. The viewer doesn't get attached to any one character and the people that Coffy murders are, after all, bad guys. Even Carter, the film's one principled character, doesn't elicit our sympathy. In fact, it's rather fun to see Coffy running around the streets of Los Angeles in her skimpy little "sizzler," toting a sawed-off shotgun in her cream colored crocheted bag. At one point she

even manages to hide a handgun inside a teddy bear!

Freely bouncing breasts are everywhere-- small ones, big ones, round ones, taut ones (but never flat ones.) There is an amazing party scene in which our heroine gets into a knock down house-wrecking fight with four other women, all of whom in one way or another get their blouses torn off! Clearly women are the most exploited people in this movie, but Coffy's endless marauding is intended to balance this fact. Coffy's vengeance is every woman's vengeance - hear her roar!

Finally, what would a movie about the drug underworld be without dirty language? There are many different four letter word combinations but by far the most popular offensive phrase is the then contemporary "mother fucker." My personal favorite foul utterance comes from Coffy herself, who, readying to shoot someone, hisses, "tomorrow I'm going to piss on your grave!"

If this movie is about visuals, there are many: polyester print pantsuits, afro wigs, period furnishings, hoop earrings, and platform shoes, etc. But by far the most captivating image on the screen is that of Grier herself. Intelligent and talented, Pam Grier should have been a major movie star. Unfortunately, her high visibility in these low budget films (Newsweek called her "Queen of the B's",) made it difficult for mainstream studios to take her seriously. She really isn't that bad; more than anything, though, it is her beauty that makes her outstanding. Whenever she is on screen, which is virtually all the time, you just can't take your eyes off of her.

Simply put, COFFY is great fun - better than most of it's kind. In fact, after it's unexpected popularity, there followed a large number of "female hero" copycat films like TNT JACKSON and CLEOPATRA JONES. Grier herself followed up with other successful adventure roles in SHEBA BABY and FOXY BROWN. It's not hard to see why films like COFFY were successful. They are fast moving, sexy, and action packed; and with beautiful black people in starring roles, they are easy to watch.

FULL HOUSE

TWENTIETH CENTURY DESIGN

133 WOOSTER ST., N.Y., N.Y. 10012 212 · 529 · 2298

GALS IN THE KNOW...

LOVE LID
VENUS VEIL
RUBY FRUIT SUIT

EVE SLEEVE
BOX TOP
RUBBER DYKIE

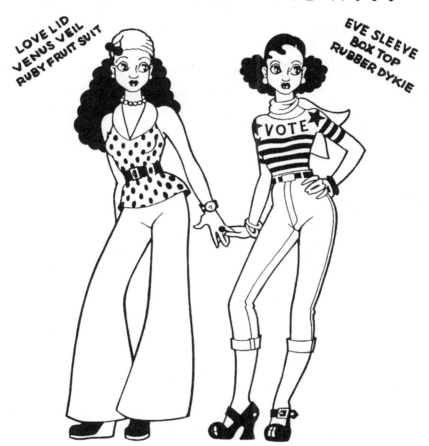

VOTE

PLAY IT SAFE!

No matter what you choose to call Dental Dams, they are the best protection during oral sex. (Plastic wrap works too.) Dental Dams are available from the Community Health Project at the Lesbian and Gay Community Center.

COOKIN

Howdy fellas! Won't you step into my cozy little roach-infested, eat-in kitchen (Whoops! I've been meaning to call the landlord about those pesky little critters). You know, sometimes people have a notion that us showgirls don't have the time or the inclination for domestic matters. Well, that's simply not true, at least not for *this* showgirl. Seldom is the night I'm not busy whipping up some delectable tidbits for the many shy and strapping young male fans who turn up on my doorstep at all hours of the night anticipating stimulating conversation and hot cocoa. Fall is just around the bend and I find that the nip in the air gives my young friends quite an appetite. They won't be satisfied with a day-old lady finger or a stale cream puff. The solution to this problem is something warm and inviting; nutritious yet sinful. You might say "Endive, does such a treasure exist in the East Village or for that matter, the world?" I say "Yes, without a doubt."Through the generosity of my dear friend, Mary Tree Garden-unforgettable prima donna, now living in her beloved duplex in the West Village-I can now share with you the secret of her famous muffins. Mary believes that a "woman's" beauty is not imprisoned by her skin, it permeates her entire home, creating warmth, love and harmony....Well, enough about Mary, let's talk about those muffins. You'll be glad to hear that these muffins are full of wholesome carbohydrates and loaded with vitamins, minerals, and enzymes and can be worked off (burned) quite easily by any young, strapping, studly male body. I do so love the aroma of freshly baked muffins when I come home late after a night of shaking my money-maker for my adoring young fans. Wait a minute! I don't remember putting raisins in these muffins. Oh no, the raisins are moving! Oh never mind, it's just my little friends, *las cucharachas*.....

Thank you so much for dropping by and remember, there's always something cookin' in Endive's Kitchen! 🏃

WITH ENDIVE

Mary's Catch-a-Man-Muffins

1 1/2 cups soy flour
1 tbsp grated orange rind
2 tsp baking powder
1 cup soy milk
1 1/2 tsp vegetable salt

1 tbsp golden oil
2 fresh eggs
Roaches (I mean raisins, optional)
3 tbsp brown sugar
1/4 cup floured walnut meats

Sift together flour, baking powder and salt. Separate eggs; beat yolks until very light and frothy. Beat sugar into the egg yolks, add orange rind, soy milk and oil. Mix well. Pour the egg mixture into the dry ingredients and mix thoroughly. Fold in whites, beaten stiff. Pour mixture into small muffin tins and bake at 300 degrees for about 30 minutes.

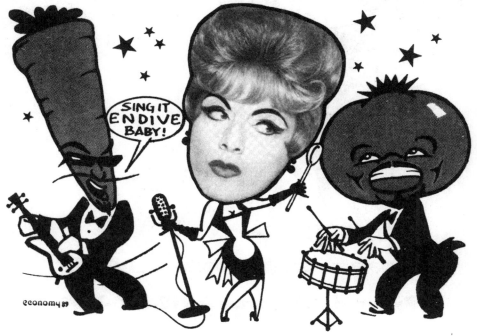

economy 89

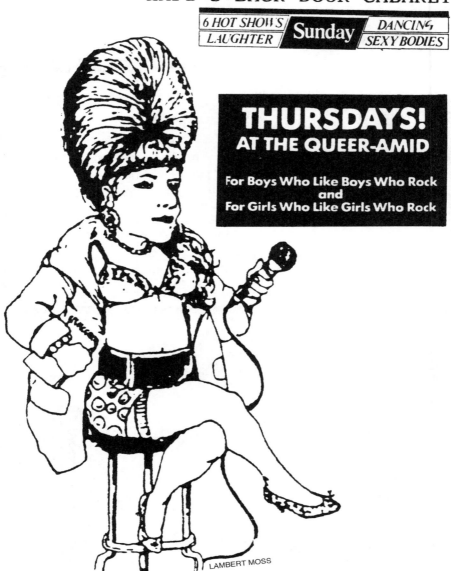

SHOWS • SHOWS • SHOWS

HAPI'S BACK DOOR CABARET

| 6 HOT SHOWS | Sunday | DANCING |
| LAUGHTER | | SEXY BODIES |

THURSDAYS!
AT THE QUEER-AMID

For Boys Who Like Boys Who Rock
and
For Girls Who Like Girls Who Rock

LAMBERT MOSS

" here the spirit of Wigstock LIVES!"

Pyramid 101 Avenue A 212-420-1590

Yaffa Cafe

Breakfast•Lunch•Dinner

97 ST. MARKS PL., N.Y.C.
(2 1 2) 6 7 4 - 9 3 0 2
LIVE JAZZ TUES NIGHTS

FREE DELIVERY "OUTDOOR GARDEN"

PANSY BEAT

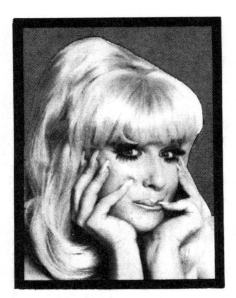

PIN-UP BUNNY
BY JOSIAH SCHUMANN

Tennessee born and bred Lady Bunny has been a star on the East Village scene for the past six years.

Persuaded to come to New York by friends and musicians from the Atlanta-based rock group the Now Explosion, Bunny became one of the founding sisters of the Pyramid Club and is now Wigstock's reigning organizer, performer and figurehead.

Every frosted white Lee Nail and every starburst eyelash in place, Bunny is known for her soulful vocalizing and heartfelt (she brings a tear to her our eye) gesturing. Singing or lip synching, she is always exciting to watch.

JOSIAH: How did you come up with the name Bunny?
BUNNY: Going to a party at the Now Explosion's house. At first it was just Bunny because in the late 70's and early 80's, 50's and 60's kitsch was a lot more in than it is now. Now it's more mainstream. Bunny just seemed like a good name for the very sweet and girlish, if artsy, look that I started out with. At that time I really did give a more girlish look and I was a lot thinner then! I just announced myself as Bunny one night and everyone screamed! They loved it! I added 'Lady' later. Actually, I've often wanted to change it to a more exotic sounding name like Alexandra, which is my favorite name of all time. Esmerelda is another. So, I love names along that line but you know, you can't change your name once you're in this business.

J: I can't decide whether I like your singing or your lip synching better--not that you have a bad voice! How do you decide which you are going to do?
B: It depends on whether or not they have a good sound system. I mean, I would rather sing. It's fun to lip synch once in a while, but I would much rather sing. I won't do it, though if a club is not equipped for it. That's the good thing about Pyramid, they always have a sound man who knows what he's doing and they have a great sound system. They're equipped for live performances, bands, using a backing tape, whatever.

J: If someone didn't know what the Lady Bunny looked like, how would you describe her?

B: Gosh. . . long, lustrous eyelashes and full luxurious hairdos with crystal clear blue eyes and a scintillating figure. And don't forget my unusual taste in clothes.

J: Have you thought about doing any of your original material?

B: I don't have any musical equipment. I don't know, I'm lazy I guess. That's what it boils down to. But I'm working on something with Dmitry and Kier (ed. note: the group Deee-Lite).

J: For yourself?

B: Something that's already written that they want to put on a compilation album, so I'm looking forward to that.

J: Is it dance music?

B: Yes, it's "Is It Up to Me?", that old Shazork tune, so that's a cute song, but you know it's difficult to write.

J: Oh yeah, who said writing songs is easy? Even the simplest lyric has to be thought of, then put into a format, and then somehow brought into life.

B: Exactly, but then again, I think all creative people are in some way insecure because somebody else could think that something I don't particularly like is really good.

J: Does your family know about your career?

B: Well, I told my Mom finally this last Christmas because she said, "What if I were to come up and see one of your shows without telling you, would you like that?" And I said, "Well, you might be surprised!" and she asked why, and I said, "Well, you know I've always had a fondness for theatrical make-up and costumes."

J: Do you have brothers and sisters?

B: One sister, three years older. Her name is Jan and she is a graduate student at LSU in Baton Rouge.

J: What is she studying?

B: Linguistics. She also graduated magna cum laude from the University of Tennessee at Chattanooga. Now that she's gone into teaching, like my father, it's kind of making me look like the black sheep of the family because I don't know what I'm doing, you know? She's a bit of a book worm but she does cut a fine figure on the dance floor.

J: Did you attend college? Is that something your family expected?

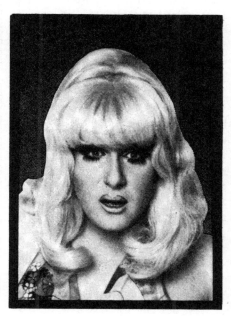

B: Yes they did. I went to UTC for about a year and a half, that's where my father teaches, but I just had to get out of Chattanooga. When I was ten, my family converted to Quakerism and we spent a year in West Africa. We spent the whole year there and that was the best year of my life. I was collecting stamps then and they had professors from all over the world there, so I would always have the best stamps. I knew then that it didn't matter where I lived, it just couldn't be Chattanooga.

J: I heard you performed for The Who, how did that come about?

B: Robert Plant wanted to give The Who a well whishing message to kick off their tour, so he called up this guy who knew me and they sent a car for us, me and Endive. Originally, we were supposed to sing for them in their dressing room, but it turned out that we were going to do it at their sound check, which was a horrible idea because you don't want some fools pestering you when you're working. So we got there and we were creating quite a ruckus outside of Radio City Music Hall.

J: Was this in the afternoon in broad daylight?

B: Yes, and Endive and I are both big girls and I had on like six inch platforms and a mile high bouffant. Anyway, after going through at least seven different security checks we finally managed to get back stage. Then someone said 'Now!' and we ran out on stage and started to sing this stupid song acappella. I think it was one of their songs called 'I'm a Boy.' Anyway, before we could get two words out of our mouths, Roger Daltry said, 'Like I really need this.' And of course he's this little bitty guy and we're both three feet taller than him. But undaunted, we continued clapping our hands and singing out that hideous tune while Pete Townsend was looking on just frowing and not liking the whole thing one little bit. Finally, I don't think we got through the whole song, we said 'We just want to wish you a wonderful tour from Robert Plant.' And Roger Daltry said, 'Well, why don't you go bug him then.' And I said, 'Well, that'll be another hundred dollars and car fare!' So my first appearance at Radio City Music Hall wasn't an entire flop. I did manage to get that line in!

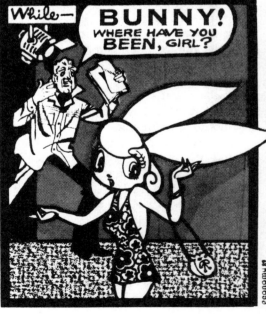

J: Who are your favorite singers/ entertainers?

B: Oh, you know that, girl. Patti Labelle, Natalie Cole, Evelyn 'Champagne' King, Aretha, Gladys Knight, Yvonne Fair who sings 'It Shoulda Been Me.'

J: The soul sisters.

B: Yes, all the soul sisters. But I like a lot of other different types of music too. They only thing I can't stomach is any type of hard rock.

J: Is it uncomfortable for you to hang out at places where you perform, out of drag?

B: You're not going to put this in any magazine, you're just asking me this, you Witch!

J: No, I mean, when Bunny is in a room, all eyes are on her. But I don't imagine you would want all eyes on you on a night, say, when you were giving comfort.

B: Well, more people recognize me now out of drag then ever before. But I remember one time a few years ago, Tangella and I went to the Boy Bar and we weren't in drag. We thought we'd go and just watch the show and hang out. But then some hideous queen screamed, "Drag Queens!" and I felt that was the most--I mean I didn't go out to the Boy Bar for years after that. Of course people would rather see me when I'm all up in drag and making an entrance. But I can have my damn night off and relax with everyone else too, and if you want to come up and try to read me, well come on, I'm prepared. But that really did upset me. Those youthful trendies just aren't my favorte type anyhow. I don't ask a boy to do a man's job and I'm not interested in going home with someone who wants to show me their modeling portfolio--I want to show them mine!

J: Do you know how exciting you are onstage?

B: No!

J: I've seen more than one person walk away from your performances with a smile on their face.

B: Well I'm thrilled. I mean, I'm glad because they make me happy too! It's an exchange. I can only do it in front of my bathroom mirror for so long!

J: Do I sense a humble Bunny?

B: Yes, she doesn't come out often.

PHOTOS BY MICHAEL FAZAKERLEY

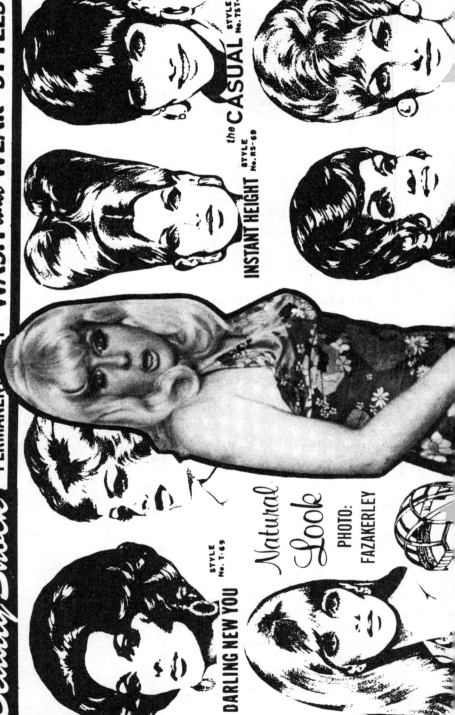

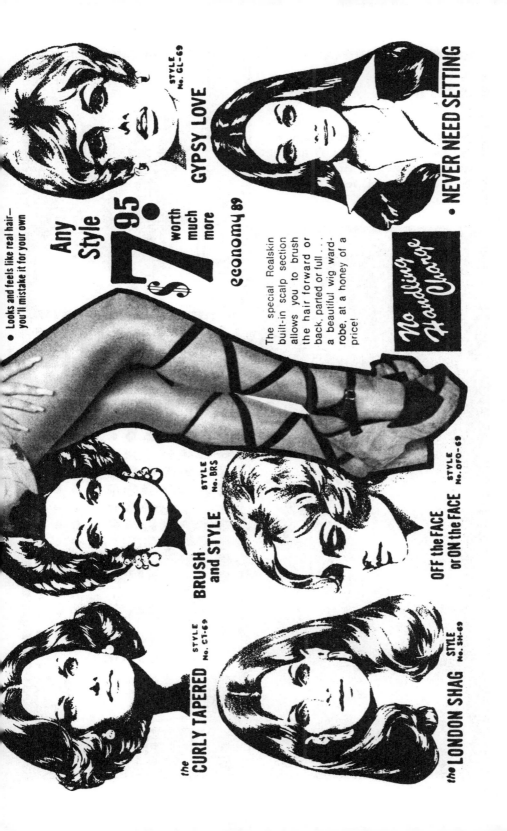

The sickly sweet smell of hairspray perfumed the air of Thompkins Square Park once again for this year's Fifth Annual Wigstock. Bigger than ever and no rain, here's our peek at this year's festivities.

NICKY NICOLE

JOSIAH SCHUMANN + GAL PAL

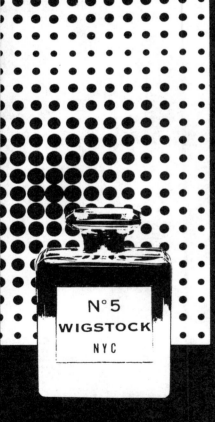

N°5
WIGSTOCK
NYC

128

Great Dame!

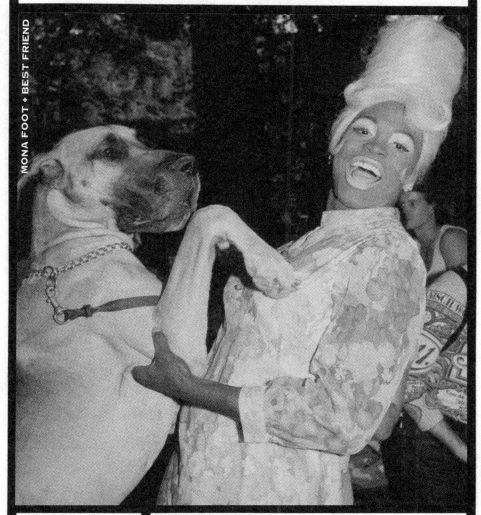

MONA FOOT + BEST FRIEND

PHOTOS BY MICHAEL FAZAKERLEY

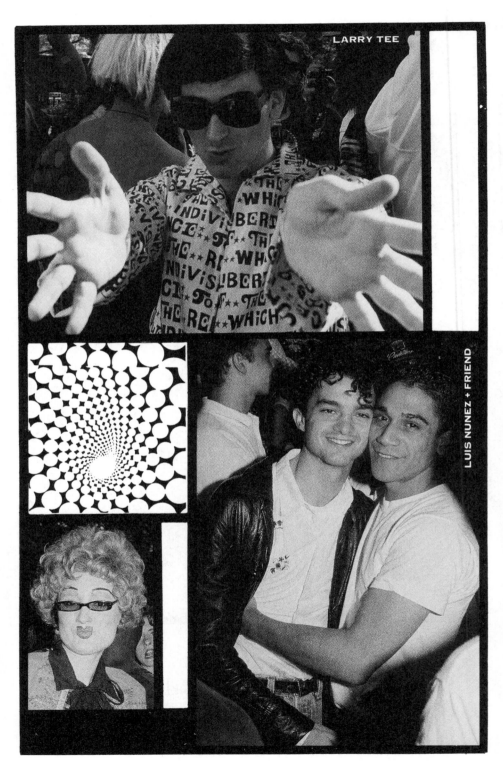

LARRY TEE

LUIS NUNEZ + FRIEND

Com'on ov'r here an gimme a li'l Pucci!

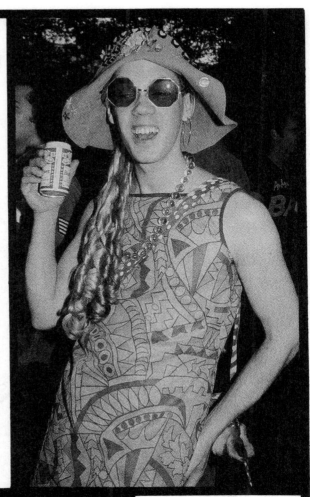

ENDIVE

N°5
WIGSTOCK
NYC

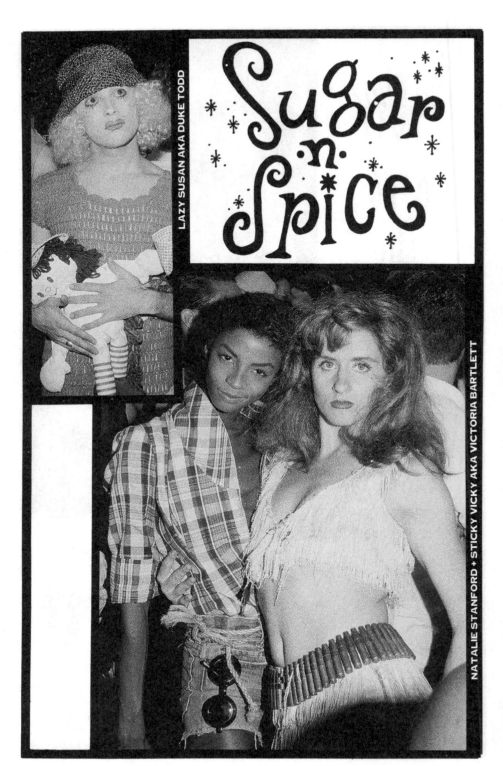

LAZY SUSAN AKA DUKE TODD

Sugar -n- Spice

NATALIE STANFORD + STICKY VICKY AKA VICTORIA BARTLETT

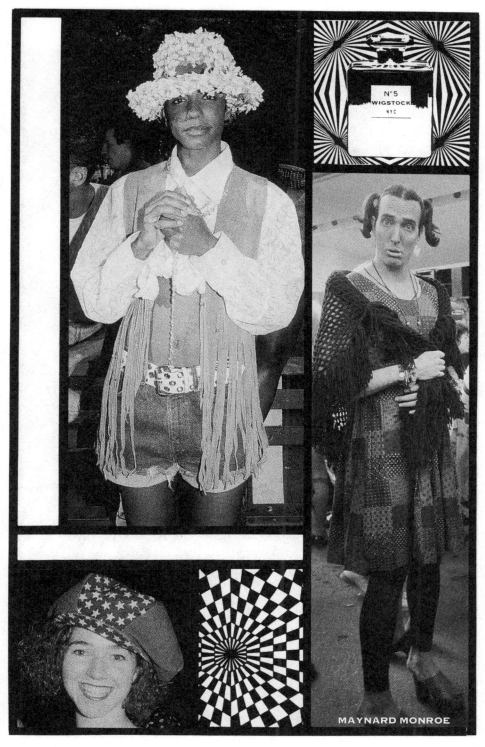

MAYNARD MONROE

133

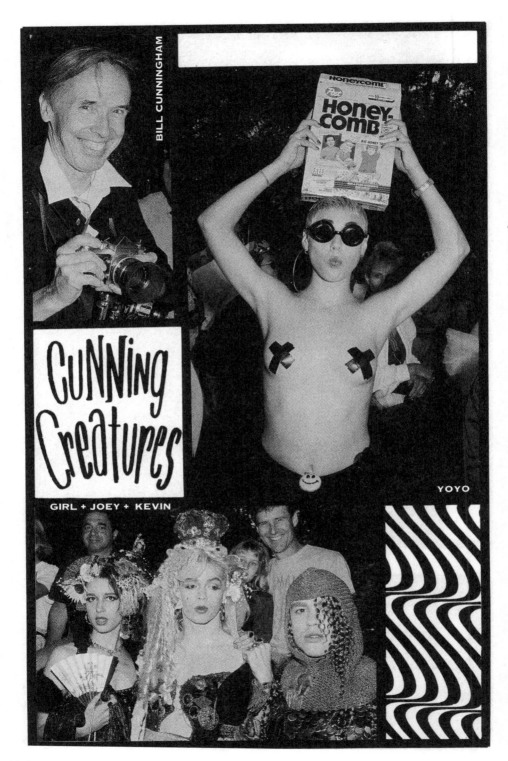

BILL CUNNINGHAM

CUNNING Creatures

GIRL + JOEY + KEVIN

YOYO

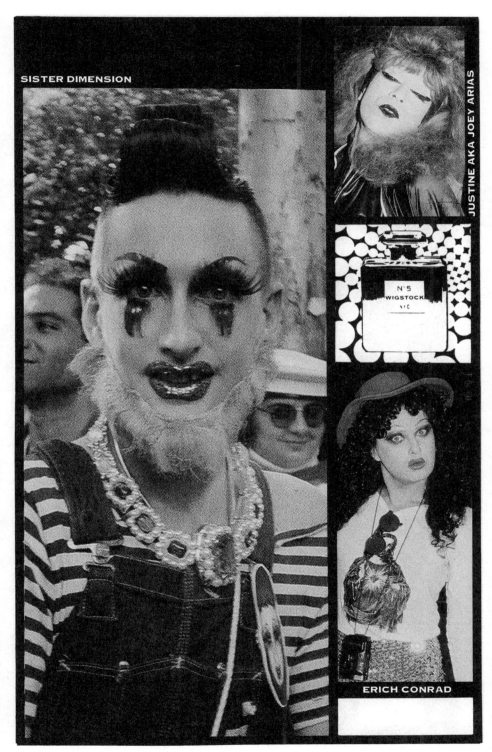

SISTER DIMENSION

JUSTINE AKA JOEY ARIAS

N°5
WIGSTOCK
NYC

ERICH CONRAD

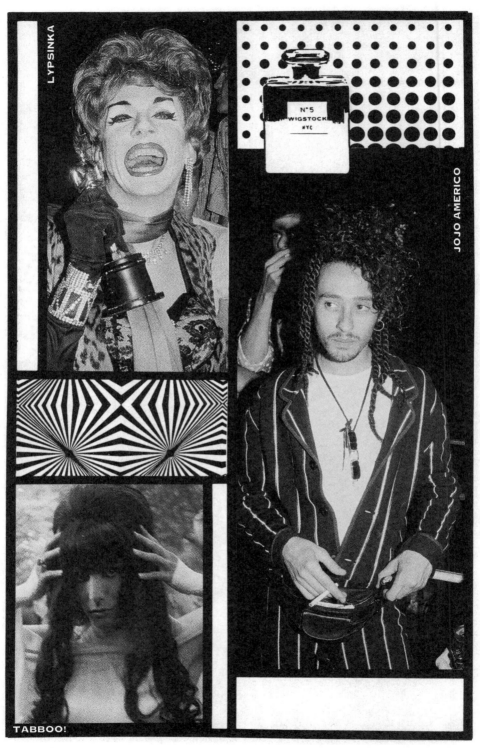

LYPSINKA

JOJO AMERICO

N°5
WIGSTOCK
NYC

TABBOO!

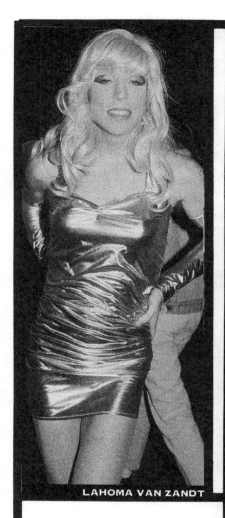

LAHOMA VAN ZANDT

PATRICIA FIELD

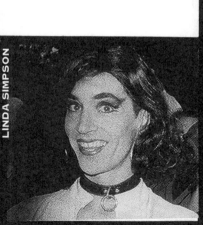

LINDA SIMPSON

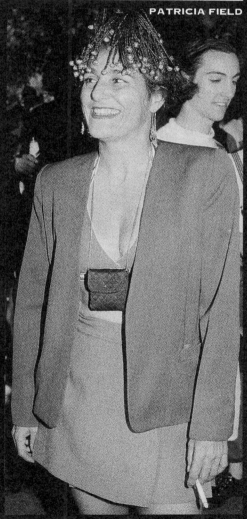

POLITICO PULSEBEAT

BY GLENN BELVERIO

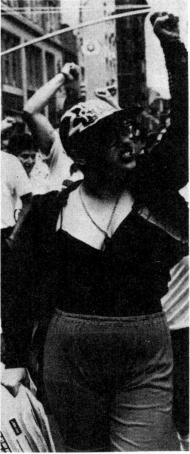

GARANCE!

Hotter than a burning flag! Slicker than a dental dam! Able to leap tall, racist, sexist and homophobic institutions in a single bound! Not just another woman of the minute, it's: Garance!-Fashionable Lesbian activist-at-large!

Whenever Garance is not busy ACTing Up, running around the West Village in a pink bra and burning flags, or designing hats with a post-modern vengeance, she pops by my Sty Town pad to discuss Life, Liberty, and the pursuit of Lesbians:

PHOTO: T.L. LITT

Glenn: What inspired you to join ACT UP (The AIDS Coalition To Unleash Power)?

Garance: The first ACT UP action I ever went to was at the Food and Drug Administration. Some friends of mine were going down there for the weekend and I just had to get out of New York. I knew things were fucked up about AIDS, but I wasn't entirely sure of the specific drug issues. Being with all those people and feeling that I could make a difference was one of the most empowering experiences of my life, because instead of being the person sitting on the couch and watching the news, I was the person making the news. I didn't begin going to ACT UP meetings regularly until Bush got elected, when that happened I decided I had two choices: leave the country or become active. I decided it would be more useful if I stayed and tried to bring about some kind of change, so I joined ACT UP.

Glenn: When you first joined ACT UP, how did you feel about the way Lesbian and AIDS issues were being addressed?

Garance: When I first joined ACT UP, I didn't know there was such a thing as Lesbian and AIDS issues. The entire topic had always been so suppressed in the media and even now there's very little known about Lesbian risk factors, although it is known that woman to woman transmission is possible through oral sex. The highest risk factor for most Lesbians is IV drug use and unsafe sex with men. I joined ACT UP when the Women's Caucus was forming, so it was sort of a process of educating ourselves about the issues. Right now we're pressuring the condom companies to manufacture dental dams, which are also known as latex squares, cunt capes, vulva veils, snatch patches....

Glenn: Recently you started a group called Radical Lesbian Action (RLA). What was the motivation behind this?

Garance: Our country is in the middle of the biggest backslide in civil rights since the McCarthy era. In the case of Webster Vs. Reproductive Health Services, this is the first time in 75 years that the Supreme Court has reversed itself on a ruling on the Constitution. Sexism is running rampant again-even within the gay community. It certainly is very difficult for me because I have many gay male friends who aren't really aware of the sexism that exists within them. It gets on my nerves.

Glenn: The first RLA action caused a bit of controversy, in which you placed black triangles on some of the artwork in the art show at the Lesbian and Gay Community Center. What is the meaning of the sudden emergence of the black triangle?

Garance: During the first meeting of RLA, a woman named Rose, who had been an activist in the Gay Liberation Front, informed us that in the Nazi concentration camps, Lesbians, prostitutes and Gypsies were required to wear black triangles. Only gay men wore the pink ones. So when you look at the pink triangle, think about whose history it really represents. We covered almost every penis in the Center Show with black triangles, because when a Lesbian walks into the Center, she is immediately rendered invisible by the artwork. Rather than finding the show 'homoerotic', I find it 'phallocentric'. It seems that in the Show as in many other areas of life, Lesbians are confined to the closet, as in the case of Catherine Saalfields's video "Keep Your Laws Off MY Body", which has been installed in the janitor's closet. Placing the black triangles on the penises was done to reaffirm our Lesbian Heritage and our existence.

Glenn: You've also started another group called F.L.A.M.E. What's that all about?

Garance: F.L.A.M.E. is Fags and Lesbians Against Massive Entrapment. We started as a group that would mix fun and politics. We held a flag-burning celebration at Sheridan Square on the 4th of July, but it was much less of a party than expected. Earlier that day I witnessed Nationalist Skinheads beating up people at a cancelled flag burning in Washington Square. I was rather traumatized by the whole thing. In the future I think F.L.A.M.E. is going to focus on anti-entrapment actions since ACT UP has become a much more vocal and much more powerful group which has caused it to become a target for infiltration. I've designed a t-shirt for F.L.A.M.E.- it consists of a picture of an upside-

down flag in flames with the words "No Equality No Flag". It's designed to call attention to the meaninglessness of the symbol and also the two Supreme Court decisions concerning abortion and flag-burning in which President Bush (God, I hate saying that!) has decided to add a fascist flag amendment.

Glenn: Aside from the F.L.A.M.E. t-shirt, you've also designed numerous hats and have created for yourself what I perceive to be a strong, confrontational fashion statement. How do you see fashion working within a political framework?

Garance: It makes for a good photo-op. For instance, Scarlot Harlot from COYOTE (Call Off Your Old Tired Ethics), the prostitutes' rights group, dresses up like Lady Liberty. Blane Mosley of ACT UP at one time had shaved the back of his head into a triangle and dyed it pink. We have to be billboards in this heterosexist society proclaiming who and what we are, so people realize that we exist. As far as ACT UP goes, I've always felt that they need a fashion consultant so we would't get stuck with things like those horrible polyester hats that say ACT UP on them. But ACT UP does have a varied assortment of T-shirts and stickers so we are making a powerful fashion statement in some ways.

Glenn: If not in clothing, at least in the sideburn department. How about the stunning visual you created for Gay Pride Week?

Garance: You mean my tits? No, really, that was a baseball cap with "RIOT" painted on it, something like the "POW" or the "BAM" in the old Batman series. For the 4th of July I designed a hat with an American flag with burnt edges and an open matchbook. That hat met an untimely death when it was snatched from Ellen Spiro's head by skinheads who shouted sexist epithets. I was told they later removed the flag, folded it military style and buried it.

Glenn: In closing I would like to ask, of all the obstructions that block women from true equality, if you had the power to make one of them disappear tomorrow, which one would it be?

Garance: Silence and the complacency that is inherent in many people about women's place in society. We live in such a sexist society and a lot of women buy into that and they perpetuate it. Then they teach it to their daughters. Women think it's so much harder to fight back. Well, it is harder, but it's also much more rewarding.

PHOTO:FAZAKERLEY

140

Talk to GO!*

MORE GO-GO THAN GODARD!

FASTER THAN FASSBINDER!

TAKE IT WITH YOU:

TUESDAY NIGHTS AT 3:00 A.M. CHANNEL D (17)
THURSDAY NIGHTS AT 3:00 A.M. CHANNEL C (16)

STARRING

GLENN BELVERIO
ROB KURILLA
IVAN STILLERMAN

DIAMANDA ACTS UP AT ALICE TULLY

BY GLENN BELVERIO

Diamanda Galas Masque of the Red Death Alice Tully Hall July 25

"There was a sharp cry-and the dagger dropped gleaming upon the sable carpet, upon which, instantly afterwards fell prostrate in death the Prince Prospero."

-The Masque of the Red Death, Edgar Allen Poe

If Diamanda Galas, shriek enchantress and operatic succubus extraodinaire, has her way, the same fate will befall the Prince Prospero of the 1980's. This new Prospero, a force more evil and pervasive than the devastation of AIDS, is a multi-faceted Mephostophiles of the Modern Age. He is the Reagan/Bush Administration, the CIA, the Moral Majority. He is the FDA, the pharmaceutical companies, the Catholic Church. He is your homophobic, racist, sexist neighbor.

In Diamanda's performance at Alice Tully Hall, "Masque of the Red Death", she unleashed a vitriolic, angst-ridden vendetta of such ferocity against the oppressor, that I wondered how any force of evil, especially one as wimpy as George Bush, could survive such an assault. Needless to say, "Masque" is a vengeance piece, reminiscent of one of her earlier works entitled "Tragouthia Apo Exoun Fonos"(Song From the Blood of Those Murdered) which was directed at the murderous dictatorship of the Greek Junta of the late 60's, early 70's. Now it's 1989-nearly a decade into the AIDS crisis-and Diamanda has usurped the right-wing, fork-tongued, anally-retentive preacher from his place in the pulpit. From there she delivers what she calls her "Plague Mass". During the Mass, Diamanda's body becomes a vessel in which enters every tormented soul who has died or is suffering through this crisis: A homeless man with PCP sleeping on a park bench in the rain. A woman who died early because her condition went undiagnosed. A person of color who couldn't afford quality health care. A man who received a placebo in a drug trial. Diamanda absorbed this pain and, channelling it through her psyche, her lifesblood, and eventually through her vocal chords, she projected the misery of these injustices and wrapped our consciousness in a shroud of sonic discord. For some, the pain was too much to bear. (Nearly a dozen audience members walked out during the performance.) Volume levels were high (and often at the point of distortion, no thanks to Alice Tully's sound system), the sound being a combination of Diamanda's vocal gymnastics, both live and taped, accompanied by a dirge-like, repetitive soundtrack that created a highly disturbing aural environment. Biblical metaphor was the dominant motif throughout the piece, which included a Leviticus scripture concerning leprosy, a Psalm about a dying man denied God's salvation, and a jazzy piano spiritual entitled "Let My People Go". At one point she stood at a pulpit, and in a mock-Evangelical sermon, she reversed the Right's belligerent obsession of blaming the victim and directed her vocal arsenal in the direction of the true enemy: government officials, homophobes, moralists. In a Southern Baptist-style drawl, she spouted statistics, attacked the media, and reinforced an undeniable truth: Aquired Immune Deficiency is homocide. This segment was one of the most powerful statements of her performance, but for me the most jarring moment occured when she revealed her emotional involvement with the piece by screaming out the name of her brother, Philip, an actor and playwright who died of AIDS.

"Masque of the Red Death" is a spectrum that ranges from morbid despair to militant action. This spectrum has breached the lives of many people affected by the AIDS crisis and is reflected in the numerous wakes and candlelight vigils and also in the displays and demonstrations of anger and power. Its message is a force that must be dealt with not only by the Prince Prosperos, but also by our own souls. 🏃

2000 Long Beach Road
Island Park, L.I., New York
431-5700
431-5701

STELLA DALLAS

VINGAGE CLOTHING ·

Toys & Tees
Drapes & Linens

218 THOMPSON STREET (bet. W.3rd & Bleeker)
N.Y.C. 10012 212-674-0447

Proudly Presents

JO JO

THE MOTORCYCLE MAIDEN
A Paper Doll Story

She was fancy-free and on her own 'cept for her lil' dog **MASHER** and a bike named **MYRTLE** that could eat asphalt like a starved hog!

HYSTERICS kept her stiched up in their super-fine finery and she smell'd like trouble, but not like her dog.

MASHER kept tellin' her "Go'n home, Girl", but **MYRTLE** was insistin' that they va-roam, va-roam, va-roam.

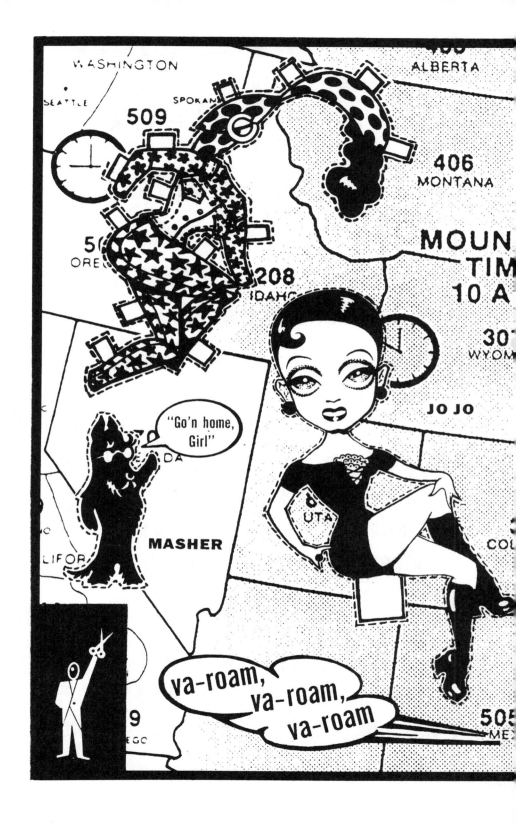

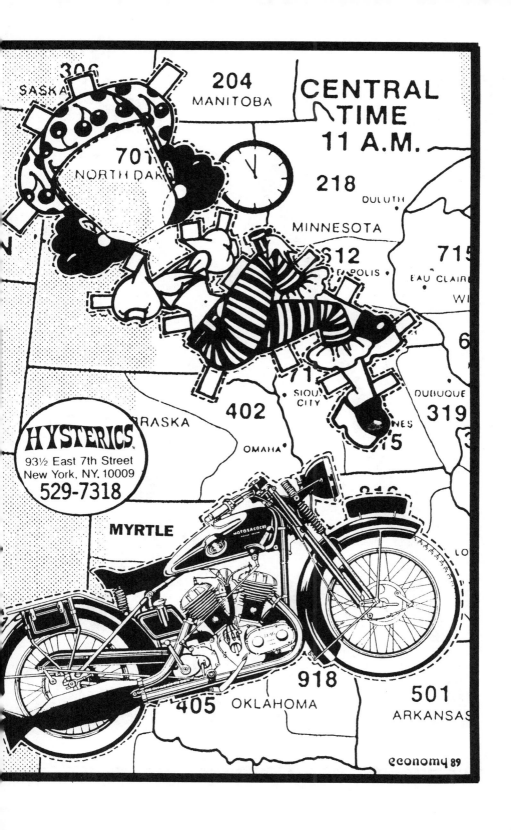

STATIONERY

PANSY BEAT

GREETING CARDS

PARTY GOODS

METRO MIX TAPES

T-SHIRTS

TOYS

almost **Avenue A** cards & stationery

126 East 7th Street
Bet. 1st Ave. & Ave. A
New York, NY 10009
(212) 533-4210

Sun—till 8 p.m.
Mon, Tues—till 10 p.m.
Wed, Thurs—till 11 p.m.
Fri, Sat—till 1 a.m.

WISHES "PANSY BEAT" EVERY SUCCESS

ENIGMAS IN MY UNIVERSE
By Cole Slaw

I pose this question to my readers: Why is a drag queen called a drag queen? I have no earthly idea so therefore the question falls under the category of ENIGMAS IN MY UNIVERSE. But since I'm a firm believer that some enigmas should remain mysterious, I will look at the facts and then try my best to ignore them. ✦

Back to the question at hand of how a man who puts on makeup and women's clothes came to be known as a drag queen. Having lost my American Heritage Encyclopedia book D two years ago, I'll begin my quest with my dictionary. In my Webster's there are eight definitions for the word 'queen' used as a noun. Explanation number eight is most interesting: 'HOMOSEXUAL (Noah's capital letters, not mine); esp: an effeminate one -- often used disparagingly.' Now definition number eight does appear to be the most appropriate of the choices, but we are searching for insight here and we must remember that what we assume is not necessarily correct. ✦

So with this in mind, what about definition number seven? 'a mature female cat kept especially for breeding.' Or number six: 'the fully developed female of social bees, ants, and termites...' Now wait just a minute. What's the difference between a social bee and just a plain old bee? Could it be possible that all gay men are just reincarnated bees? We all know how social homosexual men are and it just might explain why I like honey so much. Knowledge is scary isn't it?

O.K., so let's suppose we've all learned something. The real stinger is the word 'drag'. Looking up the word, again I find the assumptive definition under the eighth possible choice. '... clothing typical of one sex worn by a person of the opposite sex -- often used in the phrase 'in drag'. Well that's not very much help. Maybe my dictionary is old, but just where does unisex clothing fit in? Definition number four suggests: 'something that retards motion or action.' Just what does <u>that</u> mean? And just why, while we're on the subject are both 'obvious' definitions listed as the eighth explanation under both the word queen and the word drag?

Now remembering what I said earlier about assuming, just what is a drag queen? None of these definitions really answer the WHY in my question.

Discarding the 'obvious' definitions for the two words we can now theorize that perhaps a drag queen is a spastic bee with glued-on breasts. Or, a male cross-dresser is called a drag queen because he makes disparagingly effeminate motions? I'm confused, let's try another approach.

Occasionally phrases receive their name from the location they were born, such as the phrase, 'french twist' or 'rectal thermometer'. Using this premise, perhaps the first drag queen <u>was</u> spotted at a drag race, which would explain why so many of them speak so loudly. Dare I suggest to the horror of historians that Queen Victoria was spotted pulling an effeminate man by his hair in Buckingham Palace late one Saturday afternoon? ✦

This sure is a tangled web of ideas I have weaved and I'm still no closer to satisfying my curiosity. But tangling webs wear me out and just how the term drag queen came into mass use will just have to remain a mystery in my foggy mind. Till next time, when we might discuss: Are homosexual wrists really weaker than the rest of the human race's? ✦

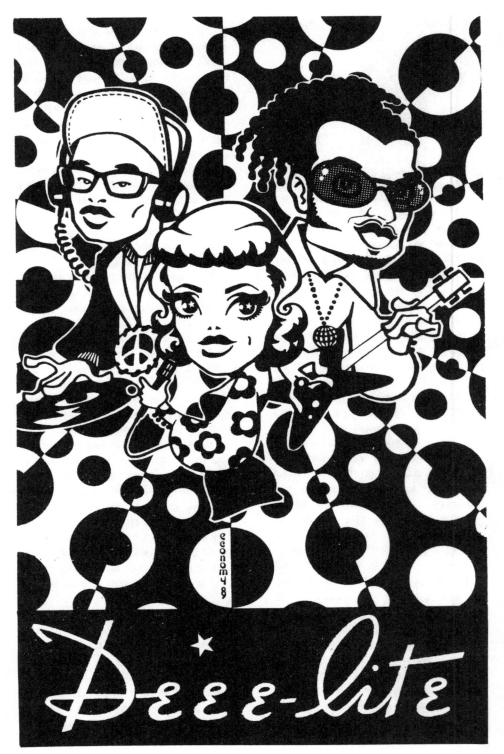

CELEBRITY FAVES

MISS KIER--SIGN: Leo (Meow) General and Vain
CHINESE ZODIAC: Rabbit, talented and affectionate
COLOR: When gasoline mixes in a puddle
SINGER: Stephanie Mills
BAND: Blue Cheer
ACTOR: Louise Lasser in Mary Hartman, Mary Hartman
MOVIE: Juliette of the Spirits, Fellini
FOOD: Peanut butter mixed with Hersheys syrup and sugar-delectible
SHOE: Those secretary shoes on TV that look like a pump, feels like a sneaker
DESIGNER: Martin Sitbon, Katherine Hamnet, Andre Walker and Scott Gibson
BOOK: Prometheus Rising by Robert Anton Wilson
PHALLIC-SHAPED PRODUCT: Tickle with a big wide ball

SUPER DJ DMITRY SIGN: Gemini--space cadet with two sides
CHINESE ZODIAC: Dragon--passionate and complex
COLOR: Rainbow Brite
SIGNER: Chaka Kahn
BAND: Parliament Funkadelic
ACTOR: Christopher Walken
MOVIE: I Hear Voices, starring Miss Kier
FOOD: My Russian Babuska's vegetarian Stroganoff
SHOE: Square toe wing tips
DESIGNER: Andre Walker
BOOK: The Mind Parasites by Colin Wilson
PHALLIC-SHAPED PRODUCT: Trump Tower and my guitar

JUNGLE DJ TOWWA SIGN: Virgo--Organized critic
CHINESE ZODIAC: Dragon
COLOR: Red
SINGER: Loletta Holloway
BAND: Sly and the Family Stone
ACTRESS: Ayumi Ishida
FOOD: Indian
SHOE: Nike
DESIGNER: Nike
BOOK: Magazines
PHALLIC-SHAPED PRODUCT: Japanese coffee spray

Romance On The High C's

Endive, top song stylist and my personal best girlfriend, called me up excitedly.

"Girl, guess what! I won a date on the Mating Game! Isn't it too fabulous? Can you be my chaperone? A girl has to protect her reputation and I couldn't possibly be alone with a man on our first date."

"Since when?" I replied.

"Bitch!" Endive hissed. "This time he's a real gentleman. How many times am I lucky enough to sucker - I mean charm - a man like that into taking me out? Besides, this one's sorta cute."

Ever the loyal friend, I immediately responded, "What's in it for me?"

"Well, the prize date is a trip on the Circus Line. As the chaperone, you get to go for free."

"That sounds like a good deal." Always on the lookout for new adventures, as well as a bargain, I acquiesced.

The next day, I went over to Endive's apartment to help her prepare for the evening's festivities.

BY DONALD CORKEN

"I don't know what to wear!" Endive cried as she sat disconsolately in a pile of feathers, sequins, and cheap satins. "I can't wear this showgirl stuff. He thinks I'm a lady. Oh, I don't want to go on this date tonight! I don't want to sit here and varnish my goddamn face!"

"Now Endive, you know you don't mean that. You're just having a case of those first date jitters." I could see that a lifetime of failed relationships was taking its toll on poor Endive.

"So now I'm getting ready to go on this cruise, and I'm supposed to look like Endive!" she screamed, becoming hysterical. "Big fucking deal!"

"Snap out of it!" I shrieked as I smacked her on the face, taking off an inch of foundation along with it. It was time to get tough. "Look, sister, you're not getting any younger, and you might not have many chances left. This time it might be for real. Now, get with it, baby! And just

remember, you are a star - you are Endive!"

"You're right. Now help me find something to wear," Endive said as she wriggled into the steal-enforced corset that miraculously seemed to shed not only pounds but years from her no-longer-young figure.

At last the appointed time had arrived. It was a clear, starlit night, and the moon was full. We had managed to find a little black dress and white gloves for Endive to wear, and I had loaned her my second-best mink stole and pearls. If not entirely lady-like, she at least looked not dangerous.

We made it onto the deck of the Circus Line. "Is my nose shiny?" Endive asked as she looked into her compact mirror for the hundredth time. "Oh, where is he?"

"What's he look like?" I asked, glancing around the deck.

"Sort of tall, dark hair, glasses...Oh, there he is!"

A young man who fit this description came toward us.

"Hi Endive," he said as he gingerly kissed my friend on the cheek. "Oh, your perfume!"

"Do you like it?" Endive asked, her face brightening.

"I sure do! It's just the kind our maid used to wear. It reminds me of home."

Endive's smile froze. "How nice for you, I'm sure. Ahem. Oh dear, where are my manners? Glenn, won't you meet my chaperone?"

"How do you do?" Glenn said, politely bowing.

"Pleased to meet you," I replied, sizing him up and down. He was sort of cute, just the type Endive always went after - inexperienced enough not to know any better.

"May I get you anything from the concession stand?" he asked us.

"Oh, I'd adore a burger and fries!" Endive was about to say before she caught sight of my disapproving expression. "I mean, just a Tab for

me, thanks. I've got to stick to my fighting weight," she said as she nudged Glenn in the ribs.

The boat began to inch away from the dock, and we drank in the exhilerating night breeze. A chill was in the air, and Endive drew her stole closer to her body.

"Ooh, I'm so chilly. Do you mind if I warm my hand in your pockets?" Endive asked Glenn.

"Not at all," he replied as he started to take off his coat and offer it to Endive.

"Uh, that's alright, honey. You keep your coat on. I guess I'm not quite as cold as I thought," she said, thwarted in her plans of seduction.

As we leaned on the rail and watched the passing skyline of downtown Manhattan, a young man walked by and recognized Endive.

"Hey, I know you, you're Endive! I'm one of your biggest fans! Hey, everybody, it's Endive! Look!"

The group of friends he was with ran over to us excitedly.

"Endive, Endive!! Sing us a song!" some young woman shrieked.

"Yeah, a song, a song!" her friends rejoined.

Endive, trying very hard to blush, demurred. "Oh, I don't think so. I'm sorry . This is my night off."

"Alright," her young fans answered, turning to walk away.

"But if you twist my arm, I'm sure I could be persuaded."

The crowd began to shout out song titles, Endive's special hits that they had grown to love. " 'Hillbilly Homo!' 'Northside Yard Sale!' 'The Bra Song!' 'Gerbils, Gerbils, Gerbils!' "

"Oh, how you all work me!" Endive cried, eating up the adulation with a knife and fork. "I think I'll sing my newest song, 'Eyelash On My Pillow'."

She reached into her large crocheted bag and pulled out the ghetto blaster and backing tape she was never without.

♪ Woke up this morning What did I see? A pair of eyelashes. Whose could they be....♪

As Endive finished her song, the audience, which by now comprised almost the entire boat, broke into rapturous applause. Fistfulls of dollars were thrust at the diva, and she was showered with a spray of coins.

"Thank you, thank you, everyone! Oh, I love you all so goddamn much! Thank you, oh, thank you!! But I'm afraid you'll have to let me go. You see, tonight's a special night for me and I really should get back to my friends."

Glenn, bursting with pride, extended his arm to Endive, and I watched as they strolled off to a secluded corner of the deck. After all, the chaperone didn't have to be with them every minute.

A quarter of an hour later, the young lovers found me. We were passing under the Queensborough Bridge, and the glittering skyline of Sutton Place completed a romantic backdrop.

"Glenn has proposed to me!" Endive gushed. "He wants to get married in the morning."

I looked at Glenn. His face and collar were covered with the distinctive red of Endive's favorite lipstick, and his glasses were all fogged over.

"Boy, Endive sure is a persuavive kind of gal!" Glenn exclaimed. "All I did was mention my trust fund, and that big theater I own which just sits there empty and unused.... Gee, Endive, I hope I can make you happy!"

"You already have, darling, you already have. Now, let's go get some hotdogs!" Endive said with a toss of her stole. True love knows no diet.

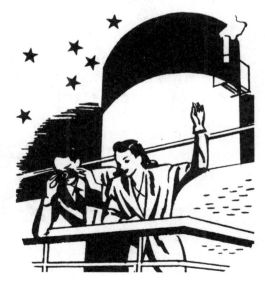

This **wraps** up the debut issue of PANSY BEAT. We appreciate your support and welcome your ideas. So send us a card, a letter, or maybe even a gift!

We'd also like to take this opportunity to thank all of our lovely advertisers for taking a chance on our Premiere Issue. And a very big thank you to Alberto Orta for his invaluable help.

So until next time. . . Happy Haunting!

Ronnie Walcott, Age: 13, Weight: 86 Lbs., Record: 90 unofficial fights, 16 official, 1 loss. Won San Angelo Paperweight Championship in 1949 and Paperweight Championship in Regional Golden Gloves Tournament at San Angelo in 1949. Lost final bout in Regional Golden Gloves Tournament at Odessa in 1950 but won return match with same boy a short time later. At age 11, when this picture was taken, Ronnie was picked as one of the most scientific boxers in these parts. Other athletic achievements: Entered four events in 1950 San Angelo City Swim Meet and won all four. He started swimming at age of four.

Little Rickie

RECKLESS

49 GROVE ST. N.Y.C. 10014 212-255-7955

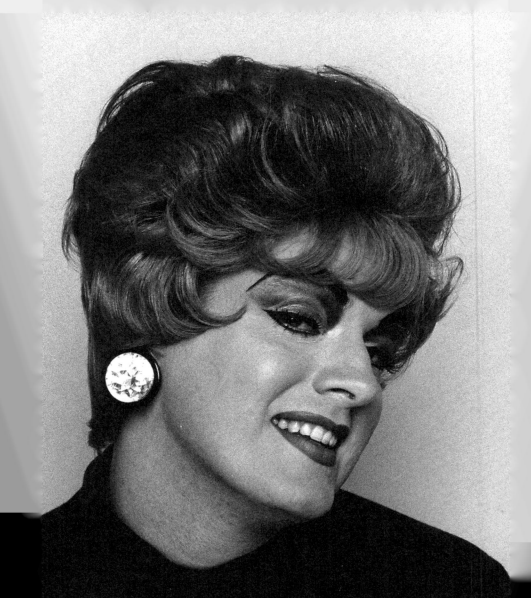

ENDIVE

Endive had a very laissez-faire attitude toward life and a very real talent as a vocalist. She could effortlessly imitate Susan Hayward in Valley of the Dolls and Olivia de Havilland in Hush...Hush, Sweet Charlotte. She was always surprising audiences who were accustomed to lip-syncing performers, to an 'act'. Her repertoire included Patsy Cline's Blue Moon of Kentucky and Doris Day's Teacher's Pet. At Wigstock 1990 she performed Roy Orbison's Pretty Woman, reinterpreting the lyrics to Big Fat Drag Queen. On or off stage, she was the same person. In or out of a wig, Alan Hamilton was always Endive.

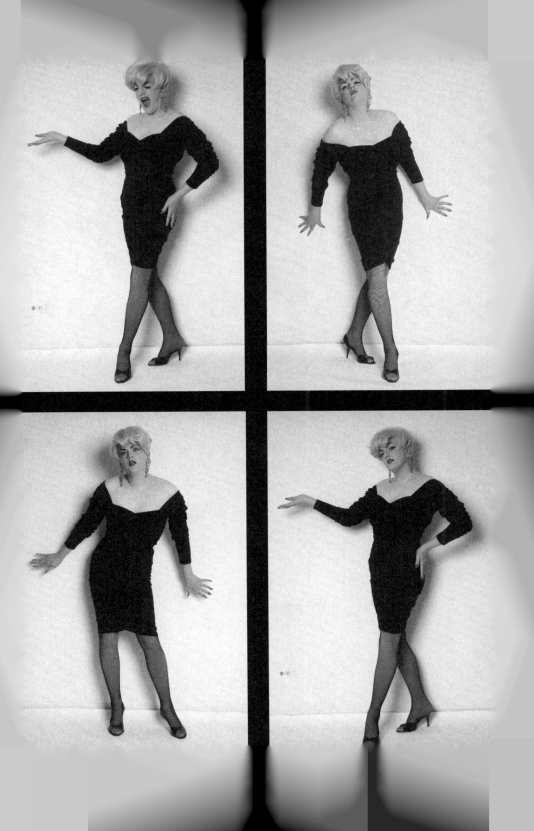

2

★
★ OUR ★
★ SPARKLING ★
★ HOLIDAY ★
ISSUE

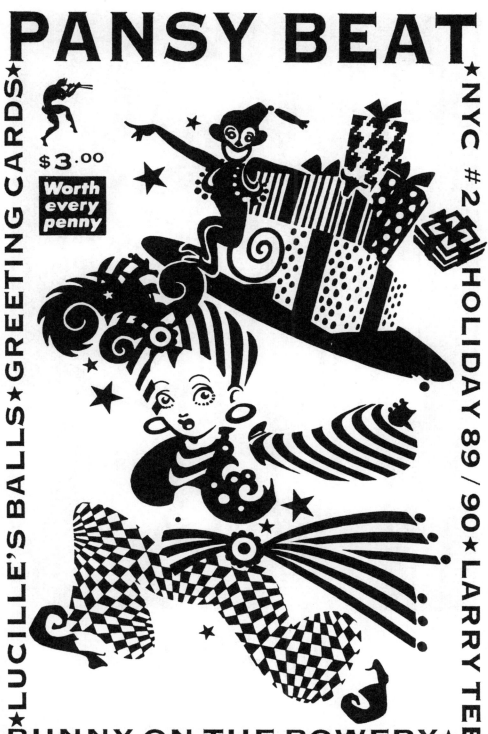

PANSY BEAT

$3.00

Worth every penny

★GREETING CARDS★

★LUCILLE'S BALLS★

★NYC #2 HOLIDAY 89 / 90★LARRY TEE

BUNNY ON THE BOWERY★

Patricia Field

ten east eight street new york city, 10003

Dear Readers,

It seems the Christmas season is upon us once again, and with it comes our sparkling holiday issue, just in time to add an extra touch of tinsel to the festivities.

So don ye now your gay apparel -

Whilst ye sing this little carol -

"Clap ye hands and stamp ye feet -

Move thy booties to the yuletide beat!"

editor-n-creative director
MICHAEL ECONOMY

associate editor
DONALD CORKEN

contributing editors
GLENN BELVERIO
COLE SLAW

contributors
DEEE-LITE
ENDIVE
MICHAEL FAZAKERLEY
RICHARD HENKE
LADY BUNNY
RYAN LANDRY
LARRY TEE
BARBARA PATTERSON-LLOYD
JOSIAH SCHUMANN

a special thanks to
ALBERTO ORTA
PHILIP TENER
DUKE TODD

PANSY BEAT PRODUCTIONS
184 9TH AVENUE., N.Y.C. 10011

Laughing All the Way
By Barbara Patterson-Lloyd

HEY Everybody! It's the seaon of merrymaking, so let's not waste another second. . .Did you hear the one about the marine biologist who went to Easter Island? He was looking for Christmas Seals!. . . and later. . .What did one goat shepard say to the other? It's ten o'clock, do you know where your kids are?. . . Overhead in Santa's workshop, "Rudolph, you really sleigh me!" . . . Don't tell anyone but Frosty the Snowman was a big flake! . . . Say people, what do you call a two bedroom igloo? An icicle built for two! . . . And right along those lines, what do you call an igloo with big windows and a Northern Exposure? Cheap! . . . Similarly, what did the North Pole say to the South Pole? Meet 'cha in Warsaw! . . . Anyway, our Christmas tree was so ragged this year that after I trimmed it, I gave it a shave! . . . And finally, I'd like to make a toast to the New Year . . . but I'm all out of bread! . . . Happy HoHos!

CONDOMS

MAKE SAFE SEX FUN!

THIS THIN RUBBER SHEATH
IS DESIGNED FOR TODAY'S
HIGH VELOCITY LIFESTYLES
AND IS A PANSY BEAT FREEBIE

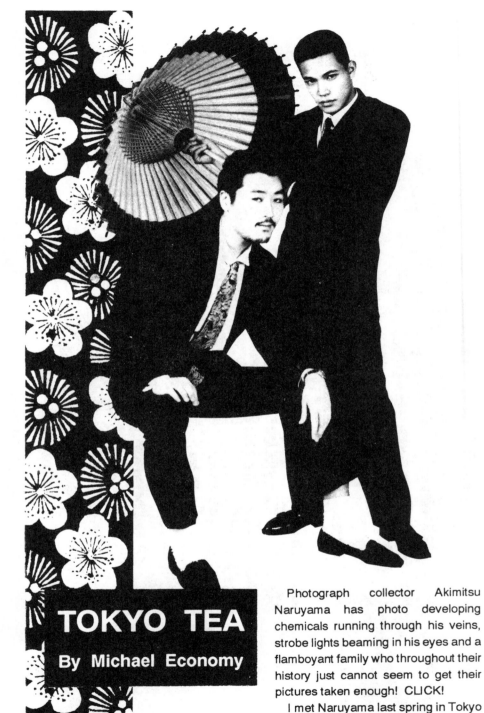

TOKYO TEA

By Michael Economy

Photograph collector Akimitsu Naruyama has photo developing chemicals running through his veins, strobe lights beaming in his eyes and a flamboyant family who throughout their history just cannot seem to get their pictures taken enough! CLICK!

I met Naruyama last spring in Tokyo when one of the photographer's

assistants on the job I had just completed invited me over to meet a friend. His eyes being like those of a tiger's, I went. After a short drive, we were greeted at the door by Naruyama, clad in gold silk Chinese pyjamas and motioning for us to come in with his short-stemmed cigarette holder. As we walked though a small hallway past his collection of snakeskin shoes I knew I was in for a treat. He entertained us all night long with photo albums and wild stories about his family. Latin jazz and Japanese 50's pop played in the background as I came to the stark realization that Kiyoshi (the one with the tiger eyes) was Naruyama's beau. CLICK!

While here in N.Y.C. this past October for photo auctions at Christie's and Sotheby's, I met up with Naruyama and put together this piece.

Born in Akasaka, an ultra exclusive entertainment district in Tokyo where real Geisha's serve sake to politicians and big business types, his was a childhood steeped in the richness of Japanese ritual and colour. Inheritor of his father's eccentric taste in clothing (champion sumo wrestlers do not usually parade around in St. Laurent suits) and his mother's ear for music (though a traditional-style dancer, she loved her latin jazz, for example, *Paris Plaid* by Tito Puente) Naruyama longed to be a part of the world of photographs and press that his family so easily attracted. CLICK!

A living testament to the mystical element of Japanese culture, Naruyama was raised by his grandmother who believed him to be the reincarnation of his notorious aunt, a socialite whose picture frequently popped up in fashionable magazines of the times she had numerous affairs with many photographers as well as actors and jazz musicians, met her fate at a young age in a gas explosion. CLICK!

Grandma, the daughter of a member of the yakuza (Japanese mafia) and once the owner of "Garbo's," a night spot in Tokyo's world famous Ginza, was no stranger to the camera either. She scandalously posed as the Sapporo Beer Poster Girl in the early 1900's. CLICK!

Obviously Naruyama's background has been a strong factor in formulating the camp sensibility he brings his photo collecting, although he stresses that the photographs themselves are not neccessarily campy. On the topic of his collection he said, "I don't want this to sound extreme but to me, owning an original Irving Penn is the same as owning this photograph here," handing over a copy of an inexpensive portrait of him and his boyfriend that appears with this article, "in no way am I comparing the quality, price or the photographers themselves. More to the point is that both photographs are part of my collection and from that viewpoint I derive equal satisfaction."

To date Naruyama's collection contains photographs by Diane Arbus, Cecil Beaton (portrait of Garbo), Hans Bellmer, Braissia (portrait of Dali at 23), Pierre Molinier, Scavullo, Edward Steichen and Weegee.

As a small boy flipping through the pages of his mother's Vogue's, he never dreamed of being the owner of this glamorous collection. When I asked him what he wanted most for Christmas, his reply was immediate, "A heart-shaped diamond from Kiyoshi ("Tiger Eyes") to be inserted into one of my front teeth!" CLICK!

SUPER GIRL(?)'S HEALTH AND HYGIENE

By Ryan Landry
"UNWANTED HAIR FOR THE HOLIDAYS"

Well, gay citizens, it's your gal-pal Super Girl (?) here to give you yet another healthful hint on how to keep your indestructible body in super human form.

The other day, while saving a busload of school children from a faulty draw bridge, I noticed a rather nasty itch beneath the "S" on my recently washed uniform.

"Could it be my detergent?" I puzzled, nearly dropping the bus, "or is it my chest hair growing back?!"

Appalled at both possibilities, I flew immediately to a library and read up on "shaving."

Shaving is the quickest, simplest, **cheapest** way to remove unwanted hair, be it from our faces, legs, torsos, or otherwise. Let's face it, electrolysis is expensive and not always reliable. Waxing is downright painful and always ruins at least one piece of cookware if done at home. If you have it done professionally, it too can be expensive and remember, I **don't** get paid for all this lifting, time travelling, and saving the random cat from some tree in the middle of the night while the fire department is off on another **coffee break!**

Well, anyway . . . to begin, always wet the area thoroughly. There's only one substance to safely lessen the tensile strength of body hair, and honey, it ain't kryptonite! It's H_2O. That's right. Hot Water!

Next it's best to lightly moisturize, but remember, before moisturizing, the more hot water you splash on, the softer the hairs become. Now that it's wet, the moisturizer will keep it weak.

Now it's time to add the shaving preparation, be it foam or lather. Please don't use aerosols. Remember, I've been there. I **know** what shape the ozone is in!

And now for the razor. No dull razors please! They'll sabotage your preliminary tactics and they hurt like hell. So keep your razors new, wet, and clean.

Don't shave against the grain, thinking you're clever and getting a closer shave. You'll most likely develop ingrown hairs and prickly irritations and if you're like me, you've got plenty of those already.

Now rinse, and be sure to wash away all shaving foam residue, as it is drying to your lovely super human skin.

ELECTRIC RAZORS

This method is a favorite of that bizarre flower from the sixth dimension, Madame Hapi Phace.

I have literally sat in her fortress of solitude (living room in layman's terms) and watched her shave her entire body with one of these. It was the saddest sight I've seen since the view outside the window of my rocket ship as I left my native Krypton on my way to Earth. Why? Because she didn't even use **pre-electric shave preparation!**

Now after shaving and proper cleansing, lightly dust the area with a talc of some kind.

Doesn't that feel better? Gorillas in **my** midst? Not hardly!

Hope this made your shave a smoother one.

Until next time remember . . ."Health is Wealth."

ROGER ROTH INC. AND DAVE
CARDS AND GIFTS

123 7TH AVE.
BET. 17TH & 18TH ST.

(212)989-1184
NEW YORK, N.Y. 10011

CᴏOᴋIN

Christmas isn't just a day, it's a frame of mind. A time of gaiety and celebration, a time of tables laden down with holiday treats. But unfortunately, the aftermath can leave one several belt sizes larger. Yes, it's an unpleasant fact, but so true. Holidays don't have to mean eating yourself into a black hole of oblivion. I would like to share with you the million dollar secret of surviving the holidays with your figure and confidence intact. Don't be afraid to hurt Aunt Millie's feelings when she passes that plate of plum pudding under your nose. I know it's not proper to talk about one's relatives, but let's face it, Aunt Millie's figure quit decades ago. You can't afford to let that happen to you, not in this season of sex, glamour and mistletoe. And another thing girls: Lay off the booze! Overdrinking does nothing for your face, your figure or your career. This holiday you need to put

things in a new perspective, one that will leave you feeling like a celebrant instead of a survivor of a nuclear gastronomic holocaust.

OK, enough carping on the do's and don'ts of the Christmas season. Let's talk about what I want (for Christmas, that is.) What I want consists not of material rewards, but gains. Costly possessions such as furs, jewels, fine raiment and lavish surroundings are nice to have, but they are nothing compared with "peace of soul." Through living my entire life on a higher spiritual plane than most, I hope to achieve both, a rare and rewarding accomplishment. Hmmm. . . all this soul-searching has made me hungry. I could really go for a rich, lucious holiday nut loaf and a reviving pitcher of hot cider. See ya under the mistletoe. . . and remember, there's always something cooking in Endive's kitchen!

WITH ENDIVE

New Recipe

Endive's Nutty Yule Log

3/4 cup of finely chopped nut meats
1 1/4 cups of cooked tomatoe
1 cup celery, chopped
1/3 cup parsley, chopped
1/2 cup onion, finely shredded
1 egg, slightly beaten

1 t. vegetable sale
1/2 t. savory
1 cup dry whole-wheat bread crumbs
2 T. sesame oil
2 T. wheat germ

Combine first six ingredients and mix thoroughly. Add the remaining ingredients and mix again. Pack into a well-oiled loaf pan. Bake in a moderate oven about 40 minutes, or until firm. Serve with lemon wedges, parsley butter or tomatoe sauce.

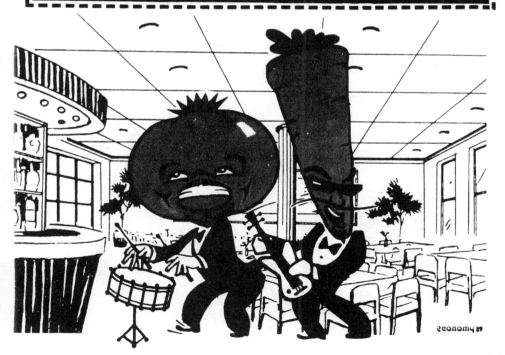

economy 89

DETENTE

96 EAST 7TH STREET, NEW YORK, NY 10009
PHONE:(212)529-7323 FAX:(212)529-7318

Season's Greeting Cards

in order of appearance

JOEY HORATIO

SACHIO KAMIA

DONALD CORKEN

ALBERTO ORTA

LADY KIER

BILL PEAKS

TREY SPEEGLE

STEPHEN TASHJIAN

horatio

174

Merry Christmas 1989 Donald Cohen

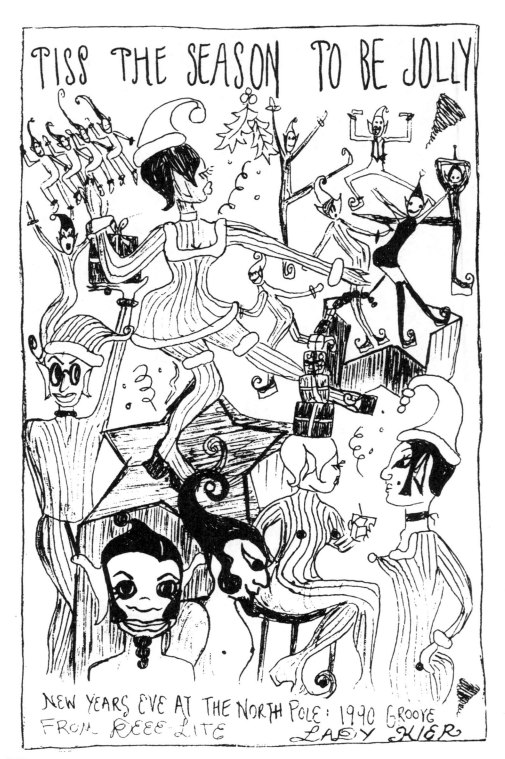

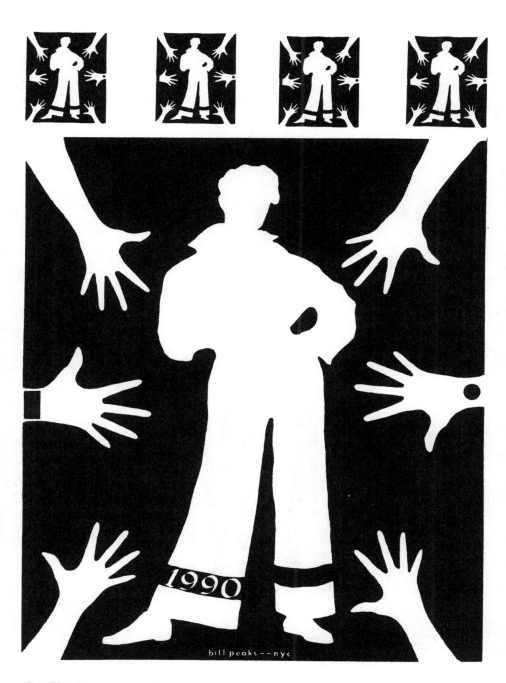

bill peaks --nyc

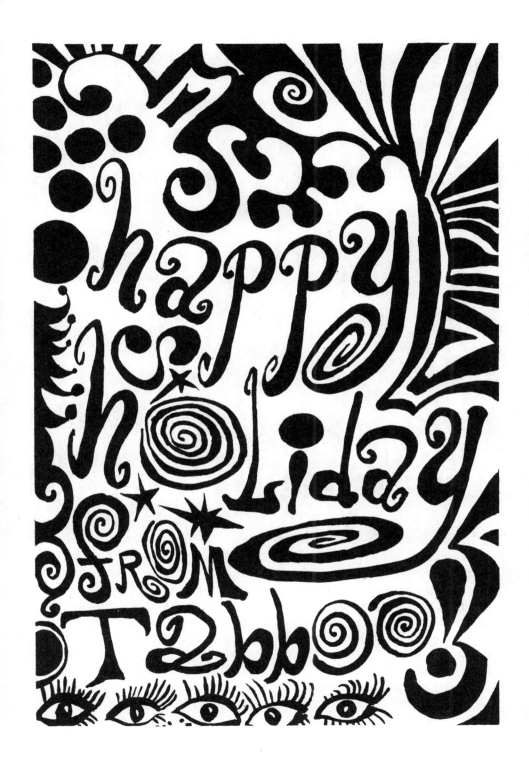

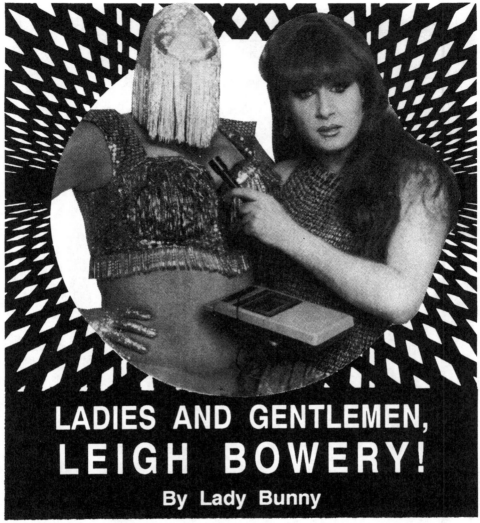

LADIES AND GENTLEMEN,
LEIGH BOWERY!
By Lady Bunny

He's wowed patrons of London's prestigious Anthony Dorphy gallery with his living installation for which he simply posed, impeccably styled, behind a one-way mirror. He dumbfolded spectators at Suzanne Bartsch's Love Ball with an insane get-up that featured a living arm refilling his champagne glass from underneath his voluminous skirts. Recently apprehended by London police for indecent exposure (imagine!), he informed the guffawing officers that,

"This is my new look, you'll be seeing a a lot of it in the streets, so get used to it!" And after years of performing with Michael Clark's dance troupe, he's expanded his light up the dance floor, night club appearances into a dynamic stage show incorporating fireworks, strip tease and flying buckets of glitter, fake blood and eggs. He calmed down just long enough for a hectic post-performance interview at Red Zone.

The Lady Bunny: Leigh! I just loved your little ol' show!

Leigh Bowery: You loved what?

TLB: Your show! Tell me about some of your inspirations for "this piece" without geting that gook all over me.

LB: Well strangely enough, Bunny, every single time I've appeared, you're throwing eggs or catsup or paint, you're doing that sort of thing with your mind, with your eyes. So you are the inspiration for that act.

TLB:You must be psychic, that's exactly what I've been feeling everytime I've seen you! (giggles)

LB: No, it wasn't even on a psychic level, it was much more base than that.

TLB: Honey, what would you like for Christmas?

LB: (Pause) I don't know. Ask me another question.

TLB: Uhm, if you were being interviewed, what would you really like to be asked? (titter, titter)

LB: Well that depends on who's asking the questions! (ker-ploink!)

TLB: Uhm . . . (at a rare loss for words)

LB: Oh Bunny, just make up all the answers, I trust you implicity. Now that boy standing right next to you, he's absolutely adorable, came up to me and said 'Hi, I just love the way your body hangs.'

TLB: Did you ask him how his hangs?

LB: Well, I hope to find out before too long, that's why this interview seems like such a waste of time. It's getting in the way of what's *really*

important. Look, how close he is to me. Uh oh! What's happening? Oh No!

TLB: Oh, I feel so guilty, he just ran off with Larry Tee.

LB: No he hasn't, he's just talking over records. If I dance for a minute, I'll get his attention again. He told Charlie

Atlas a minute ago that he was interested in the dance.

TLB: Tell me all about your relationship with dear Charlie.

LB: Well, he discovered me. I've been in a number of his films, including, *Hail, The New Puritan* with Michael Clark. We have very much the director/starlet type of relationship.

(Enters club-kid, Sean Legend)

Sean: Hi, Leigh, I met you through Kenny Kenny at Copa. I vogued for you. Oh, I'm on tape?

LB: Does Lady Bunny know you?

S: Yes, I know Lady Bunny gfrom Wigstock. She's ovah.

TLB: Aww. . .

S: And we *all* love her.

TLB: But this isn't about me!

S: We all love Leigh, too! She's beautiful!

TLB and LB: Which one do you love more?

S: Well, I got kissed by both of you, so I have mixed feelings.

TLB: Why, which one was a better kisser?

S: You are Lady, because Leigh always keeps her face covered. (squeals and giggles)

LB: You'll go home and you'll smell me a lot longer than you'll smell her. (more squeals and giggles) I'm going to find that boy who likes the way my body hangs.

THE END!

Photos By Michael Fazakerley

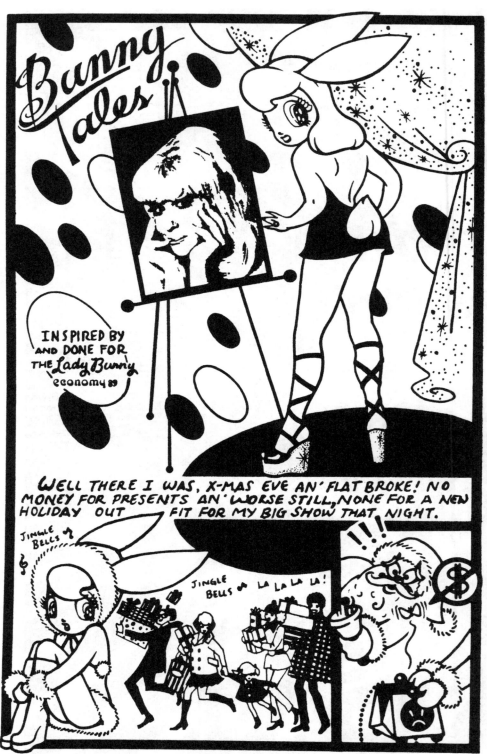

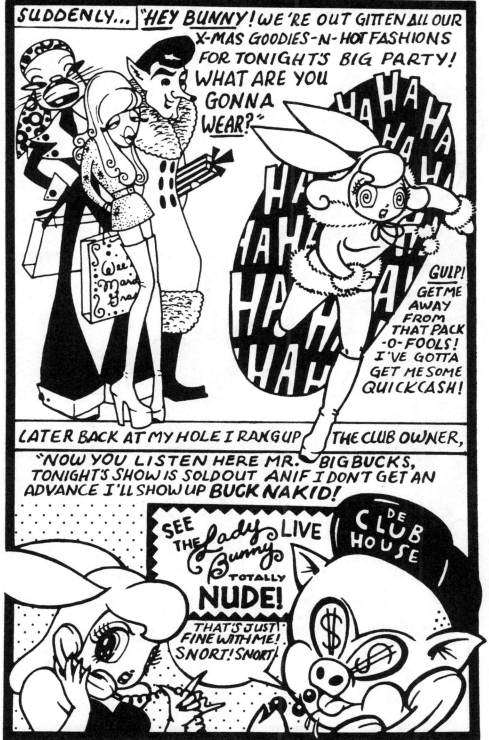

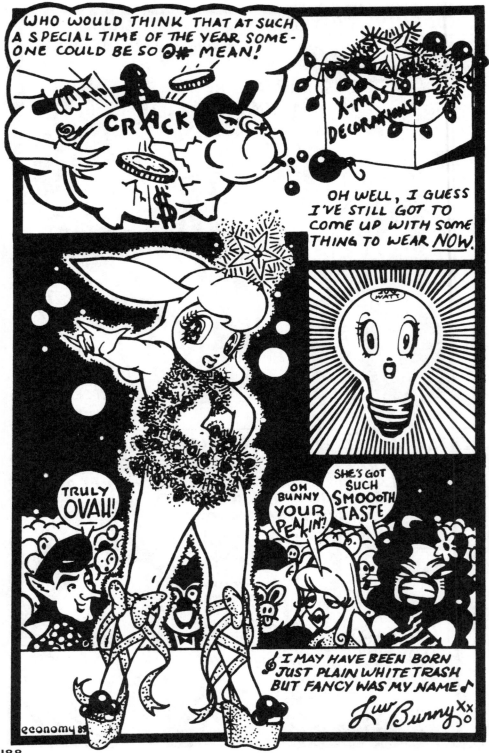

CLOTHIER

NEW REPUBLIC

NEW YORK

93 Spring St. New York, N.Y. 10012 212 • 219 • 3005

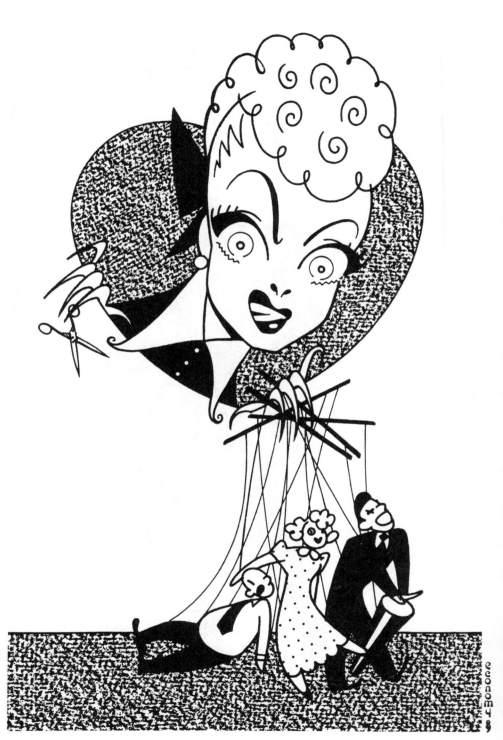

LUCILLE'S BALLS
By Richard Henke

No one could say Lucille Ball was not appreciated. Since her death last year, she has been the subject of innumerable tributes: scores of magazine articles, several television specials, even two cover stories in *People* magazine. Almost invariably, critics and fans compare her to the great clowns like Chaplin, Keaton, and perhaps most often, Harpo Marx who appeared in a famous episode of *I Love Lucy*.

But Lucille Ball's comedy is not in the tradition of those silent clowns. She may have had a knack for physical comedy, but mainly she was a master of verbal comedy. (Can you imagine watching *I Love Lucy* with the sound off?) Actually, she was much more like the insanely verbal Groucho than Harpo Marx. Her roots were not in the silent screen, but in those brilliant screwball comedies of the thirties, movies that were filled with hard-boiled talk that came fast and furious. She even was featured in one of the best, *Stagedoor*.

What has struck me most forcefully in al these tributes is that no one really likes Lucille Ball; everyone likes Lucy Ricardo. In fact, most of the personal memories of Lucille Ball hinted that in real life she was an unpleasant woman. Adjectives like "direct," "blunt," and "no-nonsense" discretely imply that she

must have been one tough cookie. But her off screen image hardly matters. In fact, avid fans perhaps secretly want their favorite stars to be a little tough, for as Helen Lawson in *Valley of the Dolls* puts it, a true star needs that "hard inner core. . . because in this business the punches come left, right and below the belt."

No, what most impressed me was the fact that although words like "comic genius" are casually used to describe her, the Lucy everyone likes had a very limited life. Miss Ball's long career may have spanned over fifty years, but as the innumerable tributes made clear, the only time anyone admires Lucy is the six years she starred in *I Love Lucy*. And not even that: does anyone really like the Connecticut *I Love Lucys*?

Lucille Ball's most famous quote must be, "I'm not funny." Carson or Cavett laughed when she said it, as if thinking "What a modest superstar!" But anyone who has ever read an interview with her or seen this sour old matron on talk shows during the last twenty years should have little trouble believing the veracity of her words. Perhaps the fact comes home with even more force when one looks at any of the television shows she did after *I Love Lucy*. *The Lucy Show*, *Here's Lucy*, and the short lived *Life with Lucy* are painful embarrassments. Watching them, can you blame anyone wondering how this woman ever could have been funny?

The answer is simply that she was. In fact, she was the most brilliant comedian America has ever produced. She *was* a comic genius.

Lucy's greatness, however, is limited to just four or five years on the most popular situation comedy to ever hit televison. Rumor has it that at any moment an episode of *I Love Lucy* is playing somewhere in the world. The $50,000 question is why was she so wonderful here when she had been so mediocre before and became so dreadful later. The answer is complicated, for what makes a comic funny is often a delicate balance that the slightest change can upset. (A friend told me that Carol Burnett is no longer funny since she has had her overbite surgically corrected.) Lucy herself may have had the best answer when she said that all the elements of *I Love Lucy* were magically right. She did not make the show funny. The show made her funny.

Lucy had always explained her comic success on her great writers. Again people assume she's being modest. Actually, the best Lucy episodes are among the best written shows I have ever seen on television. The person who is perhaps most responsible for *I Love Lucy*'s overall effect is Jess Oppenheimer who conceived the show, produced it, and along with Madelyn Pugh and Bob Caroll, Jr., wrote every single episode of the first four years. In fact, it was with Oppenheimer's departure from the series at the beginning of the sixth year--and the Ricardo's move to the country--that the quality of the show plummets.

I consider *I Love Lucy* one of the finest comedies ever produced in this country, on stage or screen. I consider it art. If your idea of art eschews the belly laugh and vulgar humor, then Lucy won't be for you. Nor will it be if your idea of art means it must have a pat moral at the end. Unlike situation comedies of today that invariably give us a concluding lesson about life and love which sums up the half hour we just watched, Lucy adheres to the morality of farce: life is a passion play in which we all make fools of ourselves and never become one whit better for it.

That doesn't mean *Lucy* isn't about anything. It just isn't didactic. The ostensible theme of the show is the battle of the sexes. Lucy is frustrated because she wants more out of life--which usually means to get into show business--while Ricky wants her just to be his wife. This concept of sex roles is pretty much out of date, which may be why feminists don't like the show. (Actually, real life belies its theme: Desi Arnaz *needs* his wife Lucille Ball to be in show business so he can get this television program on the air every week.)

But the theme is really more universal. *I Love Lucy* examines the force of desire. Usually in the first five minutes of each episode Lucy establishes what the specific desire will be--to get into Ricky's show, to be the Vitameatavegamin girl, to work in a candy factory, to stomp grapes--and the remainder of the show will demonstrate how she manipulates obstacles, usually Ricky, to get what she wants. This often involves an enormous

amount of ingenuity. *I Love Lucy* charts the elaborate creativity it takes to get your desire; it is a celebration of desire.

Her creativity often takes the form of lying, deception and manipulation. Disguises are integral to the show: people are never as they appear. And the characters can be just plain insulting. Fred says Ethel is too fat. Ethel says Fred is too cheap. Lucy says Ricky is a ham. And everybody says Lucy is . . . well, Lucy. With perhaps the exception of the *Honeymooners*, *I Love Lucy* is the least sentimental comedy in the history of television. It is much more hard edged than the issue shows of today, because it is not "about" something. It shows us people as they really are--conniving and mean spirited.

And yet likable. The miracle of *I Love Lucy* is that the characters are so amiable. Lucy in particular. That may be Lucille Ball's special accomplishment in this show. On paper her character may seem only spoilt and silly, but Lucille Ball made her lovable. The special genius she brought to that role was the ability to make Americans take Lucy into their hearts, not in spite of her faults, but because of them. Lucy is not merely madcap, or the semi-retarded character she became in the later incarnations of the character; she is a three dimensional woman with real life complications. She is a woman who is simultaneously vain, beautiful, selfish, witty, naughty, childish, condescending, and a lot of fun. Like Becky Sharp or Scarlett O'Hara, she is an original.

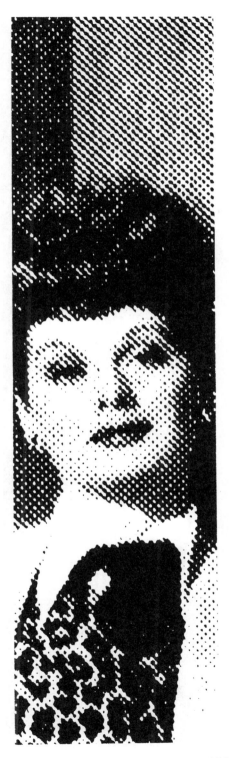

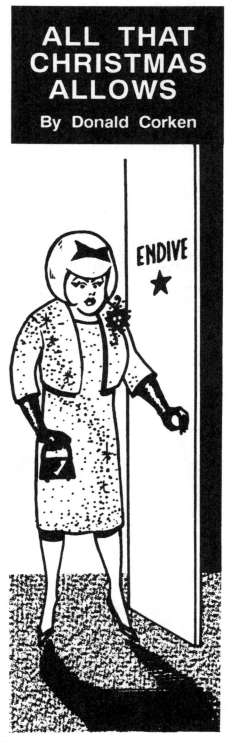

ALL THAT CHRISTMAS ALLOWS

By Donald Corken

It was a crisp December morning not long before Christmas and the production crew at WBDQ Television in Chilicothe, Ohio was getting ready to film the special holiday episode of "Endive and You," the long running daytime talk show. Endive was a beloved figure in the Chilicothe area, a "model" of virtue, a "tower" of feminimity, who brought a little bit of sophistication and culture to this sleepy midwestern town.

"Endive and You" was a popular blend of musical entertainment, provided by the unique talents of its star, and "human interest." Endive was known for attracting many fascinating "characters" to be guests on her program, and she was able to gently instruct her viewers on the many important social issues of the day.

As the stage crew busied itself with decorating the "homey" living room set with swags of garland and festive ribbon, Endive, ever the perfectionist, was making sure every last detail was in order.

"I think we should have the '101 Things To Do With Mayonnaise' segment before the 'Married Lesbians Who Love Their Husband's Mothers,'" said Endive, always sure of her decisions, "then we'll close with me singing my Christmas carol medley with the Willowbrook Elementary School Choir. Now where's the conductor? I have to go over some changes with him." There was always so much to keep the busy star on her toes.

After all these engrossing matters were seen to, Endive took time for a quiet moment in her dressing room. To steady her nerves, she liked to study

her reflection for a bit in her full length mirror. Endive could best be described as being a "handsome" woman, some might even say "formidable." A beauty when she was young, she now more than somewhat resembled the well-groomed Angela Lansbury, one of her idols. Those less kind said she looked like an industrial strength version of Rosemary Clooney. It had to be admitted that Endive had a fondness for food, and she was a long standing member of the Chilicothe branch of Overeaters Anonymous. Fortunately, through the aid of corrective "undergarments" and the prudent use of flattering camera angles, Endive always managed to look "striking" on the television screen.

As Endive began to "beat" her face with foundation, her trusted maid and "confidante," Azalea, entered the room.

"Oh, Azalea, there you are. Would you please tell Missy that I'm ready to go over my costumes? I hope he has some really special outfits for me."

"Yes, Miss Endive, I'll get him," replied the faithful servant. As Azalea left the room, Endive's princess phone rang.

"Hello, what can I do for you?" the star responded brusquely. "Oh, Steve, darling! It's so good to hear your voice. Are we still on for tonight?. . . Oh, I see, yes, yes of course. . . I understand that you can't get out of dinner with your family, but. . . But let me say this one thing. I always knew that someday we'd come to this moment in the scheme of things. You want your family and your business and a nice quiet life, and the price of all that is me. Well, you can go have dinner with your ferret-faced wife and those brats she gave you, Steve!

We're through!"

With that, Endive slammed down the receiver. "Azalea! Azalea! Where are you?"

Azalea ran in. "What is it, Miss Endive?"

"Oh, Azalea, it's too awful! How could he do this to me? ME! Endive!"

"What are you talking about?"

"Mr. Steve. He cancelled our date for this evening. Our one night together and he cancelled! It's too much to bear--I had no choice but to give him his walking papers. No one cancels on Endive more than once! Great stars have great pride!"

"Miss Endive, you did the right thing," consoled Azalea, always Endive's "rock of Gibraltar."

"But if I did the right thing, why do I feel so goddamn lousy?" Endive said as she broke into painful sobs, seeking comfort in Azalea's boney arms.

"Now, now, Miss Endive. You'll just have to try to forget about him."

"Oh, but how, Azalea?! It's so unfair, he has his wife and family and all I have is this shitty tv show!"

"Why, Miss Endive, what are you saying? You know it's in your blood. You need showbusiness the way showbusiness needs you. The show must go on--look, here's Missy now with your costumes."

Missy was Endive's costumier. She had relied on his expert taste and his considerable skill at the art of "camouflage" since her days when she was the "Early Rise Coffee" girl back at WCOW in Youngstown.

"Missy, I might as well tell you I'm not in a very good mood this morning," said Endive.

"Don't tell me--it's Steve again," Missy answered, "Nothing puts you in a bad mood faster than that man. I warned you about him."

"Very astute, Missy. But I thought I paid you good money to be my wardrobe man. If I needed cheap advise, I'd write to Dear Abbey! So let's cut the back talk and show me what you're brought."

Missy proudly hung his "creations" on the wardrobe rack. He always brought a few more "numbers" than would be needed so Endive could have a choice. There was a smart black afternoon dress, a tailored tweed suit, and a few more "splashy" gowns that Endive always saved for her "finale."

Endive's expert eye went straight for a white satin dress with horizontal black stripes.

"What's this? This would make me look like a big beached whale! You know what satin does on me. Are you blind or stupid or both?" cried Endive as she flung the despised garment on the floor.

"You're walking on thin ice," continued the anguished Endive, "I don't ask much from you, Missy, and the least you can do is make me look like the star that I am! I don't see anything remotely Christmasy here! Where are the reds, the greens, the candy stripes? Where's my goddamn Christmas corsage?! You find me something to wear, and you find it now!"

Missy ran out of the room. He was used to his mistress' "moods" and was confident that all would be well when she cooled down.

"Azalea, hand me that box of chocolates, I'm hungry."

"But Miss Endive, you know what happens when you eat before. . . "

"I said, give me those chocolates, NOW!"

The devoted maid handed over the box of bonbons with an air of resignation, and watched as Endive tore into them lustily. With less than two hours until air time, Azalea was worried what Endive would eat so much that she wouldn't be able to fit into her dresses. Azalea had more than one painful memory of poor Missy having to use safety pins to close Endive's gown.

"Oh, these are just what the doctor ordered! So delicious. Azalea, give me that takeout menu. I think I'll have something sent up."

Just then a handsome young man appeared in the doorway. The tight T-shirt and snug overalls he wore highlighted his trim, muscular frame. Endive didn't remember seeing him before.

"Hello, who are you?" the star asked, dabbing the corners of her mouth with a napkin.

"I'm Cubby, the new assistant stage manager, ma'am. Today's my first day."

Endive couldn't help but notice his sandy blond hair and his open friendly smile. "I knew I didn't recognize you. Now what is it I can do for you?" asked Endive as she furtively hid her box of chocolates behind a pillow.

"I'm supposed to make sure we're running on schedule, ma'am."

"I see. Azalea, would you be a dear and go help poor Missy with my costumes? And please tell him I"m sorry I blew up at him. Such trying times. I'd like Cubby to go over my lines with me."

Being the professional that she was, Endive intended to pour herself into her "work." True, it was sad to love and lose somebody, but there was lots of happiness to be found in working hard.

An hour later, Azalea returned with Missy and discreetly knocked on the star's door.

"Miss Endive, can we come in?"

"Just a minute, Azalea," came Endive's breathless answer. They heard a great deal of scuffling and hurried footsteps and then Endive herself appeared at the door.

"Come in, please. Cubby was just leaving, weren't you?" She shot her "protegee" a telling glance.

"You bet ma'am. I'll go tell the director that everything seems to be in order." He hurried out, looking slightly embarrassed, or so it seemed to Missy.

"Who was that?" Missy asked slyly.

"That's Cubby, our new assistant stage manager. He seems to have great potential, a real aptitude for this business. You know, there's a lot more to him than shows in those overalls, and I intend to make use of it."

Happily, Endive loved the new dress Missy brought her, a red and green cabbage rose print caftan. In no time at all, Endive was dressed, coiffed, and bejeweled. Looking every inch a great star, she strolled into the wings and waited for the orchestra to break into the special "Endive and You" theme song. As she stood there, she caught sight of Cubby off to the side, busy with a hammer. She thought of the promise the new year held, and was filled with renewed faith in the true meaning of Christmas. 🏃

NATIONAL BESTSELLER!

"You'll never go hungry on **MY** diet!"

- "During the holidays, I like pumpkin pies as a meal!"

- "You know what they say--big mouth, big appetite!"

- "And they say I can't have my cake and eat it too!"

- "I say, let **ME** eat cake! In fact let me eat everything!"

- "I told the editor, 'You just stick to your drawing table and let **ME** do the eating!'"

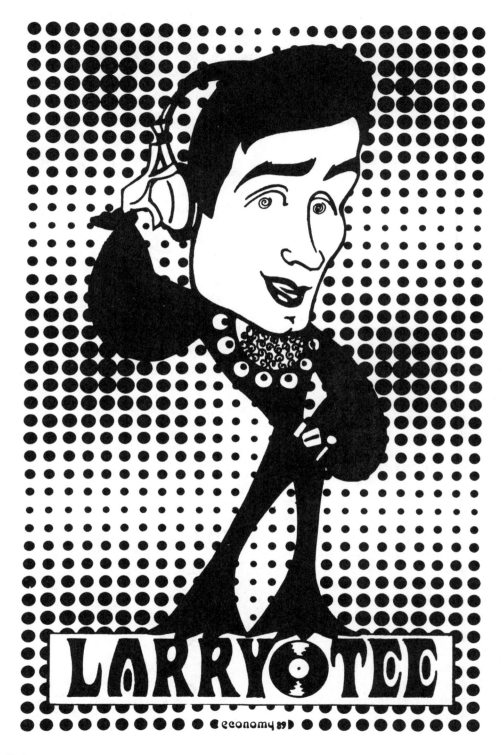

CELEBRITY FAVES

Soon to be internationally famous recording star, and currently D.J., party promoter, actor, renaissance man, Eagle scout and a non-stop schoomze.

Sign: Libra
Chinese Zodiac: Boar--galant and noble
Color: Mustard
Singer: Cindy Wilson
Band: Butt Hole Surfers
Actor: Matthew Modine and Sylvia Miles
Movie: Almovidar's *Law of Desire*
Food: Thai
Shoe: My Chuckies (Chuck Taylor tennis shoes)
Designer: Rue Paul
Book: Media Sexplotation
Phallic-Shaped Product: My microphone

Top Ten Disco Hits:

1. Let's Start the Dance/Hamilton Bohannon
2. Our Love/Donna Summer
3. Disco Heat/Mighty Real/Sylvester
4. Native New Yorker/Oddessy
5. I Don't Want to Lose Your Love/The Emotions
6. Free/Denise Williams
7. Don't Stop Till You Get Enough/M.J.
8. Dazz/Brick
9. Do You Wanna Get Funky With Me?/Peter Brown
10 Double Dutch Bus/Frankie Miller

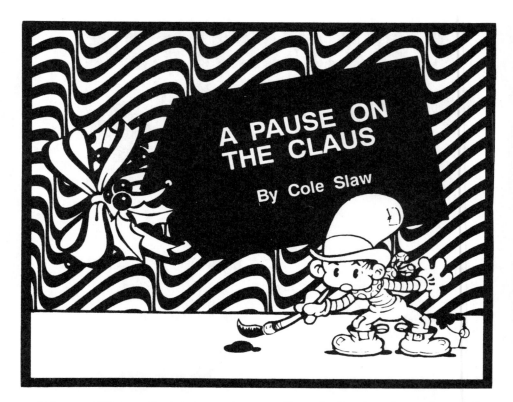

A PAUSE ON THE CLAUS

By Cole Slaw

At Issue: Sitting on Santa's lap and telling him if you've been a bad boy or girl, or as it's referred on the street: Santa Sitting. Is Santa Sitting the innocent ritual of childhood we've believed it to be for years? Or, is sitting on Santa Claus' lap the national disgrace others purport? These opposing individuals loudly scream yes, quoting scripture and denouncing the act as sin in it's purest form.

Yours truly, not understanding the reasoning behind this latest phenomenon sweeping the nation, decided to talk to some of the people involved in this brewing controversy. I conducted several telephone interviews in order for us to take a microscopic look at Santa's lap.

My first interviewee was thirteen-year-old Somona, California teen Dody Buckley, whose mother

Rose is the founder and executive director of Mothers Against Santa Sitting, an organization whose sole goal is to ban Santas from department stores across this littered land of ours. Dody is the reason why Rose founded MASS.

Cole: Tell me, Dody, is your mother listening to us right now?

Dody: 'Course, (whispering) hold on, doorbell just rang. She's gone.

C: Good.

DB: Like, you can say that again.

C: Now, truthfully speaking, do you think your mother is crazy?

DB: Like, she says she's not, but I don't know.

C: Dody, tell me true, what did you do to make your mother form MASS?

DB: Like, a couple of years ago, I kinda like went overboard, OK?

C: How so?

DB: I was skipping school and like

hanging out at the mall and I, like fell into sitting on Santa's lap.

C: But why?

DB: Because it like felt good, dumbo ass.

C: Cole Slaw is no dumbo ass, Missy, but I still can't see why skipping school to go to the mall would make your mother get so crazy, I mean involved.

DB: I started going crotchless, OK?

C: You mean no panties? Is your mother a born again Christian?

DB: She's been born again like three times this year. (Silence) Because he asked, Mother!

C: Pardon?

DB: I can't read minds like you, you know!

C: Are you still talking to me?

DB: Fuck you, Mother! (silence)

C: Hello? Hello?

Rose Buckley: My daughter can't talk now.

C: Mrs. Buckley? Can you tell me. . .

And with a click then silence, the conversation was concluded.

I'm afraid I must decide to discount the Buckleys as too emotionally unstable a duo from which to gain any insight. Let's look at some statistics. Eighty-one percent of the nation has sat on Santa's lap at least once in their lives. Sixty-nine percent have done it more than once. Thirty-three percent do it every year. What does this tell you? Well to me these stats earmark Santa Sitting as a traditional Christmas ritual, that up until now anyway, Americans have embraced with open arms and bended knees. Is all this about to change?

My next telephone call was with the Reverend Jimmy Stout, pastor of the Pulaski, Tennessee First, Second, Third and Fourth Streets Baptist Church

and Orphanage. Rev. Stout, perhaps this country's strongest opponent to Santa Sitting, was instrumental in the state's sentencing of William Hawkins to seven years in prison for rape and sodomy because it was discovered when dressed as Santa Claus, Mr. Hawkin's fly was open while holding a seven year old boy on his lap. Both Rose Buckley and the Rev. Stout seized the opportunity to further their cause and demanded rape charges be brought. Both attended the trial that ensued, holding circus-like pep rallies on the court house lawn.

Cole: Reverand, why do you believe Santa Sitting is a sin?

Rev. Stout: Son, because it is!

C: I see. And just how did you derive this conclusion?

RS: Are all your questions goin' be this stupid?

C: You agreed to this interview.

RS: Yeah, I did, before I found out you ain't writin' for no gardenin' magazine.

C: Several celebrities read my column, Reverend.

RS: What's your next question?

C: You never answered my first one. Can you provide actual quotes from the Bible backing up your claim?

RS: Just like the devil! Young man, the devil tried the same damn game against Jesus and we all know how Jesus reacted!

C: How?

RS: Well, if you don't know, I ain't gonna waste my time tellin' you!

C: Let me ask you a question about William Hawkins. Reverend? Reverend? That son of a bitch!

I tried calling the Rev. Stout again, but all I got was his answering machine which said: "You have reached the most holy answerin' machine of the

most holy Rev. Jimmy Stout. Please leave a message at the beep." I left several unholy messages over the next couple of days and received neither a holy or unholy response.

Perhaps the most heartrending story I encountered came from the tiny hamlet of Petersboro, New Hampshire. It is here in this sleepy little town where the incident occurred and where the real ramifications of a hate campaign can be felt. I was able to reach William Hawkins at the New Hampshire Really Hard Labor Camp just outside Manchester.

Cole: First let me say thank you for taking time out from your busy schedule to talk to me.

William Hawkins: Are you making a joke?

C: Serious journalists never joke. Now tell me, Mr. Hawkins. . .

WH: Call me Willy.

C: OK. Now, Willy, just what did happen?

WH: It wasn't my fault. It's the head of that damned department store who ought to be in here, not me.

C: You're saying Abe Finkelstein, III, president of Finkelstein's Department Store, the retail establishment who employed you to portray Santa Claus, forced you to work with your fly open?

WH: No. The damn zipper was broken and they wouldn't pay to fix it. They told me it was my responsiblity. I broke it, I fix it.

C: Then just why didn't you fix it?

WH: Because I don't know how to sew!

C: You mean to tell me you're behind bars because you can't sew?

WH: I suppose so. It's all that damn Rev. Stout's fault. He's one of the ones that came into Petersboro and started stirring up all the trouble, demanding rape charges.

C: I've talked with the Rev. Stout.

WH: Well if you talk to him again, you can tell him I said I hope he burns in hell.

C: I doubt I'll be speaking with the Reverand again. Tell me, Willy, do you have the American Civil Liberties Union in on this case?

WH: What's the American Civil Liberties Union?

C: Maybe I can make a call for you.

WH: I'd sure appreciate it.

C: Willy, let me ask you a hard question: Do you think it's a sin to sit on Santa's lap?

WH: Why hell no!

C: Not even when Santa has an erection?

WH: I did not have an erection! They would have known it if I did!

C: You don't say.

After that, we exchanged addresses and I promised to write every week and fill him in on the progress of Pansy Beat's crack legal team. It just breaks my heart to see an innocent man behind bars.

So, Readers, what have we learned this time? Are these people merely zealots suffering from extreme cases of santarectophobia? Well, in my opinion, if it feels good to sit on Santa's lap, do it. Why people such as Rose Buckley and the Rev. Jimmy Stout think they have the right to tell people otherwise will just have to remain an enigma to all of us. Happy Holidays!

KANAE

212 677-1990
718 486-7484

501 E. 6th ST., NYC 10009

One of a Kind Designs
Clothes - Hats - T-Shirts - Jewelry -
Bustiers - Accessories

Open Wednesday - Saturday 1:00 to 8:00

413 East 9th Street, NYC

212-505-8915

SISTER
BLISTER

A TALK WITH CARL MICHAEL GEORGE

Allied Artists co-founder and experimental filmmaker, Carl Michael George has proven to be a real Renaissance Man. He recently dropped by for a visit to chat with Pansy Beat.

Pansy Beat: Do you think of yourself as a gay filmmaker or as a filmmaker who happens to be gay?

Carl Michael George: I've always found that question difficult to answer because I consider myself a filmmaker who is gay and I'm also a gay filmmaker. I know that sounds very confusing but that's the way I feel. I remember the first time I was asked by Sarah Schulmann and Jim Hubbard to be in the Gay and Lesbian Film Festival, I had a lot of qualms about doing that because I'm very adamant about ghettoization, in that it's very important to try to maintain a global political sense. So I had to really think about it before I took part in it. Then I realized that of course I would be in it because I'm gay and I'm a filmmaker and I'm a filmmaker who's gay.

PB: A lot of your earlier films seem to be of a camp nature. When did you decide to do a serious flim about AIDS?

CMG: I wouldn't say that they were primarily campy, many times the aesthetics involved is based in a camp idelogy but I think overall my films have a definite artistic bent.

I made a conscious decision to make a film about the drug DHPG because two friends of mine, Joe Walsh and David Conover were going through a very traumatic time in their lives because David had AIDS and had developed CMV (Cytomegalovirus, an opportunistic infection that causes blindness.) Joe and I came up with the idea for the film and suggested it to David since he was the one who had to inject the drug DHPG daily.

PB: What I liked about *DHPG Mon Amour* was that it dispelled the notion that people with AIDS are at the mercy of the medical establishment. How do

you feel the film can empower people living with AIDS?

CMG: Well, what it does is take the monopoly of medical care out of the hands of the people who are killing us. The Community Research Initiative (CRI) wants to use this film to teach nursing courses at Columbia University as part of the curriculum because they feel that it does show people that they can administer drugs to themselves at home outside of a clinical environment. The film helped one man directly, for instance, who came up to me after the film and told me about his lover who was in Beth Israel that night trying to decide whether to get an Infuse-a-port (which David had had implanted under his skin for infusing the drug) or a Hickman catheter (which functions the same way but has tubes sticking out of it). After speaking to David's lover, Joe, the man and his lover decided to get the Infuse-a-port.

PB: A review appeared in the Gay Community News that questioned the motive of *DHPG Mon Amour*. What was the reason for that?

CMG: The reviewer stated that the film undermines itself by not fully explaining the situation with DHPG and touts it as a wonder drug. The reviewer obviously did not listen closely to the film because Joe states in the dialogue that he and David knew that David was going on the drug later than he should have because the CMV had already progressed to the point where it had entered the retina. At that time, that was the criterion that a patient had to reach before he or she could obtain the drug from a physician because it hadn't been approved by the FDA yet. The reviewer made light of the film noting that David couldn't even

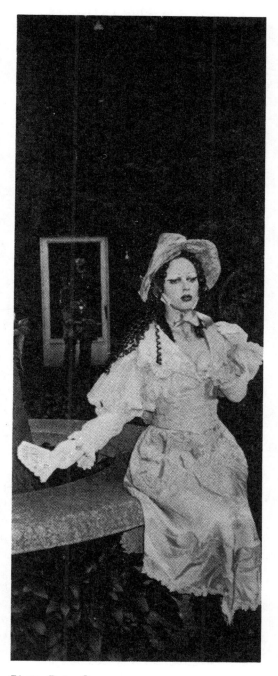

Photo: Peter Cramer

A scene from Carl Michael George's *Les Lesbians Dangereuse*

see the flim because he had lost his sight. I think it was irresponsible journalism to write that critique before getting the facts straight. But otherwise, the reviews have been unilaterally supportive.

PB: The scene in *DHPG Mon Amour* in which David administers the drug was very difficult for me to watch. What were you feeling while filming it?

CMG: At first I felt voyeuristic, but since David, Joe and I had reached a concensus to make the film and had agreed that the end product would be beneficial to everyone, I soon got over that voyeuristic aspect. It was very difficult to film nonetheless, because it was very intimate and very personal. It was very generous of David to allow me to make the film. Although his sight was nearly gone, he was still able to view it when it was finished. It was all he talked about for weeks afterwards.

PB: Where did you film *Les Lesbians Dangereuse*?

CMG: Parts of it were filmed in Miami at a huge museum estate called Vizcaya which was built by this big rich queen. Incidentally, this was the theme of a room that I decorated in a hotel in Miami Beach. I called it Petit Vizcaya. Anyway, we filmed part of in the garden without any of the actresses and when I got back to New York we finished filming it in an enormous garden in the west village which turned out to be the garden that the PWA Coalition uses. I didn't know this at the time.

PB: Tell us about Allied Artists.

CMG: Allied Artists is a not-for-profit arts organization that Jack Waters, Peter Cramer and I started eight years ago. What we do is organize shows, exhibitions and events and act as fiscal management for artists and small arts organizations like ABC No Rio, for example. We did a project last spring at the Leonard Beach Hotel which was called the Artists In Residence Project. This came about when I met the man who owned the hotel and suggested that he needed artists to come and paint the rooms. He agreed and paid the plane fares and artists fees. People came down for three weeks at a time and lived in the rooms that they painted. The rooms are incredibly individualistic. Some of the artists included were Tabboo! and Leslie Lowe. It received lots of international press. We plan to continue the project at the end of this year. Allied Artists are now organizing exhibitions in Hamburg and Frankfurt and some film screenings with Naked Eye Cinema. So apart from being a filmmaker I also have this administrative angle to my life.

PB: In the future do you see yourself pursuing filmmaking or becoming more involved with Allied Artists?

CMG: I think that filmmaking definitely preoccupies my mind and Allied Artists probably preoccupies a little more of my time. The filmmaking is definitely more important. A new project I'm working on now involves making a film about a book that documents the incarceration of homosexuals after the revolution in Cuba. The book (the title of which I can't mention) relates the story of a work camp where imprisoned homosexuals are sent to cut sugar cane. If I can secure the option to the book, I'll probably spend the next year working on the film.

PB: Since this is the holiday issue, what do you want for Christmas?

CMG: I want a Mighty Mite vacuum cleaner. ⨍

100% COTTON T-SHIRTS / **L** OR **XL** / BLACK WITH GARISHLY COLORED HAIR / $15.00 INCLUDES POSTAGE AND PACKAGING / SEND CHECK OR MONEY ORDER TO: JOHN B. FIDDLER C/O DETANTE / 96 E. 7TH STREET, N.Y.C. 10009 / ALLOW TWO WEEKS FOR DELIVERY.

NAME _____
(please print or type)
_____ **L** _____ **XL** _____

ADDRESS _____

CITY _____ STATE _____ ZIP _____

I WANT MY GAY TV

By Glenn Belverio

This pansy is hopping mad. I'm mad because the "How Do I Look" video festival which ran from October 14-25 was the only place I could see quality lesbian and gay programming in a format that is often referred to as "The World of Television Entertainment." Not that I minded sitting amongst my lesbian and gay comrades sharing a moment of couch potatoe solidarity, but hey, shouldn't I be able to watch this stuff at home on my own television instead of settling for crap like hetero Alf, hetero LA Law, and hetero reruns of The Odd Couple? And don't give me that line about the latent homosexuality in Felix and Oscar's relationship.

OK, I'll admit maybe some of the videos in "How Do I Look" are a little too raw for NBC or Fox, but really, how often are the words avant-garde and prime time used in the same sentence anyway? For instance, Suzie Silver and Lawrence Stenger's *Peccatum Mutum (The Silent Sin)* featured homemade backdrops drawn in crayon and magic marker and over-dubs that were mismatched with the players' lips. Nevertheless, this story about lesbian nuns was slicker than slick and confirmed something I've always suspected--nuns do play footsie under the table when they're supposed to be praying. Less revealing, however, was Caroline's Sheldon's *17 Rooms, or What Do Lesbians Do In Bed?* which

did little to solve this conundrum for me. What I did learn was that they do a lot of the same things I do in bed: listen to music, gossip on the phone, kiss, and contemplate the meaning of life. In one confusing scene, two lesbians are sitting on a bed while white arrows containing such terms as cunnilingus and oral stimulation are superimposed over their bodies. But while this is happening, they're playing Scrabble! I don't get it. And I thought my sex life was a bore.

Things began to pick up in Margaret Moore's *Surely To God* in which a hot lesbian couple spend their time out of the sack trying to win the lottery. When they finally do win, their lucky ticket is dicovered to be stuck to a frozen chicken. While cooking the chicken to remove the ticket, the lucky lovers have sex right in front of the oven, and this time it's the real thing (no Scrabble!). What this video succeeds in doing is draw attention to the inseparable links between the urgent erotocism of wealth, food, tv and the media and acts that lesbians perform out of bed (contrary to 17 Rooms' premise). In one scene, our heroines become excited after vegetable shopping and have sex on the floor of a room that contains nothing except stacks of newspapers and a tv that is showing "Wheel of Fortune". Now *that's* entertainment!

For all you pansies out there who aren't involved in the AIDS activist movement because you think it has little to do with high fashion (aside from a few activantes), you should chck out John Gross' *Stiff Sheets*. During a week long AIDS vigil in Los Angeles, some members of ACT UP/LA staged what they called "the Fabulous Fascist

Fashion Show". Some of the outfits included a stunning hospital evening gown with matching IV bottle hat (for those long walks down the hospital corridor), three identical radiation protection-style suits with matching white boas that represented the virus (the French LAV, Gallo's HTLV-III, and the now-accepted HIV), a band aid suit representing the government's response to the epidemic and a fascist version of a safe sex bride who was wrapped in a white latex gown and sported a germ protection mask.

One of the most exciting videos in the series was Gregg Bordowitz and Jean Carlomusto's *Seize Control of the FDA* in which a coalition of AIDS activists shut down the Food and Drug Administration headquarters in Rockville, Maryland because of its murderously slow approval of AIDS drugs. The interviews with members of ACT UP/NY were highly informative and relatively free of complicated jargon making this video the perfect initiation for new activists. *Seize Control* is proof positive that the AIDS activist movement is the most energetic and productive grass roots movement that has ever existed (in less than one year after this action, ACT UP has begun to call the shots within the FDA rather than banging on the fortress doors from the outside.) The only flaw in this video lies in the soundtrack in which homophobic Public Enemy performs "Don't Believe the Hype." Which brings me back to the beginning of this story (when I was hopping mad, remember?): Lesbian and gay culture is forced to exist outside an ever oppressive heterosexual framework. After leaving the Anthology Archives and coming home to my own tv I turn on homophobic Pat Buchanan on CNN, homophobic Guns 'n Roses on MTV, and homophobic sitcoms that rarely, if ever, present a positive image of a lesbian or gay character. What the fuck is going on here? Do I exist or what?

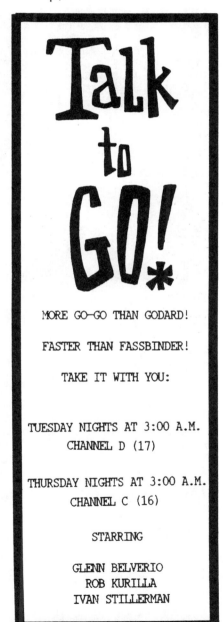

MORE GO—GO THAN GODARD!

FASTER THAN FASSBINDER!

TAKE IT WITH YOU:

TUESDAY NIGHTS AT 3:00 A.M.
CHANNEL D (17)

THURSDAY NIGHTS AT 3:00 A.M.
CHANNEL C (16)

STARRING

GLENN BELVERIO
ROB KURILLA
IVAN STILLERMAN

KLAUS
VON ERSTEN
PRESENTS

METROPOLIS
Fridays Only!

FEATURING:

- **HOUSE**
- **TECHNO**
- **NEW-BEAT**
- **ACID HOUSE**

AT LAST IT'S HERE ...

2000 LONG BEACH ROAD
ISLAND PARK, NY (516) 431-5700 - 1

This photo was not taken in our Black and White Photobooth

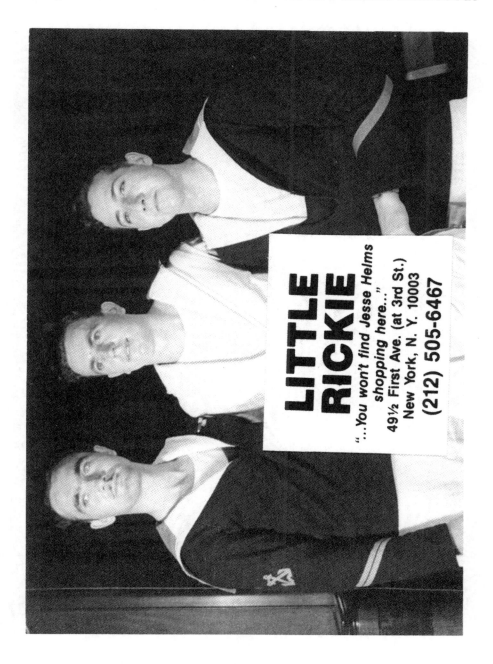

Don't forget to come get your free 6th annual

Glow-in-the-Dark Calender

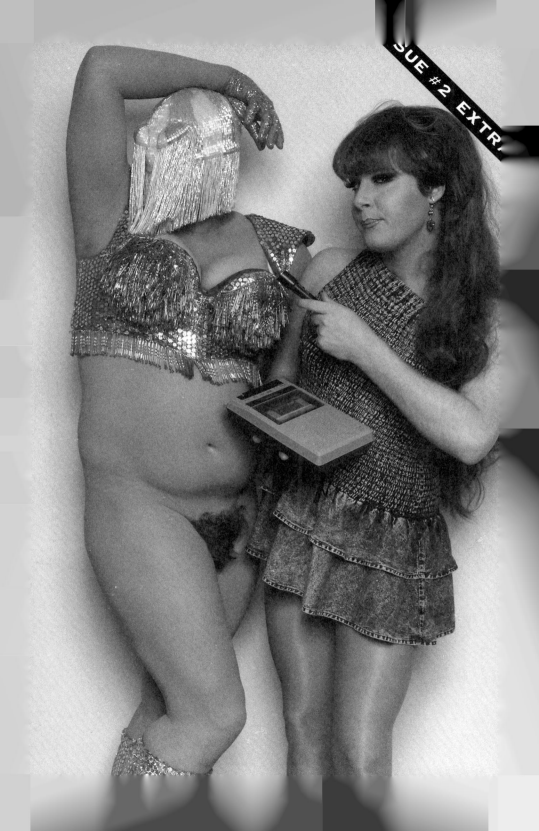

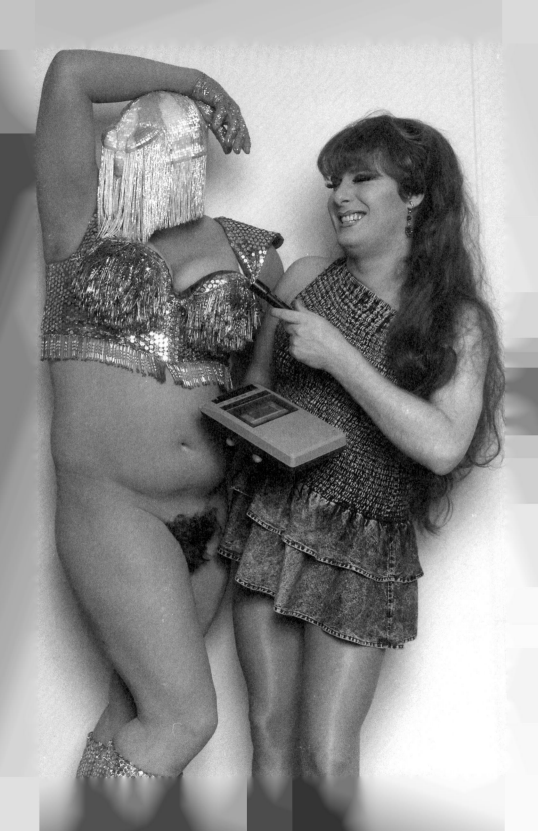

At the Pansy Beat shoot, Leigh Bowery was posing up a storm and literally rolling on the walls. Bunny was hamming it up as well and it was hilarious to watch them vie for attention, both being such characters. When they left, the walls of my apartment appeared as if someone had taken an enormous, powder puff and pounded them with orange, because every inch of Leigh's visible flesh was covered in theatrical pancake make-up. Also if you look closely at the photos, it appears as if Leigh is wearing glitter gloves but in fact, his hands are sprayed with glue and sprinkled in gold glitter. The Pansy Beat centerfold artwork of Leigh Bowery was included full page in the first ever complete monograph on his life published by Violette Editions in 1998.

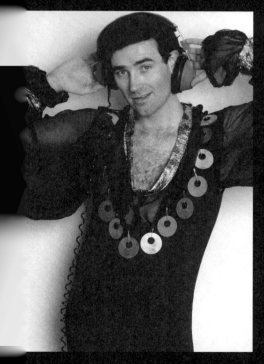
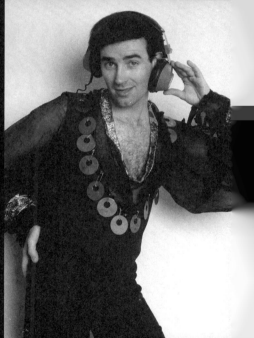

LARRY TEE

These photos of Larry Tee were used as reference for Michael's illustration in Issue #2's Celebrity Faves on page 198. Larry is also featured in the comic strip Bunny Tales, on pages 186-188, as a fox, along side RuPaul and Lahoma Van Zandt.

3

**OUR THIRD
ISSUE
◆ A CHARMER ◆**

PANSY BEAT

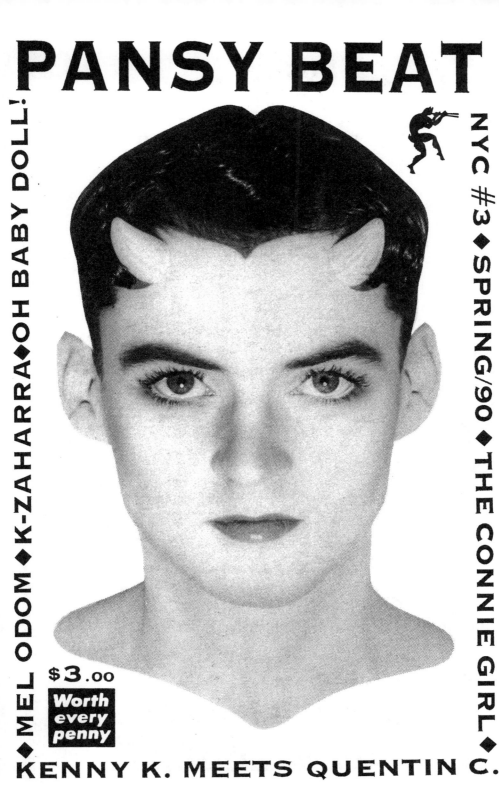

NYC #3 ◆ SPRING/90 ◆ THE CONNIE GIRL ◆ C.

◆ MEL ODOM ◆ K-ZAHARRA ◆ OH BABY DOLL!

$3.00

Worth every penny

◆ KENNY K. MEETS QUENTIN C.

HOUSE OF *Field*

Patricia Field
TEN EAST EIGHTH STREET
NEW YORK CITY 10003
254-1699

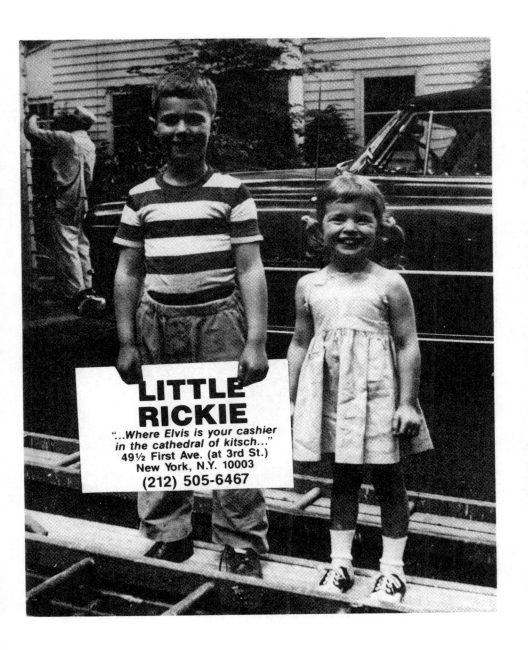

Dear Readers,

Here we are blooming into spring with our third and best issue yet. Even as we on this planet are not human "beings," but human "becomings," Pansy Beat is not new and improved--it's new and improving! Thank you all for your patronage.

p. 46

editors
DONALD CORKEN
MICHAEL ECONOMY

contributing editors
MICHAEL FAZAKERLEY
COLE SLAW

contributors
AARON COBBETT
THE CONNIE GIRL
ENDIVE
BILLY ERB
KENNY KENNY
K-ZAHARRA
LYPSINKA
NAO NAKAMURA
MEL ODOM
CHIP WASS

p. 30

special thanks to
MICHAEL ALIG
JOHN BADUM
MATTHEW KASTEN
ALBERTO ORTA
PHILIP TENER

Our cover pan is fab make-up artist Billy Erb who has flown off to Berlin to **bee** with his **honey**. Photo by Michael Fazakerley.

p. 27

published by
PANSY BEAT PRODUCTIONS
184 9TH AVENUE, N.Y.C.
10011
copyright 1990

p. 36

THE
Connie Girl

p. 48

p. 20

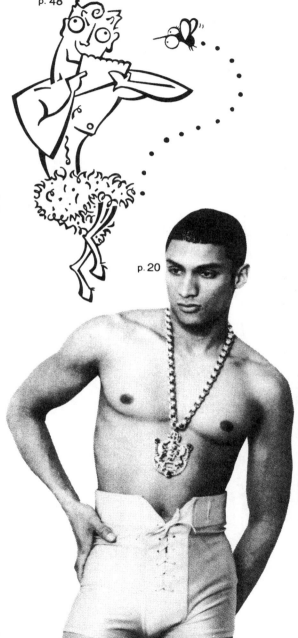

ST.

p. 57

THIS IS
TOMMY

CLOTHIER
NEW REPUBLIC
NEW YORK

93 Spring St. New York, N.Y. 10012 212 • 219 • 3005

Na Na

414 AMSTERDAM AVE
NEW YORK NY 10024
212-496-2955

THOSE OBSCURE OBJECTS OF DESIRE

By Donald Corken

Lady Head - the words are cozy, yet glamorous, like those coveted objects themselves, conjuring up images of Grandma's kitchen windowsills while evoking that certain "star quality" of an age gone by. But these "ladies" are still very much with us, gracing the homes of many a modern New Yorker. For if you haven't the good fortune to inherit one from *your* grandmother, they are still out there for the taking, at flea markets and antique "malls" throughout the country.

There is some dispute over exactly what these ceramic *objets* are for. Some maintain that they were meant to be vases for small bouquets of flowers, while others contend that they were once holders for hat pins. In fact, there is even some discrepancy over what to call them. Although most people use "lady head," there are those who prefer the more pedestrian term "head vase." Whatever the manufacturer's practical intent may have been, I consider them art. Yes, they're cheap and mass produced, but if beauty is in the eye of the beholder, then surely value is in the mind of the owner. And I wouldn't trade my lady head collection for all the Dresden china in . . . well, Germany!

There are rumors that some lady heads were patterned after the likenesses of famous women. As they were manufactured from the 1940's through the 1960's, we might find anyone from Ginger Rogers to Jackie Kennedy immortalized in cheap porcelain glaze. I myself own a red-headed vase that is a dead ringer for Lucille Ball. But I prefer the more generic anonymity of the majority that I've come across, their blank stares gazing at nothing in particular, their vacant countenances ours to fill in.

But let me get to the point of my story. Any Tom, Dick, or Harry can fork over forty dollars or so for a lady head, at, say, the Sixth Avenue flea market almost any Sunday of the year. This method is gratifying certainly for those who choose to indulge in it, but far from adventurous. Or clever. No, the true joy of "lady heading" is when you find these little gems nestled among dusty jelly jars and some old granny's bifocals at a *real* flea market. That is, a flea market found almost anywhere outside this Tri State area of ours, where lady heads go for anywhere from twenty-five cents to ten dollars.

Be that as it may, it is not just for such a vulgar reason as price that I prefer the less illustrious flea markets of our more rural areas. No, it's for the thrill of the hunt. As time goes by, more and more lady heads are being snatched up, and while there are still plenty to go around, it might take more than one trip to unearth these treasures.

And when the happy "head hunter" brings his prize catch home to join the other "ladies in waiting," he has not merely one more knickknack to dust, but a momento of a certain day as potent as any snapshot. For when I look at, say, my white and pale green pompadoured 40's lady head, I remember the day I bought her in 1977 at the Washington Courthouse, Ohio flea market. And a pink-hatted

brunette reminds me of a winter day in 1981 at a yard sale in Somerset, Kentucky, where I was visiting my grandmother. A pearl drop-earringed dazzler was given to me by a friend on the occassion of my twenty-fourth birthday in 1984. And so on. Lady heads--a shelf full of loveliness, a lifetime of memories.

DETENTE

96 EAST 7TH STREET, NEW YORK, NY 10009
PHONE:(212)529-7323 FAX:(212)529-7318

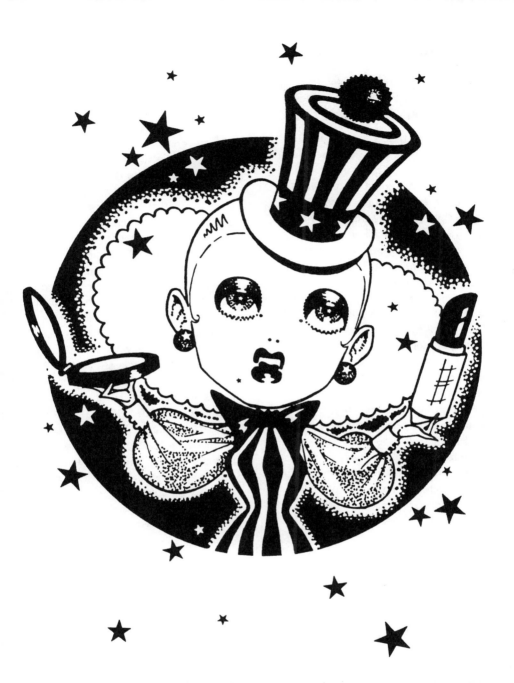

H·Y·STERICS

93½ EAST 7TH ST., N.Y.C. 10009 TEL: (212)-505-9893

MEL ODOM

By Donald Corken

Mel Odom has been a leading commercial illustrator for over ten years. Born in Virginia in 1950, he studied art at Virginia Commonwealth University, continued his education at Leeds Polytechnic Institute in London, and came to New York in 1975. Since then, his work has appeared in countless magazines and he has produced several award winning book covers. In addition, he has had two collections of his work published: *Mel Odom First Eyes* and *Dreamer*. Mel's flawlessly executed pictures are often sexual, always sensual. He is a master of technique, but his work is far from academic.

Pansy Beat visited Mel at his sparsely furnished Upper West Side apartment. Surrounded by the organized clutter of various works-in-progress (not to mention a mouth watering collection of vintage Barbie dolls), we discussed Mel's life and career.

Pansy Beat: You frequently do illustrations with homoerotic overtones. Do you feel that art directors seek you out to do these because you're gay, or is it just a coincidence? Or are you just drawn to them anyway?

Mel Odom: I was real lucky. The first one of those I ever got, the first "homosexual" book was an Edmund White book called *Nocturnes of the King of Naples*. It wasn't my favorite of his books that I've read, but it was very successful and it's considered "real" literature. It was considered a serious book, and the cover was very successful. As a result, I started getting offered books by gay authors with homosexual themes that were also considered good books. And it never even occurred to me, I mean I was so happy to be getting work at that point–that's the first book cover I ever did–that it wasn't like, 'Oh, I don't want to do that, I don't want to get pigeon holed.' I mean I could have cared less. In fact, I was excited because I could do something that I thought was really beautiful and positive, and just worth doing. I know that I get offered certain books because I'm willing to do it and they know I'm gay and I'm not nervous about it. And I always consider it a real privilege because so much of the stuff is so bad. The graphics and things are so . . .

PB: Second rate?

MO: Well, yeah. Like with that book, *Carnivorous Lamb*, with the two brothers looking at each other. This was for a small publisher in Boston, and I was really not offered much money. But the book was so beautiful and I thought at least maybe a few more people will read it if I do a really beautiful cover for it.

PB: What impact do you think the quality of the cover has on book sales?

MO: A lot.

PB: So people *do* judge a book by the cover.

MO: Well, paper back sales are, and this has been studied a lot, are like 90% impulse buying. People will just pick up something because of the cover. And more and more as our culture gets visually attuned, the image gets more important.

PB: But even earlier in your career, before you were doing the book covers, wasn't a lot of your work very homoerotic?

MO: The first thing I ever did was for *Viva* magazine, and that had a naked man with an erection in it. I immediately started working for *Blue Boy* magazine after that, and I worked for them for years. And they let me do anything I wanted to do. They gave me some good fiction, and I didn't have to do any stuff I felt bad about. I did some of my best work for them. So I'm sure that's where *Playboy* saw my work.

PB: They didn't have any problem with you being gay?

MO: *Playboy* magazine has been the coolest magazine to deal with in their handling the fact that I'm gay or that some of my work is. It has never once entered any discussion or any, 'Don't make it look a certain way', 'Don't do this.' They have never treated me like anything weird in the ten years I've been working with them. I think a lot of people are willing to interpret things I do as being more [homoerotic] sometimes than certainly I intend them. On a subconscious level, I may be putting all sorts of stuff in these drawings. I hope I am.

PB: What have some of your inspirations been?

MO: Well, Walt Disney had me by the throat from the time I was a baby on. All of his movies, the way people looked in them.

T.V. magazines--a lot of magazines. Ads from the fifties--I was born in '50, so I was little. Ads with mermaids in them, things that had been humanized. Flowers that moved. There was one ad that I loved that was little bows that walked around on their tail ends and I thought that was so great. And I would make bows and pretend that they could walk around.

Aubrey Beardsley, in the 60's there

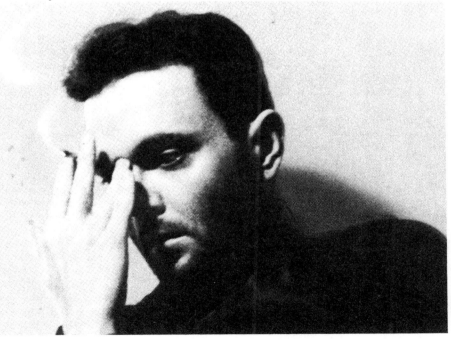

was a big revival. I flipped out for him. He was the first real name I ever became impassioned about.

Twilight Zone. Rod Sterling did more to me as a child. I think he and Christopher Lee were probably the two most responsible for my loss of sleep.

PB: So what projects are you working on now?

MO: I'm working on my new book. I don't have a publisher, but I have a wonderful writer who's going to do the forward. The name of the book is

BIRTHMARK

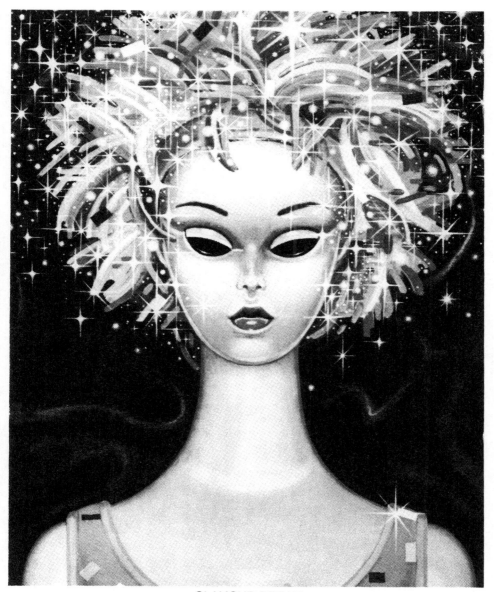

GLAMOUR DREAM

Dark Attraction, and the whole premise is the fact that, in media anyway, the villians are always more attractive. It's sort of. . . what is that thing that makes you go to movies that you know are going to scare the shit out of you and at the same time you pay for the privilege? It's an aesthetic I put into my work. I mean I try to put things in it that keep it from being saccharine-looking. Like little quirks or clues, something that makes you wonder what's going on. I think it makes people look at it for longer than they would if everything was just readily there.

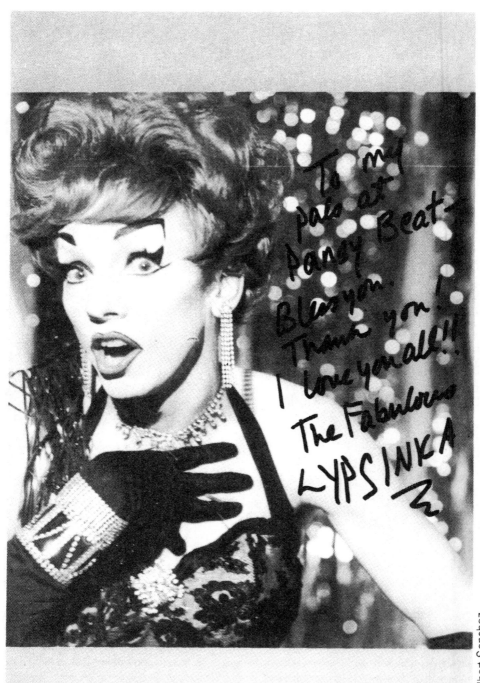

To my pals at Pansy Beat~ Bless you. Thank you! I love you all!! The Fabulous LYPSINKA

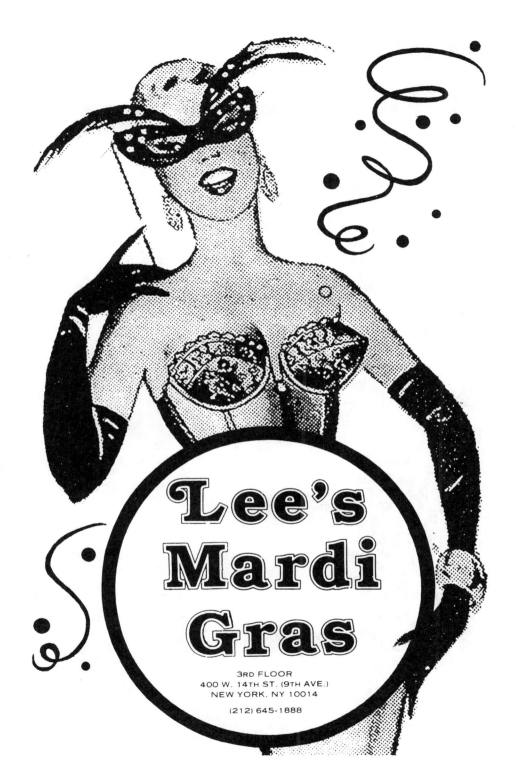

Lee's Mardi Gras

3RD FLOOR
400 W. 14TH ST. (9TH AVE.)
NEW YORK, NY 10014

(212) 645-1888

K-ZAHARRA

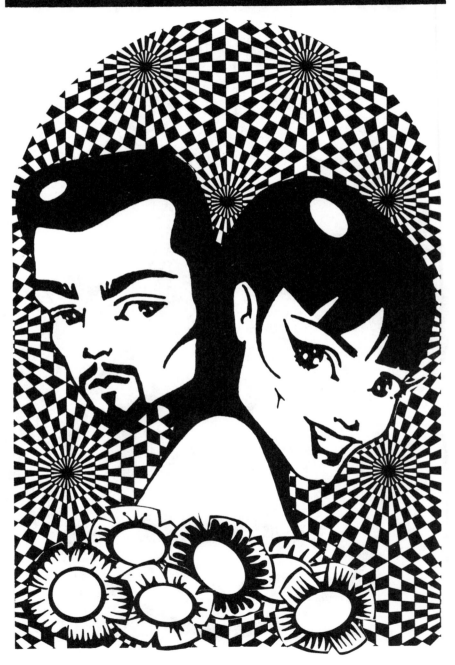

CELEBRITY FAVES

Begonia and Fernando, recently signed to Quark Records, are the sibling duo that form the Latin-house music sensation **K-ZAHARRA**. Look for their upcoming single this Spring.

BEGONIA

Sign: Pisces
Chinese Zodiac: Tiger--forthright and sensitive
Color: Bright pinkish red
Singer: Carmaron de la Isla Fairuz and Celia Cruz
Band: Pata Negra
Actor: Carmen Maura and Divine
Movie: All of Almovodar's!
Food: Spanish, Arabic
Shoe: My men's flamenco boots
Designer: Andre Walker, Tafetan, George & Johnny, Richie Cruz
Book: *A Thousand and One Nights*
Singer/Actress/Dancer: Lola Flores

FERNANDO

Sign: Gemini
Chinese Zodiac: Rabbit--talented and affectionate
Color: Blue
Singer: Perlita de Huelva
Band: Peret y sus Gitanos
Actor: Matt Dillon
Movie: All of Almovodar's!
Food: Basque, Thai
Shoe: English shoes
Designer: Andre Walker, George & Johnny, Richie Cruz
Book: Any Ernesto Sabato book
Singer/Actress/Dancer: Lola Flores

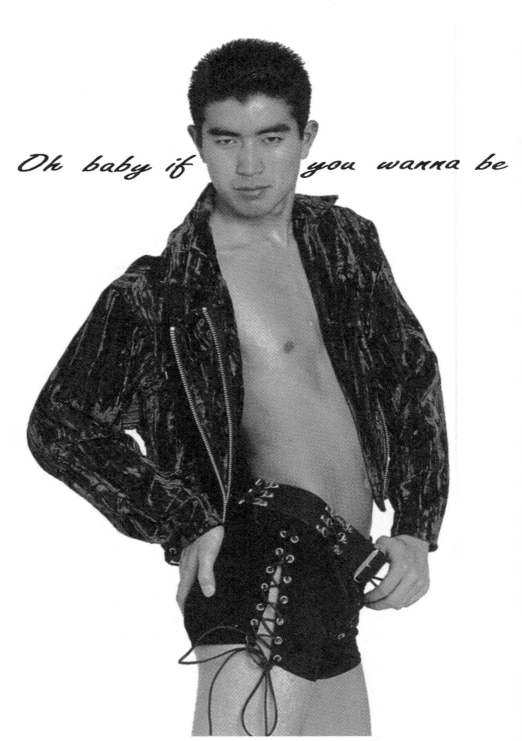

Oh baby if you wanna be

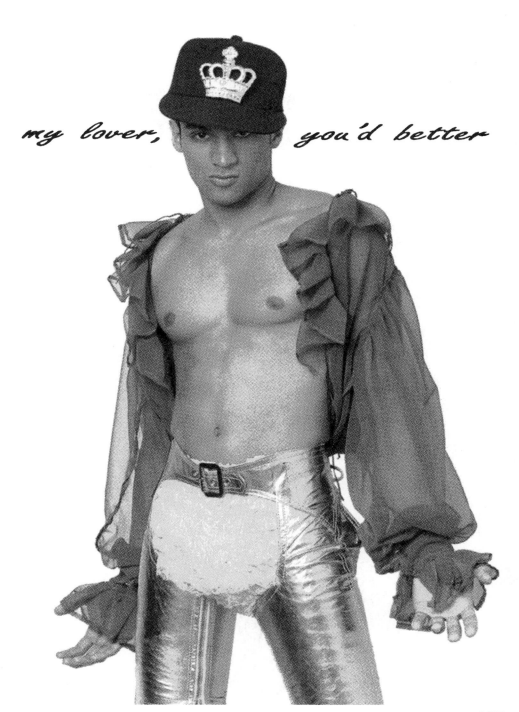

my lover, *you'd better*

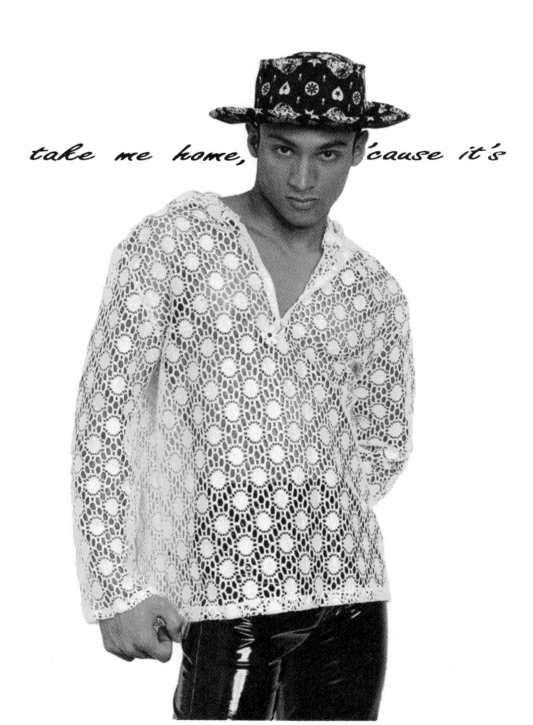

take me home, 'cause it's

a long, 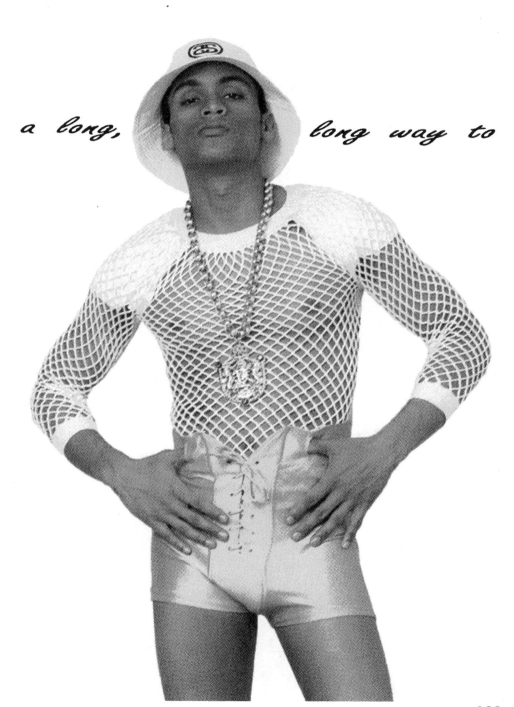 *long way to*

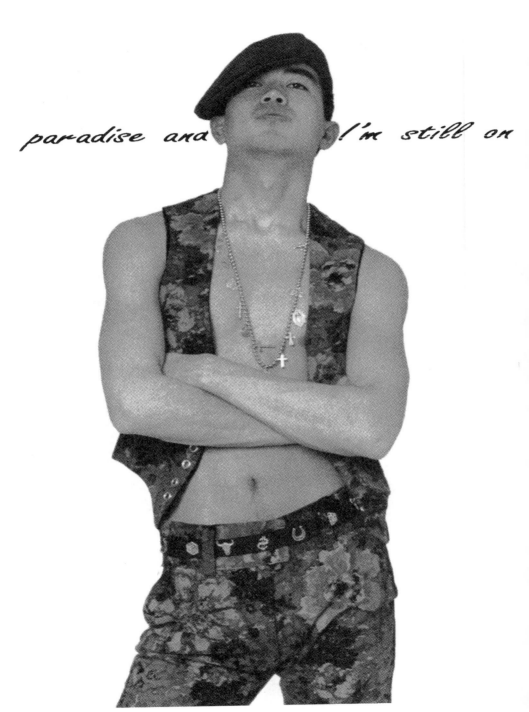

paradise and *I'm still on*

my own.

Oh baby if you wanna be my lover,

Jacket by Lip Service and hot pants by Rubio Leathers. Both from Patricia Field. Belt from Nana.

Cap by Beat the Meat from Detente. Blouse from Greenella Thistle by appointment only 718-486-7732. Chaps by Rubio Leathers from Patricia Field. Petti-pants from Nana.

you'd better take me home,

Crusher hat by Abyss from Nana. Hooded shirt by Amanda Uprichard for Living Doll from Screaming Mimi's. Wet vinyl pants by Lip Service from Patricia Field.

Hat by Stussey, fish net shirt and football shorts all from Patricia Field. Chain medallion from Hysterics.

'cause it's a long, long way to paradise

Cap by Country Gentleman from Tokyo. Vest and pants by Greenella Thistle. Charm necklace and belt by Ian McColl from Reckless.

Big dot blouse from Hysterics. Pants from Screaming Mimi's.

and I'm still on my own.

Photos: Michael Fazakerley
Models: Javier, Shigeyasu & Giorgio
Styling: Michael Economy & Donald Corken
Lyrics from Alice Cooper's "Be My Lover"
Written by Michael Bruce

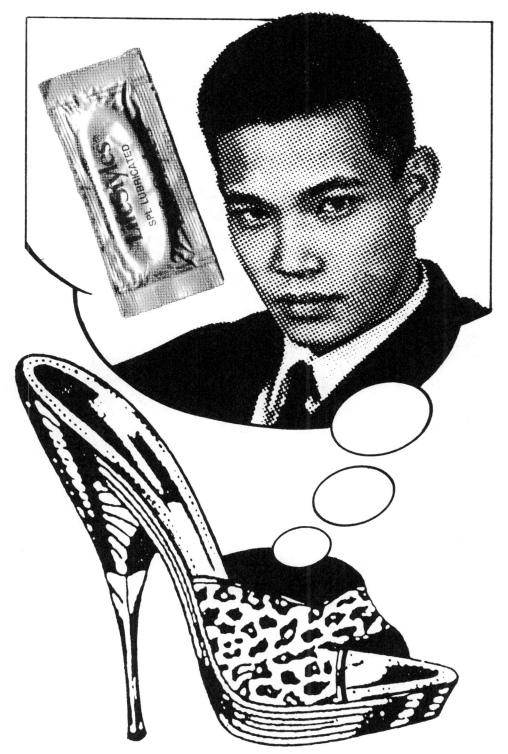

243

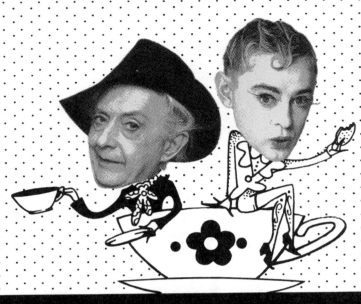

TEA WITH
QUENTIN CRISP
and KENNY KENNY

Kenny Kenny, club doorman *extraordinaire*, jumped at the chance to meet one of his idols, fellow British expatriate Quentin Crisp. Mr. Crisp, of course, gained international fame in 1976 when the dramatization of his autobiography, *The Naked Civil Servant*, was televised. Since then, he has resided in New York and enjoys a successful career as a writer and lecturer. His latest work is *How to Go to the Movies*, a collection of his film reviews.

Kenny Kenny can be seen on Tuesdays at Love Machine and Fridays at Quick!, where he hosts Panty Girdles.

Kenny Kenny: I see you as a figure of camp, but also sort of glamorous like, say, Jean Harlow. Do you think there's anyone around today with that kind of glamour?

Quentin Crisp: I don't think people nowadays aim to be glamorous, because glamour must contain a certain amount of remoteness, or mystery. Whereas modern performers aim to be coarse and immediate and brazen.

KK: Do you think real glamour will ever return?

QC: No, I don't think it will ever return. I don't think anything ever really comes back to be the way it was

except as a kind of joke. People might return to wear imitation Victorian clothes or imitation 1920's clothes, but they wouldn't become Victorian people.

The prevailing image today is one of changing as soon as possible from any one thing to any other, and never caring whether it has any meaning or not. The idea is to be bizarre whether you really are bizarre or not. And that seems to me to be a pity with the young people. Their clothes are interesting and amusing and startling, but I don't know that *they* are interesting or startling. I think they cast about for something to do or wear or say without really deciding whether it represents *them*.

KK: I get the feeling that you were sort of an outcast when you were growing up. Did this have anything to do with your determination to be true to yourself, to only do what you wanted to do?

QC: Well I *was* an outcast. It's not difficut to be an outcast in England, especially in the suburbs. I was born in the suburbs to middle class people who only ever know people like themselves and therefore, the slightest variation caused them to be in a panic. But there was no way in which I could disguise myself as a real person, it would never have worked. I mean I am speaking of a long time before I plucked my eyebrows or any of that rubbish. I was a failure as a schoolboy.

KK: But I see you as a survivor, someone who has carried on and become something people can admire.

QC: Well, I think it's only here, in certain parts of New York, really Manhattan. You see, when the English say America they mean New York, and when they say New York, they mean Manhattan. It's here that I'm allowed to behave in the way I do.

KK: I don't know, I think even someone like my mother would accept you because you're such a strong person, strong but not threatening.

QC: Some people of course always have recognized that there was no other way I could behave. When I was in court one of my friends was sitting next to a stranger and halfway through the trial the stranger said [affecting a Cockney accent] 'They can't do nothing with him, he can't help hisself. You can see that.'

KK: How do you feel about the time you were on trial and the sort of lifestyle you lived? I see it as being sort of the most outside of society you can get. Do you feel you were pushed into it, and are you regretful?

QC: Not really, I don't think it's any good regretting anything. The life *was* forced upon me. I couldn't live any other way, and inevitably it limited my life.

I think that you have to live as though you might only have one thing you really want. And what I came to want was my social freedom, and for that I had to give up being rich or having friends, or anything, really. I just lived that life because that's the only way I knew how to.

KK: I see it all as being glamorous in way. Did you think so?

QC: I didn't think of it at the time as glamorous, I thought of it as dangerous. Because in London, if you are conspicuously effeminate you are in danger. All the time.

KK: What made you come to

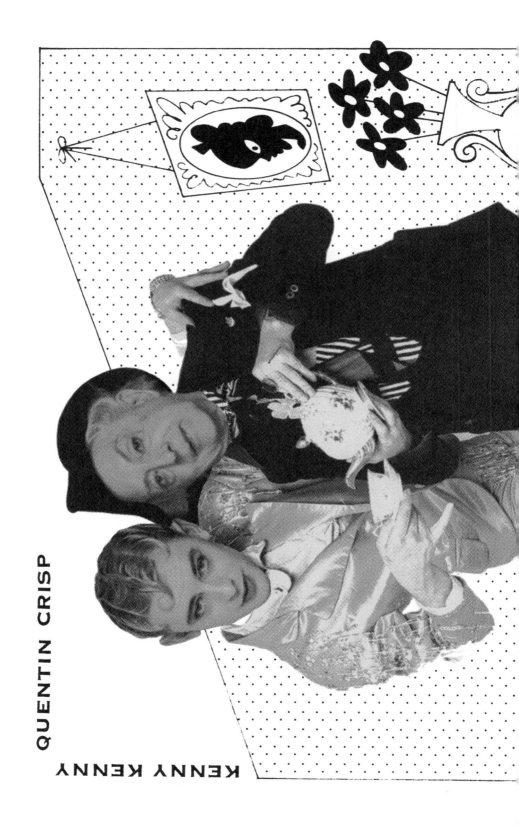

QUENTIN CRISP

KENNY KENNY

Photo: Michael Fazakerley

America?

QC: People have said to me, 'If you're so mad about America, why didn't you come here years ago?' And the answer is I couldn't have paid my fare. I never earned more than 12 pounds in one week in my life. So I had to wait.

KK: Why didn't you like London?

QC: Well, I didn't like London because nobody is your friend. Here, absolutely everybody is your friend. Your eccentricities in America are a joke, whereas to the English, they are in some way a sin. People used to come up to me in the streets of London with their faces six inches from mine and say, 'who the *hell* do you think you are?' Here they make fun of me of course, but it's lighthearted. The other day I was waiting for a bus on Third Avenue and a black gentleman saw me and said, 'Well my, you've got it all on today!'

KK: Are you a citizen now?

QC: No, I'm a resident alien, which is all I am anywhere in the world.

KK: Is there anything going on, any new person or thing, that excites you or inspires you today?

QC: Well, no, I'm beyond the age where you can get excited. My only pastime is people. I only do the writing to make some money. If I didn't have to do that I would spend my time either in my room or with people.

KK: You have a certain way of dress that doesn't vary, that you've sort of carried on as your style.

QC: That's true, I don't ever decide to startle the neighbors by doing anything really strange. For one thing, everything I have on at this moment someone gave to me. I never spend money on clothes. So I tend to wear what I'm given.

KK: But clothes are important to you?

QC: I suppose in a way, yes.

KK: I mean, I can't imagine you coming out of your house without your cravat, without your hat.

QC: I very seldom do, that's true. You come to have a vision of how to represent yourself to the world. And I suppose that's what I do. I wish everybody did it. Because the whole point of your appearance is that it cuts away the dead wood of human relationships. It means you don't have to put up with any of those generalizations. Nobody ever talks to me about the weather.

KK: How do you feel about men sexually? Do you have any advice for me, being a queen, on how to get a man? Any words of wisdom?

QC: I don't think I have. Of course I'm now not sexually interested in anybody, nor have I been for many a long year. In a time gone by, by some sort of luck I suppose, I was attractive to men who I found attractive. I haven't thought about it 'til now, but very tough men were attracted to me, momentarily, but they were. And I think I would have felt very lonely if I had had no effect on them whatsoever.

KK: Did anybody ever break your heart?

QC: No, I don't think my heart is breakable. Although people are my pastime, I don't reside my life in anybody else. I've known from the moment I left home I was alone. 𝄐

Redacted by DONALD CORKEN
Teapot & cup courtesy of **Somethin' Else!**

SISTER DIMENSION
KENNY KENNY
BELLA BOLSKI
at

Quick!

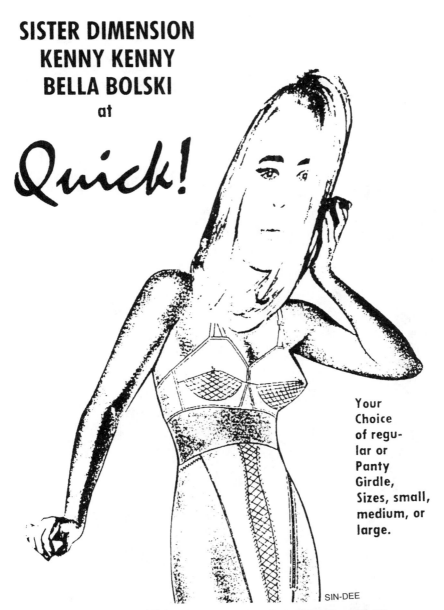

Your
Choice
of regu-
lar or
Panty
Girdle,
Sizes, small,
medium, or
large.

SIN-DEE

PANTY GIRDLES
(for ladies and gentlemen of all sizes)
157 HUDSON STREET
NEGLIGÉE ENTRANCE

THE *Connie*

HIGH

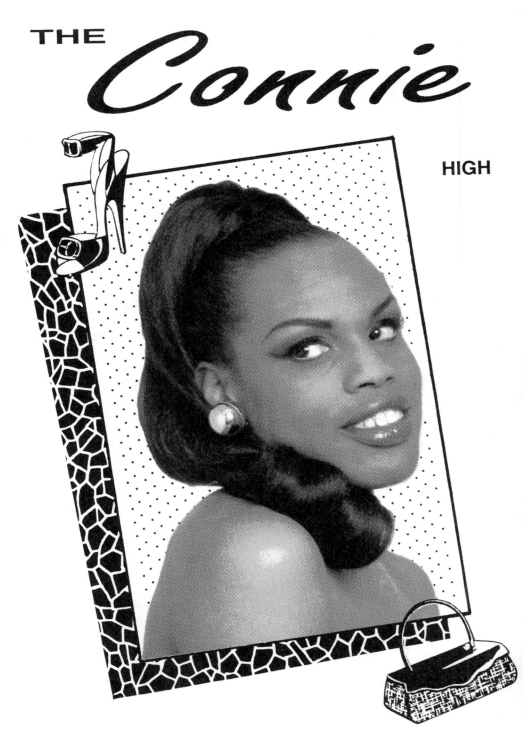

Hair & Makeup: Billy Erb

Girl ®

FASHION RUNWAY MODEL

NOW SHE'S A DOLL

And you too can play high fashion stylist with THE CONNIE GIRL in your very own home! This eleven and a half inch doll made of fleshtone plastic is patterned after the exotic boybar beauty, THE CONNIE GIRL. The ultimate haute couture model comes equipped with moveable head, arms and legs that make it easy to dress her up in these exciting outfits. . .

Photos: Michael Fazakerley

251

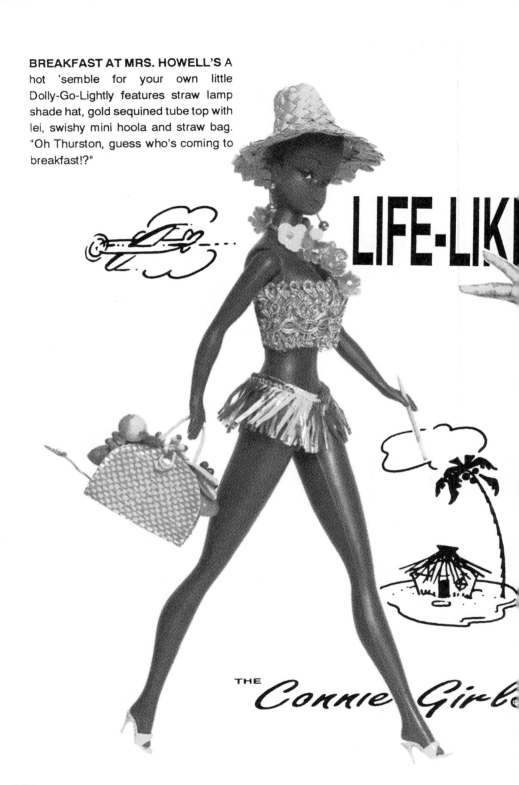

BREAKFAST AT MRS. HOWELL'S A hot 'semble for your own little Dolly-Go-Lightly features straw lamp shade hat, gold sequined tube top with lei, swishy mini hoola and straw bag. "Oh Thurston, guess who's coming to breakfast!?"

LIFE-LIK

THE *Connie Girl*

UNWAY POSES

GREASE IS THE *WORD UP* And Connie's striking an ultra-retro chord in this day glo pink "Card Shark" bra top with Katy-K's acid lime green ruffled clam diggers. Both from Screaming Mimi's. TWANG!

AND
SHE CAN
EVEN DO SPLITS
JUST LIKE THE REAL

Connie Girl®

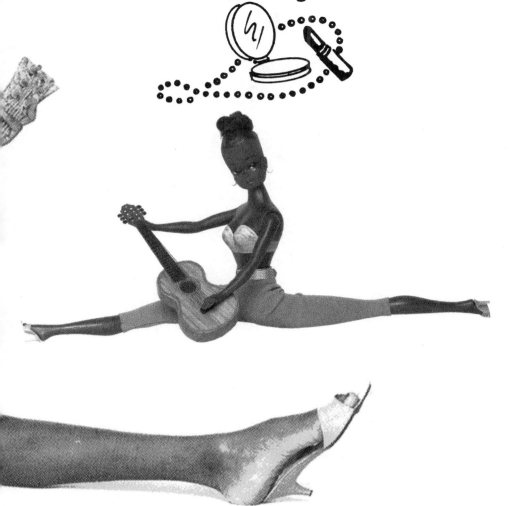

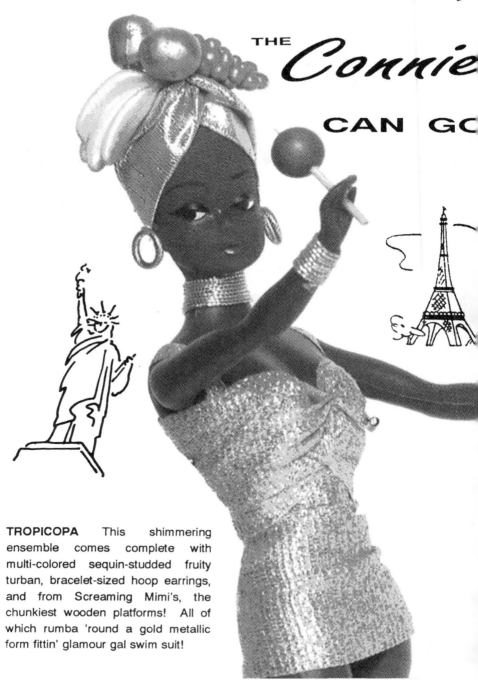

TROPICOPA This shimmering ensemble comes complete with multi-colored sequin-studded fruity turban, bracelet-sized hoop earrings, and from Screaming Mimi's, the chunkiest wooden platforms! All of which rumba 'round a gold metallic form fittin' glamour gal swim suit!

PARIS, TOKYO,

Girl ®

ANYWHERE

YOU GO!

CHICA-CHICA
CHICLETTE

MADE IN HONG KONG

By Michael Economy

ENIGMAS IN MY UNIVERSE

By Cole Slaw

Enigma for the spring: What's in a name? The reason I ask this enigma is because some among us oppose using the word pansy as a label for homosexuals. I can certainly understand the argument that since it is a word used derogatorily against gays, if we include the same word in our vocabulary, we are belitting ourselves. The intelligent side of my brain understands this logic, but alas, it is the wild and contrary other side of my brain that throws in, "Yeah, but what's in a name in the first place?"

Taking this stance, let us see if we can gain any insight by zeroing in on one word, pansy perhaps, and let us explore what one word can mean. PANSY. It is also a flower, not really my favorite flower but the delicate creatures are very stunning and colorful when clustered together. I know this from my many visits to Opryland U.S.A. That park has pansies all over the place, but I don't think that is the issue at hand.

Let me throw another enigma at you: Would it matter if a different flower was used to slur gays? Maybe gays are offended by the use of the word because the pansy is too delicate and wilts at the drop of a hat. There might be other species of flowers more suited to today's hard-shelled world.

How about calling all gay men 'rosies'? No, it reminds me of that mentally ill woman on those television commercials. You know, the woman whose world revolves around the worship of paper towels. Gays do not need that kind of association. What about birds of paradise? No, too long. How 'bout lilies? Would you rush to *A Different Light* for your latest issue of LILY BEAT? On second thought, lilies are fairly fragile flowers too. What about mums? They do have strong stems and they hold up against cheer leaders remarkably well. (As you know, you can't be a gay man and be affected by bouncing breasts.) Granted, mums are stout bloomers, but MUMS BEAT? I think not.

I must admit I don't feel any closer to solving my spring enigma. Possibly if we dig a little deeper into the meaning of names. But just how deep do names get? I suggest we approach this stubborn enigma from a different angle. People create words, so let us explore what words mean to people. I'll go first.

In the small Tennessee town where I blossomed into gayhood, there is a phrase to describe an apparently socially accepted behavior that is, I believe, common throughout the world. I'm speaking of *name callin'*: The practice of using words, usually spoken in a snarling manner, to try and inflict pain--albeit mental--on another person. Name Callers have a virtual endless supply when it comes to picking their ammunition of choice. Speaking from my own experience, I don't remember being name called a pansy in my youth but the word sissy came up about two hundred more times than I would have preferred. It was the *way* the word was spoken, not the word itself that . . . Ah-ha! Have I hit upon the answer to what is in a name?

How many of us heard or even said while growing up, 'sticks and stones may break my bones but names will never hurt me'? I suppose I never understood what that cliche meant during those years of never fitting in with the "boys do this" program. Words *did* hurt--more piercing than any Ginsu kitchen knife. I think what I understand now, that was too hard to comprehend then, is that words themselves float harmlessly in the air and sit motionless on the page and what gives words meaning are people. But then again, what really matters to me more than a word spoken by another is the face that looks back at me in the mirror, no innuendos, no bigoted tones, but that face and what I see in it.

I concede that the people who enjoy the sport of name callin' have the right, but I don't have to become upset due to their stupidity. Just because I am a grown man who still likes to play with dolls and occassionally enjoys pretending to be the ghost of Marilyn Monroe having a group birthday party for Jack, Bobby, Martin and Abraham, doesn't mean I'm inferior. Crazy maybe, but not inferior. So, if name callers want to call me a pansy, fine. For in Cole Slaw's mental dictionary, I see the word: PANSY \'pan-ze\ 1: an extraordinarily beautiful, handsome and vivacious man; usually a creative, artistic type--sought out as guests for cocktail parties 2: a pretty flower found at Opryland U.S.A.

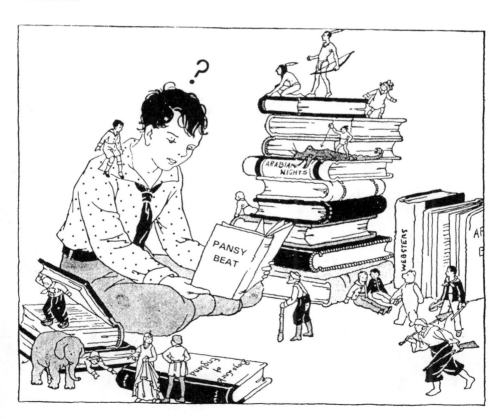

a Spring field of Pansy's

When you think of a bombshell, you think of Monroe or Mansfield, you don't think of a three-hundred pound man. People like to be shocked.

DIVINE
1945-1988

When traversing a world of unceasing flux, the only thing of importance is to radiate beauty.

YUKIO MISHIMA
1925-1970

I have been perfectly happy the way I am. If my mother was responsible for it, I am grateful.

CHRISTOPHER ISHERWOOD
1904-1986

If you removed all of the homosexuals an
regarded as American culture,　you would be pretty

The only way to get rid of temptation is to yield to it, resist it and your soul grows sick with longing for the things it has forbidden to itself.

OSCAR WILDE
1854-1900

Whatever the public blames you for, cultivate it: it is yourself.

JEAN COCTEAU
1889-1963

...mosexual influences from what is generally ...uch left with Let's Make a Deal. FRAN LEBOWITZ

Coming Soon ... Gay Sundays!

HEALTH • EDUCATION • AIDS LIAISON

For Information about non-toxic interventions for the immune system during the current AIDS crisis

Come to a HEAL Meeting Every Wednesday 8:00 to 10:00 PM

▼ at the ▼

Community Center 208 West 13th Street Manhattan

or Call **212/674 • HOPE**

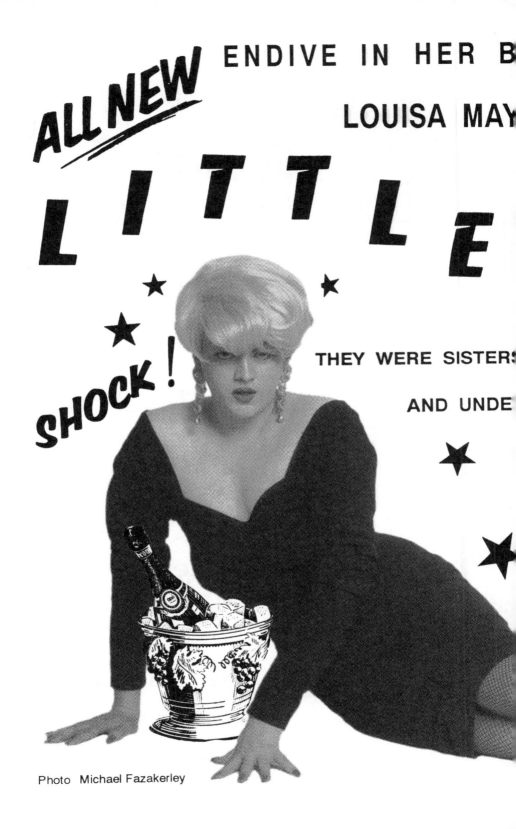

ALL NEW

ENDIVE IN HER B

LOUISA MAY

LITTLE

★ ★ ★

SHOCK!

THEY WERE SISTERS

AND UNDE

★ ★

Photo Michael Fazakerley

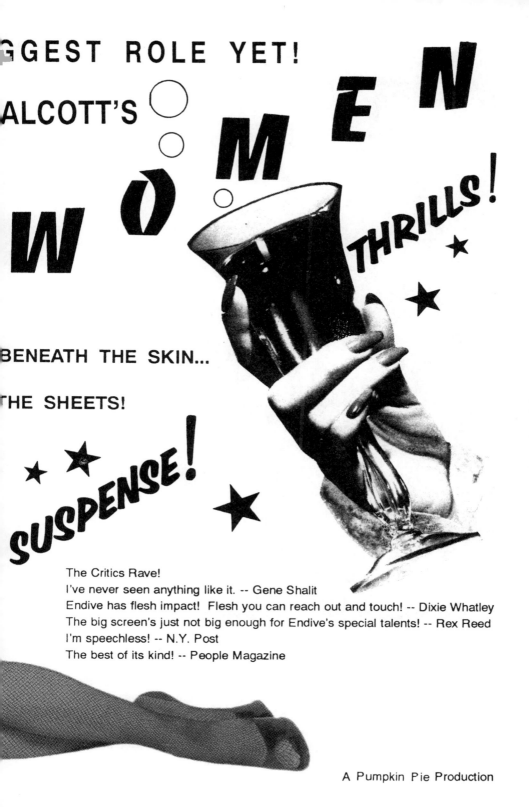

GGEST ROLE YET!

ALCOTT'S

WOMEN

THRILLS!

BENEATH THE SKIN...

THE SHEETS!

SUSPENSE!

The Critics Rave!
I've never seen anything like it. -- Gene Shalit
Endive has flesh impact! Flesh you can reach out and touch! -- Dixie Whatley
The big screen's just not big enough for Endive's special talents! -- Rex Reed
I'm speechless! -- N.Y. Post
The best of its kind! -- People Magazine

A Pumpkin Pie Production

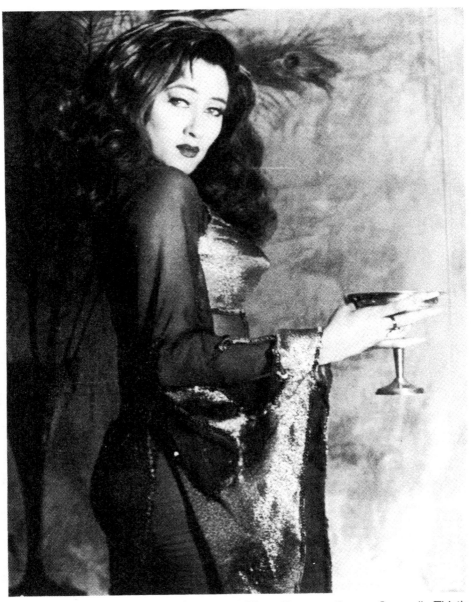

Photo: Aaron Cobbett Hair & Makeup: Thom Perry Gown: Greenella Thistle

Presenting Greenella Thistle! With her "flawless face and body and beautiful voice," her "physiognomy is a collaborative effort by a group of artists called the Cult of Beauty" headed up by Aaron Cobbett. "I am the embodiment of pure creative energy," Greenella coos, "and I have come into existence to spread the gospel of individual expression, and to use the laws of supply and demand to crush the anti-art crusade led by philistines such as Jessie Helms." Performance artist and fashion designer, some of her "fantastic fashion manifestations" are featured in this issue.

大紐育通信
FROM PANSY BEAT N.Y.

N．Y アンダーグラウンドシーンを代表するラジカル・マガジン"PANCY BEAT"からお送りする大紐育通信一。
今回は「アイ・ラブ・ルーシー」でおなじみ、おしくも昨年亡くなった女優ルシル・ボールに関する話をあれこれ…。

LUCILLE'S BALLS
by RICHARD HENKE

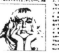

STREET CULTURE PAPER

大紐育通信
STREET BEAT FROM NEW YORK CITY

毎回N・YORK発のその街を紹介している雑号が"大紐育通信"一、なんとこのたび本誌11号で登場したN.Y
ハ゛ーク゛ラウンドペーパー"PANSY BEAT"と連載記事の転載ができる運びになりました。今回お送りするのはニュー
ヨーク・ダウンタウンのスター"レディ・バニー"のインタヴュー。最新（号の？）の新しい魅力にせまっております一。

PIN-UP BUNNY
BY JOSIAH SCHUMANN PHOTOS:MICHAEL FAZAKERLEY

ST. is Tokyo's hippest street culture newspaper

featuring interviews with the city's up-n-coming scenesters and is absolutely free.

Published monthly by **FROM GARAGE GROUP**, a Tokyo based production company, **ST.** is like a cross between *Paper* and *Project X*. **ST.** contains columns with titles like Gadget City News, Tokyo Street Syndrome and I Love Fashion Victim, all printed in color by Japanese state of the art technology.

Pansy Beat is **ST.**'s newest contributor thanks to DJ and **ST.** editor Nao Nakamura our Tokyo correspondent. Nao has been responsible for the translation and beautiful presentation of several articles from our first two issues which have appeared in **ST.**

With **ST.** newspaper timed just right with Tokyo's current club boom it's exciting to note we're sending our own particular brand of journalism to the other side of the globe.

DJ and **ST.** editor Nao Nakamura

PANSY BEAT

PANSY BEAT

IS AVAILABLE AT

THESE FINE SHOPS AND
BOOKSTORES

It's Different! **Makes You Feel Refreshed, Invigorated!**

the 'innest' thing
for NYC

SEE HEAR
59 E. 7th St.
982-6968

SLIM SLAX

BY ODMAN

**Newest, slimmest
trimmest slacks
ever!**

DETENTE
96 E. 7th St.
529-7323

NO C.O.D.'s

270

Auntie Em's Farm

RD 2 BOX 455
LIVINGSTON MANOR, NY 12758
914-439-4237

Auntie Em's Farm *was conceived as a retreat for the gay and lesbian community. As many of our friends worry that they may find themselves in an awkward or inhibiting situation, we are limiting our clientele to those who, shall we say, are friends of Dorothy. Consequently we are a private club with doors closed only to those who feel the need to stare or harass.*

Auntie Em's Farm *is located at the edge of Catskill State Park, just two and one half hours from Manhattan. We feature cozy, but well appointed double rooms with shared baths, and charming country decor throughout our recently renovated farmhouse. There are nine acres of meadow and forest to meander in, as well as lovely walks and hikes through the nearby area.*

...there's no place like home

FRED HODGES HAIR EXTRAORDINAIRE

542 LaGUARDIA PLACE, N.Y.C. (212) 777-0223

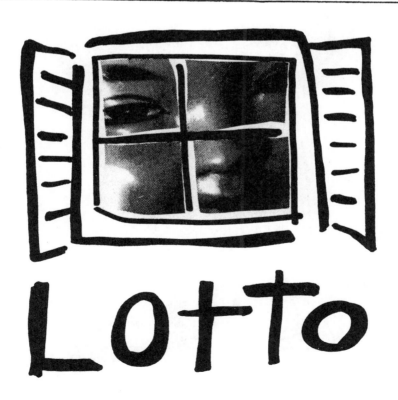

LARRY TEE'S

La Palace
De Beauté

Grand Opening
April 28th

THE HUNK CLUB
Sunday Night Parties for Men

Open every Friday, Saturday & Sunday

18th street between Broadway & Park/tel: 254-4005

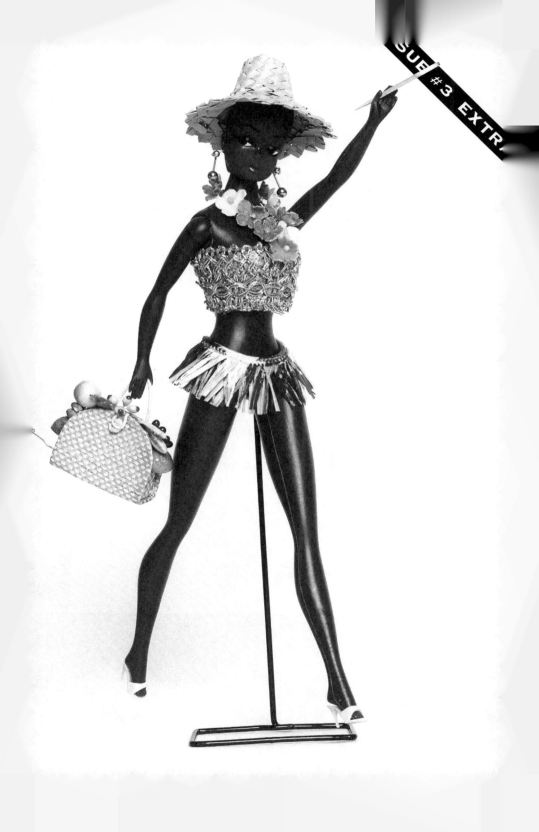

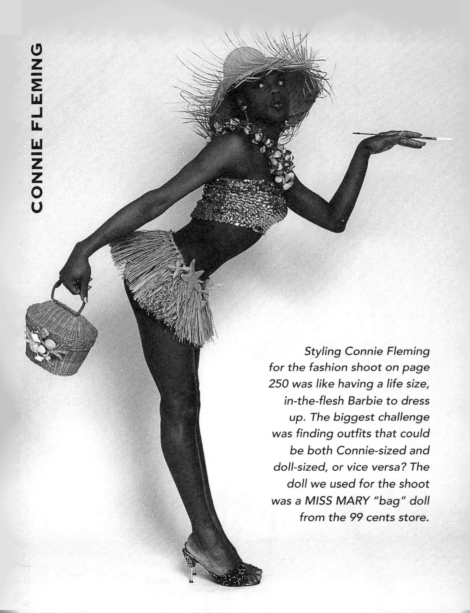

Styling Connie Fleming for the fashion shoot on page 250 was like having a life size, in-the-flesh Barbie to dress up. The biggest challenge was finding outfits that could be both Connie-sized and doll-sized, or vice versa? The doll we used for the shoot was a MISS MARY "bag" doll from the 99 cents store.

QUINTIN CRISP

Trey Speegle was friends with Quintin Crisp and asked if we wanted to feature
Pansy Beat. Donald Corken had the idea to invite Kenny Kenny to do the interv

K-ZAHARA

The irrepressible Richard Alvarez introduced us to the exciting brother/sister ho

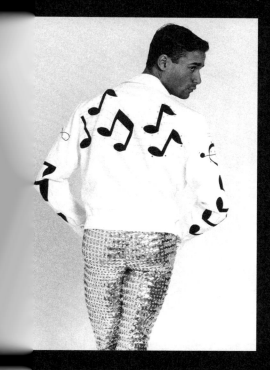
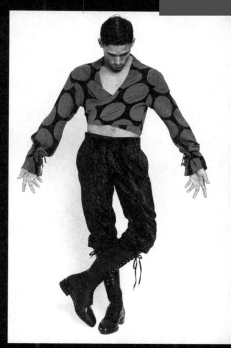
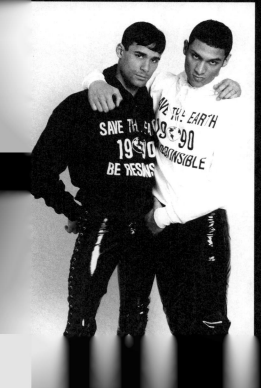
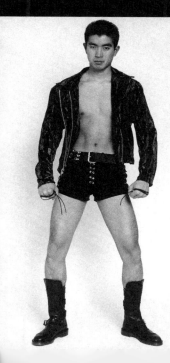

OUR
● **MAKE BELIEVE** ●
ISSUE

PANSY BEAT

NYC #4

90

$3.00

Worth every penny

PANTY GIRDLES
(for ladies and gentlemen of all sizes)

157 HUDSON STREET
NEGLIGÉE ENTRANCE

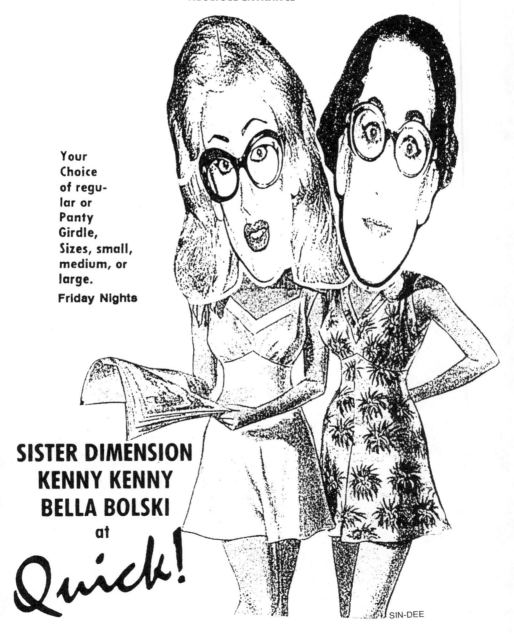

Your
Choice
of regu-
lar or
Panty
Girdle,
Sizes, small,
medium, or
large.
Friday Nights

**SISTER DIMENSION
KENNY KENNY
BELLA BOLSKI
at**
Quick!

SIN-DEE

delicious
deLovely
deLectable
DiViNE
Degorgeous
De With it
DEGROOVY
Deee-Lite

Dear Readers,

IS

MAKE BELIEVE

editor
MICHAEL ECONOMY

contributing editors
DONALD CORKEN
MICHAEL FAZAKERLEY
COLE SLAW
CHIP WASS

contributors
ROBERT ANDERSON
LADY BUNNY
LYPSINKA
SISTER DIMENSION
DUKE TODD

a special thanks to
PHILIP TENER

Our cover boy and *Slapshot!* centerfold is the fetching Jaime Roldan, photographed by Michael Fazakerley. Swim cap and bathing suit from Patricia Field. Beach ball courtesy of Little Rickie.

published by
PANSY BEAT PRODUCTIONS
184 9TH AVENUE, N.Y.C.
10011
copyright 1990

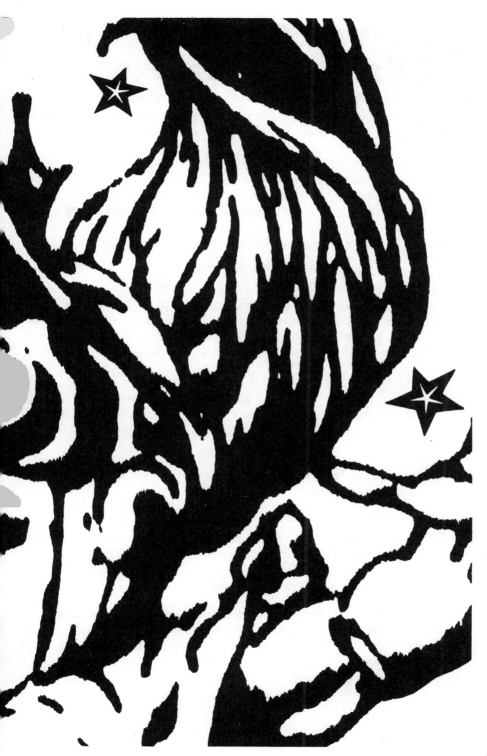

COLE SLAW'S SUMMER SCHOOL

Why wile away the summer getting skin cancer when you can expand your knowledge of the world around you? Come to **Pansy Beat Summer School**. *Enroll now!* Here's a sample of our deliciously diverse curriculum:

Global Cosmetology

A hair sprayed traipse around the world learning the do's from several nations such as the secrets of the hard to hold South African "Blood Knot" and Tibet's mysterious "Karma Hive". We will also pretend visit the chic salons of Paris and Milan!

Supplies Required: 5 gals. of hair spray, teasing comb and face mask

Capturing Your Best Side

We here at Pansy Beat U feel the poor quality of photographs we see in kinky personal advertisements is appalling. This class will show you how to pose properly by gingerly hiding those double chins and bellies and giving you the most flattering shots of yourself for future admirers. We will also touch upon the importance of proper lighting and the power of makeup and prosthetics.

Wiggle Your Way to Success

A walk is worth a thousand words? Famous writer and former Atlantic City showgirl, Danielle Collins, thinks so: "I'll show each and every one of you how to bring a fabulous party to a silent halt when you wiggle into the room!"

Spurious Cleavage 101

Want bigger breasts? Save thousands without surgery! Learn the ancient Japanese art of cleavage drawing.

Spurious Cleavage 102 (or Tittie Tapeology)

This continuation of Spurious Cleavage 101 will show you the all-important tricks of taping your chest in order to give you the fullness you desire.

Find Yourselves

Split personalities are *IN, IN, IN!* If you want to impress your friends at your next cocktail party, let Dr. Nancy Elizabeth Jill DiLoria, noted lesbian and child psychotherapist, help you discover just who you (all) are. Dr. Nancy will ease you into the process of separating your moods into distinct personalities. Dr. Elizabeth will help you with mind boggling psychotic "growth" games and Dr. Jill will be there with a hanky if it's just all too much for yourselves. Let Dr. DiLoria's team work for yours!

A Mind is a Terrible Thing to Taste--Gets you started with the vegetarian lifestyle you've been meaning to adopt.

Introduction to Tap Dancing--Burn calories and meet nellie hyperactive men all at the same time!

Puppy Love--Whether you agree or not, come listen to bestiality experts debate the issue of Real Safe Sex with representatives of the A.S.P.C.A.

See ya on campus!

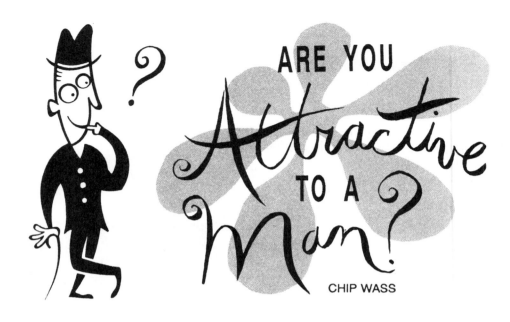

ARE YOU Attractive TO A Man?

CHIP WASS

Do you wear clothes that make you a little more up-to-the-minute than the other men in your set?

Fine; provided your taste is reliable and the clothes suit you.
Men may rant about that "crazy lid" but they beam with manly pride when their male companions arouse admiring stares.

DO YOU TELL A MAN HE IS BEAUTIFUL EVEN IF YOU FIND HIM ONLY AVERAGE LOOKING?

THIS HABIT HURTS NO ONE AND MAKES A LOT OF MEN "SWELL" WITH PRIDE.

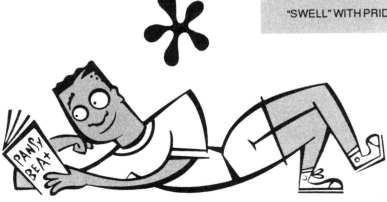

HAVE MEN ALWAYS MARVELED AT YOUR CAPACITY FOR HOLDING LIQUOR?

A GRAVE MISTAKE—THIS CAN EARN YOU A FAST REPUTATION, AND IT QUICKLY BURNS A HOLE IN YOUR POCKETBOOK.

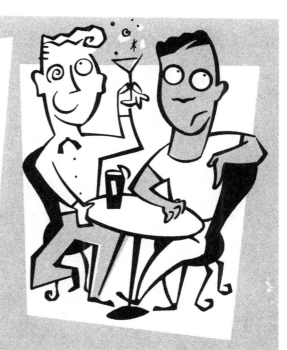

Do you keep a man interested by hinting that later—not tonight—you'll be more demonstrative?

This is a low down trick and one a surprising number of men see through at once. If you kiss a man it should be for your own pleasure and not as a reward for him.

IF YOU ARE ASKED TO PICK ANOTHER YOUNG MAN FOR A FOURSOME, DO YOU CHOOSE ONE OBVIOUSLY LESS ATTRACTIVE THAN YOURSELF?

YOU WOULD BE UNWISE TO DO SO. FIND THE MOST GLAMOROUS GENTLEMAN YOU KNOW. THE OTHER MEN WILL BE DELIGHTED.

SCREAMING MIMI'S

the Girdle of Many Colors

The American Idea...

FASHIONS THAT GIVE YOU

THE Million Dollar Look

SCREAMING MIMI'S NEW YORK / 22 EAST 4TH STREET

NEW YORK, NEW YORK 10003 / 677-MIMI

SCREAMING MIMI'S TOKYO / 18-4 DAIKANYAMA-CHO

SHIBUYA KU, TOKYO, JAPAN 150 / 03-780-4415

 including **THE KATY K BOUTIQUE**

Drag magazine, then the official voice of the Queens Liberation Front

DRAG RAGS TO RICHES

A PROFILE ON LEE G. BREWSTER

By Lady Bunny

Aw shucks! That last rousing chorus of "It Should've Been Me" had shattered yet another platform heel--even after my bikini season "slim-down"! Thank goodness *Lee's Mardi Gras* is right on my way to the pier!

Let's meet the winning personality who makes Manhattan's one-stop transvestite boutique really happen--*Miss*-ter Lee G. Brewster. Lee hails from atop Big "A" Holler in Virginia, a teensy (population 300) mining town, which fostered another noteworthy coal-miner's daughter, Miss Loretta Lynn. High-tailing it to New York, a budding Lee left Loretta and his other homespun neighbors behind in the coal dust, sporting sultry and immaculately styled human hair falls, pants-drag looks with modish low heels and the very "in" upper *and* lower lashes--the embodiment of well-turned out Southern Sass. Lower lashes aside, Lee was certainly no stranger to the other major movement of the late 1960's: civil rights. In 1969 (before Stonewall, thank you) Lee founded the Queens Liberation Front with his long time cohort Bebe, an equally vivacious sister who still works at the boutique on Saturdays when she's not teaching mathematics in drag to junior high school students.

Anyway, that's another article!

Lee remembers the "old style queen" with teased men's coiffures, light maquillage and swishy mens clothes who might otherwise be arrested if clad entirely in female attire. Honey, these girls needed to dress *all* the way up, okay? Q.L.F. began lobbying against the four administrative codes which outlawed full, public drag. Lee and company made frequent appearances (always dressed to the teeth) at various gay forums and managed to befriend a helpful government official named Bess Meyerson. Within a year and a half, they actually had all four codes removed from the books.

The Q.L.F.'s success garnered criticism from many activists within the gay community who felt that cross dressers "brought down" the tone of "their" movement. The constant voicing of this screwball opinion (still heard today from sad gays who deny their own feminine sides) eventually alienated Lee, a valuable soldier in the fight for gay lib. The conservative Gay Activists Alliance protested the TV's presence in early Gay Pride Day marches by asking the media not to photograph the TV's and also urged city officials to put the four "anti-TV" laws back on the books as a bartering device to help sell the gay rights ticket as a "whole." "They wanted to use us, the queens, as scapegoats," Lee says. When the gay rights bill did come through, Lee continues, "it was so watered down that it didn't mean much of anything."

But the Q.L.F. had accomplished what they had set out to do. Lee hit the college circuit in full drag,

DRAG

Lee G. Brewster on the Pat Collins talk show N.Y.C. early 1970's

lecturing on transvestism, where he was always enthusiastically received. ("Straights understand role playing," he says with a saucy wink.) Lee also developed *Drag* magazine in 1969 as a voice for the Q.L.F. with oodles of eye-popping photos, pageant dish and luscious illustrated covers, mingled with coverage of newsworthy events pertaining to TV's and their changing role in society.

Speaking of society, Lee was quite the hostess as well, staging elaborate drag balls with some riotous entertainment including, for all you dragophiles, impersonator Chris Moore of the famed "Jewel Box Revue," comic stripper Pudgy Roberts (with an early seventies Sister Dimension-type flair) and Adrian, whose "Dance of the Seven Veils" climaxed with her *own* climax while clutching John the Baptist's bust to "her" pelvic region; but let me stop. I don't mean to give Miss Olympia any more ideas. Lee's soirees (advertised for years in the *Village Voice* after a legal battle forced them to accept Lee's copy) continued well into the 1980's, allowing inexperienced queens to socialize with their more savvy sisters and TV fanciers, but without the lewd meat market feel of, shall we say, Sally's Hideaway?

Lee never exactly planned to become a drag entrepreneur but his many activities put him into "contact" with queens from all over and keyed him into their special needs, i.e., major-sized pumps. He began to dabble in mail order. Hell, he'd liberated the queens, he might as well keep them well shod, corsetted and coiffed--*et voila*, Lee's Mardi Gras was born! After fifteen years at the Times Square location, where he still runs a thriving TV literature shoppe (Honey, this sly fox even started her own publishing company!), he relocated to his present, convenient 14th Street address. His clientele now includes film and television wardrobe departments, female celebs like Dianne Brill and Liza Minelli, fetishists from around the country, club kids serving an adrogynous "fashion" statement and of course, show girls *gay-lore*: Hapi Phace, Ethyl Eichelberger, Ru-Paul, Lypsinka, myself and every other sasquatch ham in town. Yet Lee uses "only one percent of [his] business potential." He enjoys personally assisting his colorful customers and keeping tabs on all the girls since Miss Lee doesn't step out that much these days. Flipping through some priceless old photographs, we "accidentally" happened across a recent snapshot of an awfully attractive scantily clad young Puerto Rican stallion. (It's no wonder Lee's taken a liking to at-home entertaining.) I'm just glad that this vital, successful business woman includes a little "monkey business" in her very full agenda!

It's a pleasure doing business with ya, honey!

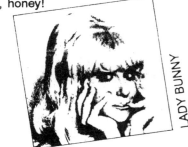

LADY BUNNY

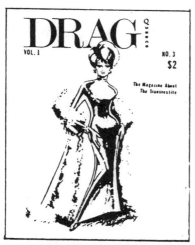
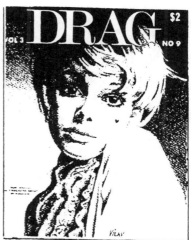
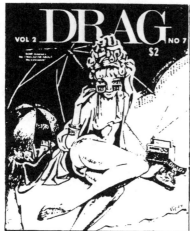
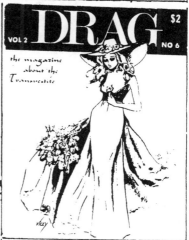
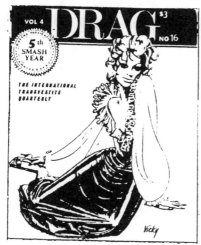
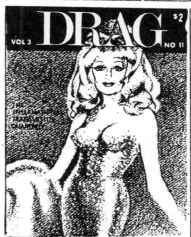

Drag mag circa early 70's featured illustrated covers by Vicky West

49 GROVE ST. N.Y.C. 10014 212-255-7955

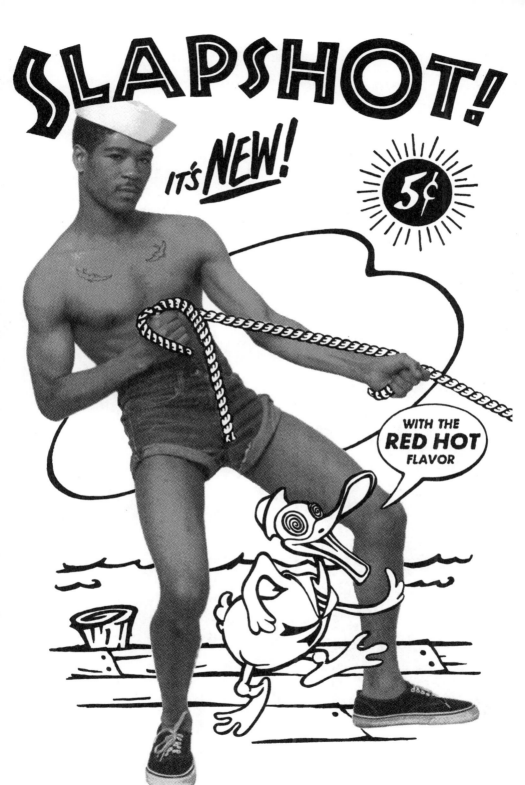

TRY
LIVING
in

Italy

See

HAWAII

Discover

Mexico

CALCULATED·TO·ATTRACT·

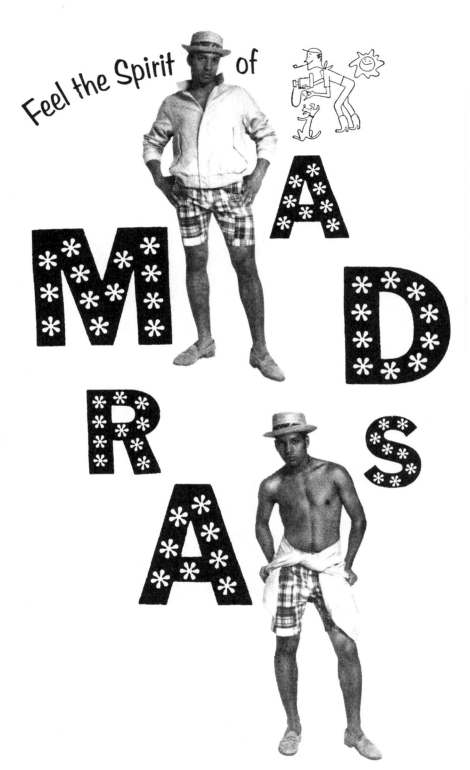

Feel the Spirit of

MADRAS

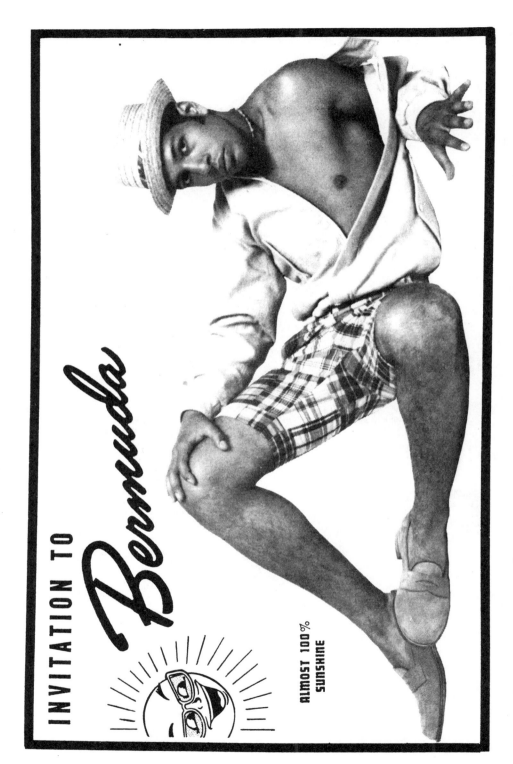

INVITATION TO *Bermuda*

ALMOST 100% SUNSHINE

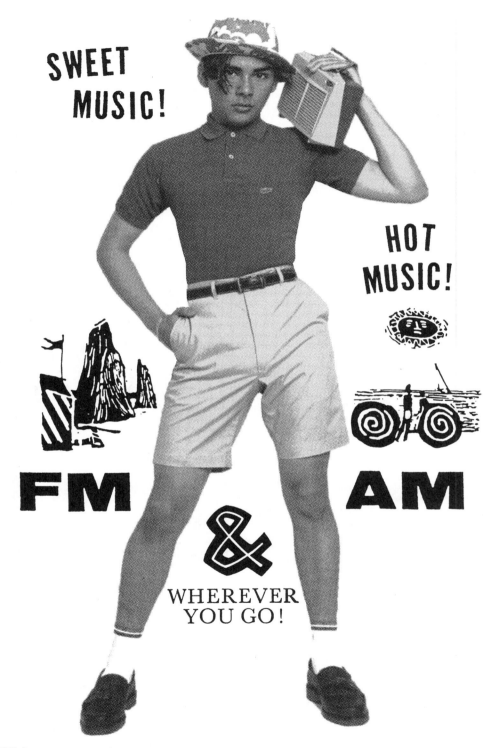

Javier wears shirt from *Screaming Mimi's*. Bermuda shorts from *New Republic* and shoes from *Nana*. p. 20

Burt wears sun visor and slacks from *Cheap Jack's*. Lei from *Little Rickie*. Adidas sneakers from *Patricia Field*. p. 21

Javier wears hat and shoes from *New Republic*. Shirt and shorts from *Cheap Jack's*. p. 22

Elias wears shirt from *Cheap Jack's*. Jeans from *Patricia Field* and shoes from *Nana*. p. 23

Elias wears hat and Bermuda shorts from *Screaming Mimi's*. Silk jacket from *Patricia Field*. Loafers from *New Republic*. p. 26 p. 27

Danny wears cap from *Patricia Field*. Chemise Lacoste stylist own. Bermuda shorts from *Screaming Mimi's*. Shoes from *Nana*. Socks from *Paragon*. Radio from *Little Rickie*. p. 28

Javier wears cap and swim suit from *Patricia Field*. Shirt from *Hysterics*. p. 30

Photos: Michael Fazakerley
Models: Jaime, Javier, Burt, Elias,
Danny and Joey
Produced by: Michael Economy

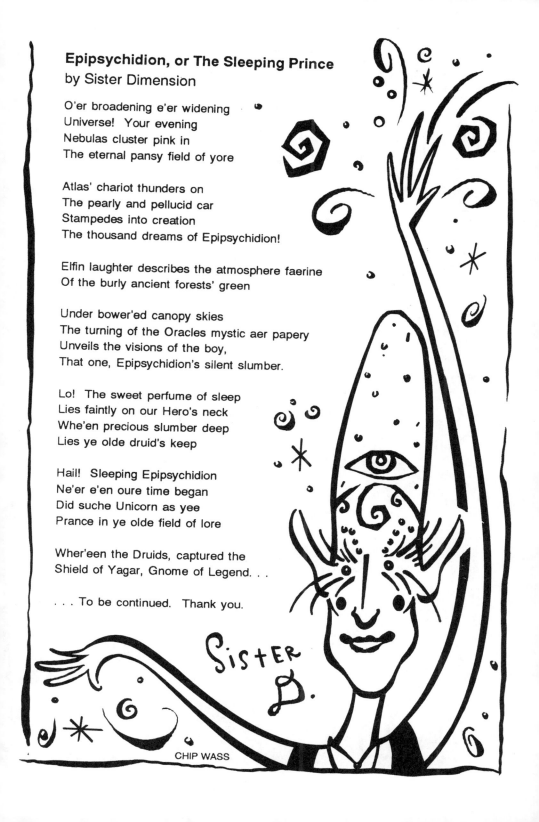

Epipsychidion, or The Sleeping Prince
by Sister Dimension

O'er broadening e'er widening
Universe! Your evening
Nebulas cluster pink in
The eternal pansy field of yore

Atlas' chariot thunders on
The pearly and pellucid car
Stampedes into creation
The thousand dreams of Epipsychidion!

Elfin laughter describes the atmosphere faerine
Of the burly ancient forests' green

Under bower'ed canopy skies
The turning of the Oracles mystic aer papery
Unveils the visions of the boy,
That one, Epipsychidion's silent slumber.

Lo! The sweet perfume of sleep
Lies faintly on our Hero's neck
Whe'en precious slumber deep
Lies ye olde druid's keep

Hail! Sleeping Epipsychidion
Ne'er e'en oure time began
Did suche Unicorn as yee
Prance in ye olde field of lore

Wher'een the Druids, captured the
Shield of Yagar, Gnome of Legend. . .

. . . To be continued. Thank you.

SISTER D.

CHIP WASS

Dear Readers—Having a time! Here's your damn recipe. Mona and I are appearing nightly at the SHANGHAI SNACK BAR!! Tell Matthew Kasten that if we ever get back home we're gonna serve him up a mess of Lady Fingers for booking us in this DUMP! Yours Endive + Mona xxo

PANSY BEA

184 9th AVE

N.Y.C. 100

P.S.

us A

Shanghaied Shrimp

1 1/4 lbs. medium-size shrimp
16 large spinach leaves
16 white endive leaves
1 small head Boston Lettuce
4 thin slices red onions, in rings
Freshly ground pepper

1/4 t. hot pepper flakes
3/4 cup olive oil
salt
1/4 cup wine vinegar
2 T. chopped fresh dill
3 T. finely chopped chives

Peel and devein shrimp. Set aside. Arrange greens and onions on four serving dishes. Heat the oil in a skillet and add the shrimp. Cook, stirring, about 30 seconds. Add the pepper flakes. Cook, stirring, about 1 1/2 minutes. Add the wine vinegar and cook about 30 seconds. Add the dill and toss. Spoon the shrimp and the sauce over the greens. Sprinkle with chopped chives and serve!

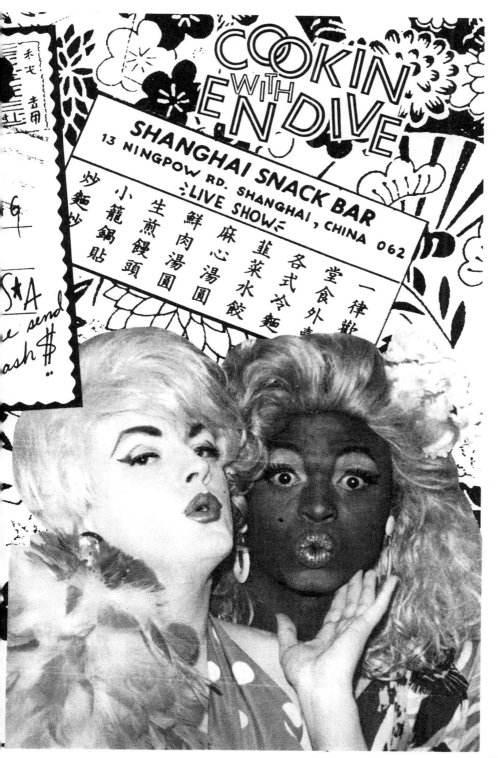

Come Home to The Center!

 Lesbian and Gay New Yorkers have something that most other gay people can only dream about... Our very own Community Center. A real life bricks-and-mortar home where over 200 lesbian and gay groups organize, network, socialize, and provide services and support.

Whatever you're looking for--social events, cultural events, help with a personal problem, or some way to make a meaningful contribution to the health and growth of our community--you'll find it at The Center.

To get a calendar of all the events and services available, stop by any day between 10:00 a.m. and 10:00 p.m, or give us a call.

And we hope you'll want to become a member, too. Individual membership is $25 a year. Household membership is $40. Send us your check and we'll mail you your membership card.

**Lesbian and Gay
Community Services Center**
208 West 13th Street
(between 7th and 8th Avenues)
New York, NY 10011
(212) 620-7310

Join Our Center Family!

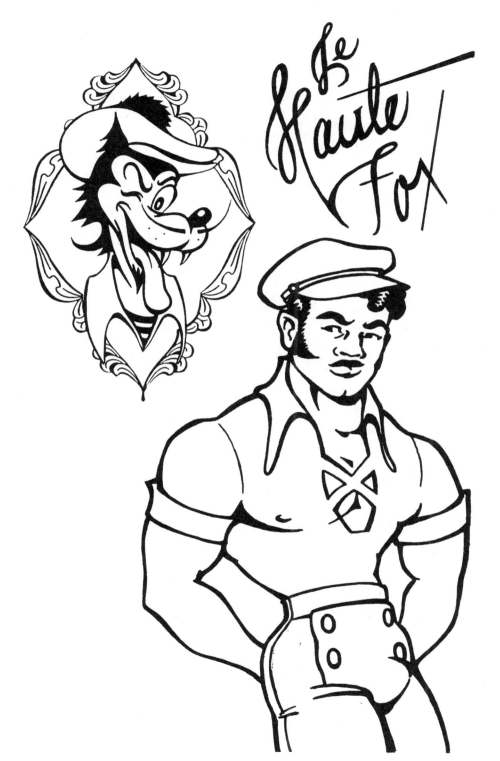

Le Haute Fox

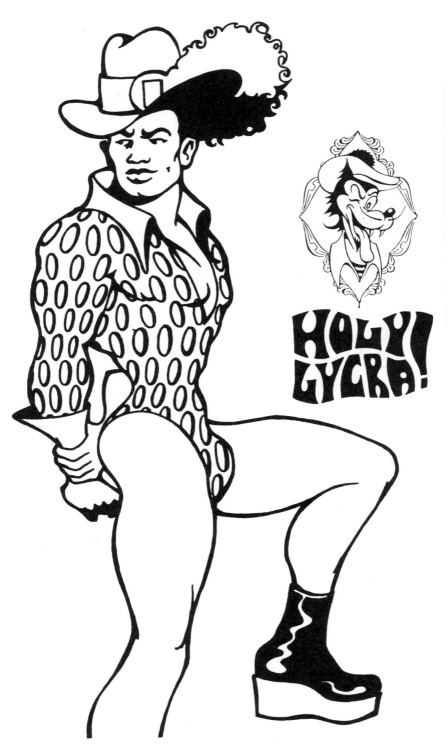

HOLY! LYCRA!

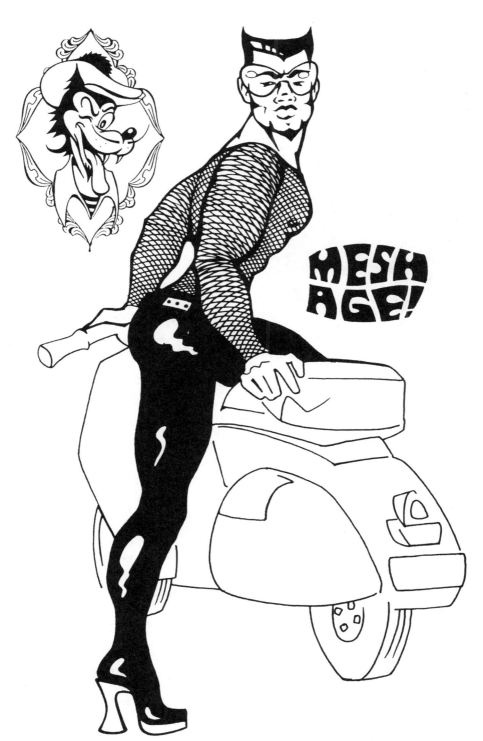

MESH AGE!

313

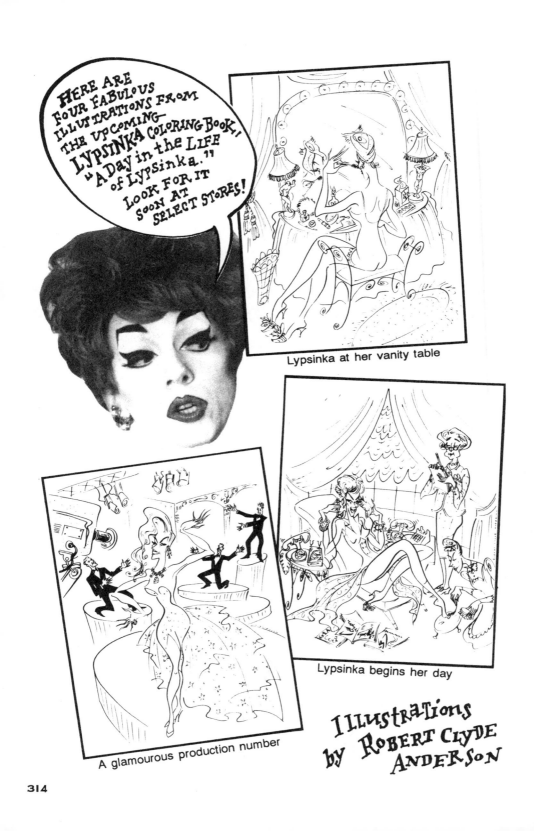

Lypsinka at her vanity table

Lypsinka begins her day

A glamourous production number

314

The Lypsinka

COLORING BOOK

GUARANTEED TO PLEASE

Lypsinka wins the Academy Award

TEXT BY
JOHN EPPERSON

93 Spring Street New York NY 10012 (212) 219-3005

Thomas Holtorf

SUNDAYS FOR GAY MEN AND LESBIANS

A GROOVY
KIND
OF LOVE

THE AIR CONDITIONED

ROXY

515 West Eighteenth Street
between Tenth and Eleventh Avenues

A STORE THAT LOVES YOU.

Little Rickie

212-505-6467 49 ½ 1st ave. at 3rd St. n.y., n.y. 10003

WE SALUTE GAY PRIDE - SUMMER 1990...

MARS NEEDS MEN

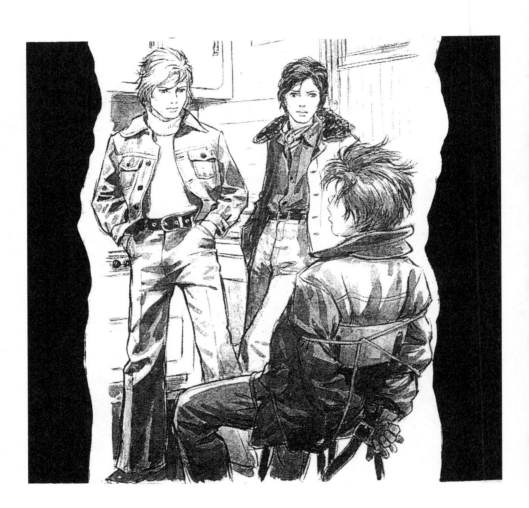

S U N D A Y S

Chip Duckett presents MARS NEEDS MEN Sundays at Mars/live bands/drag queens/go-go boys/5 floors of fun & a roof/dance DJ's Michael Connolly, John Suliga, and Larry Tee/New York's premiere Drag DJ Perfidia/West Side Highway and 13th Street

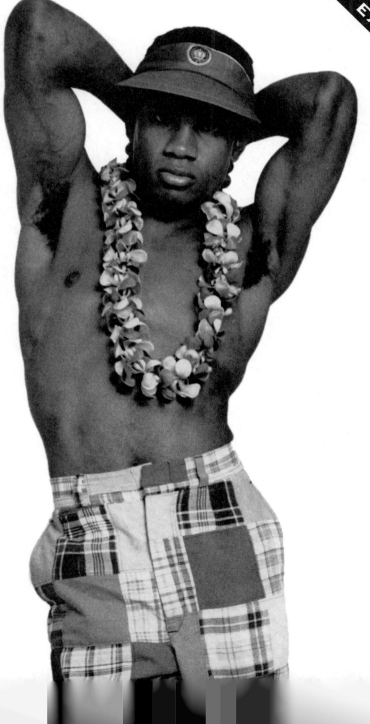

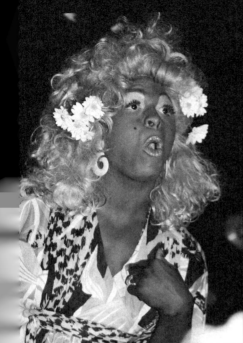

Mona Foot's glamazon style

Endive purrs

*Lady Bunny's performance
brings on tears*
of laughter

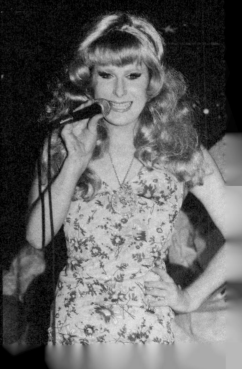

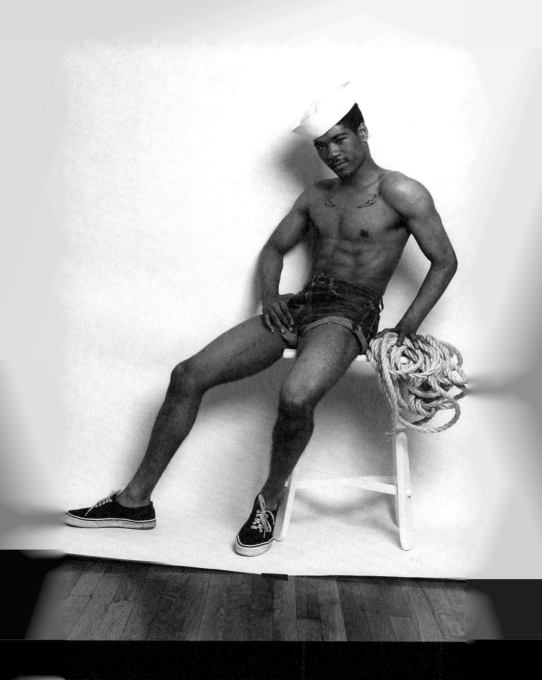

RODUCING SLAPSHOT!

...ay of including more men's fashion editorial, we introduced SLAPSHOT!,
...magazine inspired by Bob Mizer's Physique Pictorial magazine. Model Joe
...in a classic mode. Previous ...age, Burt the beautiful sho...'s off his le...

OUR
GONE-TOO-SOON
ISSUE

PANSY BEAT

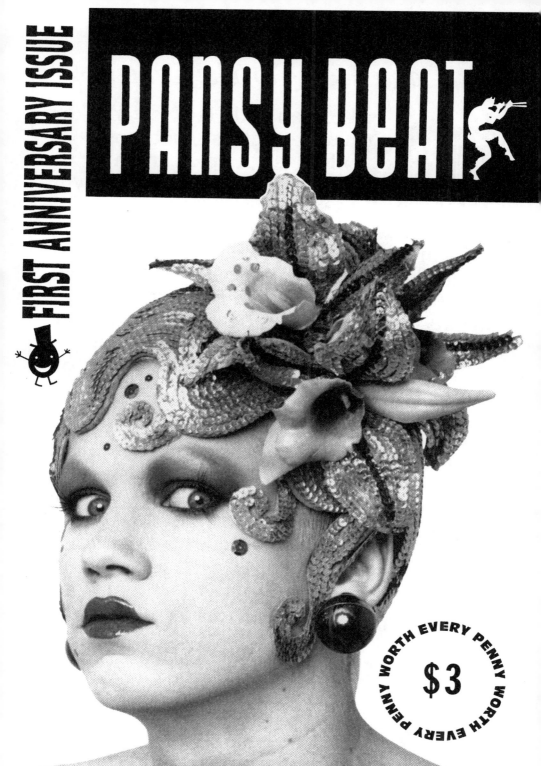

WORTH EVERY PENNY WORTH EVERY PENNY WORTH EVERY PENNY

$3

Come Home to The Center!

 Lesbian and Gay New Yorkers have something that most other gay people can only dream about... Our very own Community Center. A real life bricks-and-mortar home where over 200 lesbian and gay groups organize, network, socialize, and provide services and support.

Whatever you're looking for--social events, cultural events, help with a personal problem, or some way to make a meaningful contribution to the health and growth of our community--you'll find it at The Center.

To get a calendar of all the events and services available, stop by any day between 10:00 a.m. and 10:00 p.m, or give us a call.

And we hope you'll want to become a member, too. Individual membership is $25 a year. Household membership is $40. Send us your check and we'll mail you your membership card.

**Lesbian and Gay
Community Services Center**
208 West 13th Street
(between 7th and 8th Avenues)
New York, NY 10011
(212) 620-7310

Join Our Center Family!

Weeeee!!

CHIP WASS

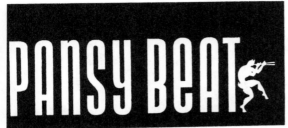

EDWIGE BELMORE

EDITOR-N-CREATIVE DIRECTOR
Michael Economy

ART DIRECTOR
Matthew Waldman

CONTRIBUTING EDITORS
Michael Fazakerley
Cole Slaw
Chip Wass

CONTRIBUTORS
Michael Bartalos
Robert Clyde Anderson
Aaron Cobbett
Donald Corken
Sister Dimension
Laurie Pike
Tom Rubnitz
Natalie Stanford

SPECIAL THANKS
Michael Alig+Disco2000
The Lady Bunny

1991 CALENDER

PHOTO: MICHAEL FAZAKERLEY

THIS ISSUE IS DEDICATED IN THE MEMORY OF TAMAGO

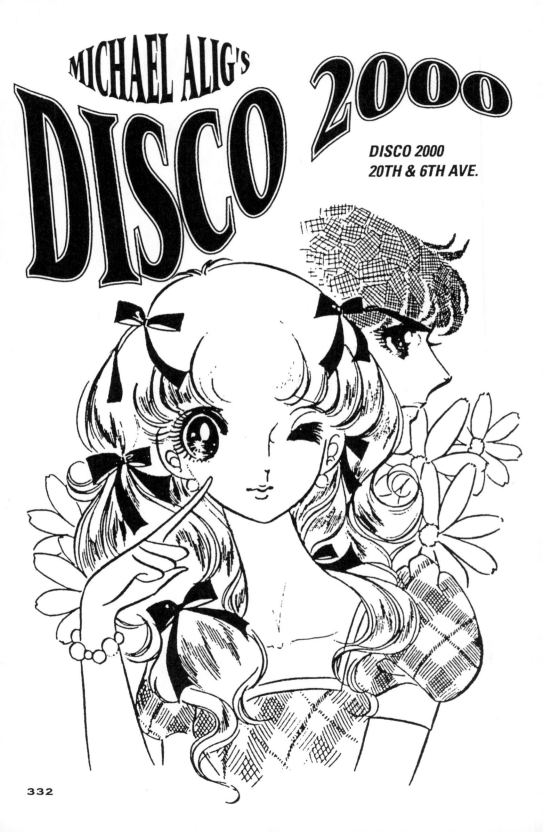

Chyna Bleau
has got the
ERGE!

Saucy Capricorn, **CHYNA BLEAU**, hails from Cuba via Miami, and is our First Anniversary Cover Star. Pictured above with Scorpian boyfriend, Erge, originally one of Chyna's hair clients.• **ERGE**, a graffiti artist who sports two tattoos on his arm dedicated to his grandmother, is also featured in this issue's fashion editorial. • **Cover photo by Michael Fazakerley. Sequined orchid wig by the illustrious Pearl for Kenny Kenny. Thanx, Doll!**

He's a devil and an angel, dynamic and demure.
Men find him slightly baffling, maybe even a little bit maddening.
He's easily the most exciting man in town.
With fool-proof formula for melting a male, he's the

Pansy Beat Man!

(Are you?) Take this simple test and see!

❶
Do you love to dance
with your shoes off?

❷
HAVE YOU EVER SMOKED A CANDY
CIGARETTE?

❸
When a recipe calls for one dash of
bitters do you think its better with two?

❹
Would you dye your hair lavender
without consulting your boyfriend?

❺
IF TOURIST FLIGHTS
WERE RUNNING
WOULD YOU
TAKE A TRIP TO MARS?

by Chip Wass

6
DO YOU SECRETLY HOPE THE
NEXT MAN YOU MEET WILL BE A
BODYBUILDER?

7
DO YOU BLUSH
WHEN YOU FIND
YOURSELF
FLIRTING?

10
HAVE
YOU
EVER
WORN
A
FeZ?

8
Does gypsy music make you sad?

9
DO YOU THINK ANY MAN
REALLY UNDERSTANDS YOU?

If you can truthfully answer "yes" to at
least eight of these question,
congratulations, you're a winner!

SCREAMING

SCREAMING MIMI'S NEW YORK/22 EAST 4TH STREET NEW YORK, NEW YORK 10003/677-MIMI

SCREAMING MIMI'S TOKYO/18-4 DAIKANYAMA-CHO SHIBUYA KU. TOKYO. 150/03-780-4415

economy 90

MIMI's

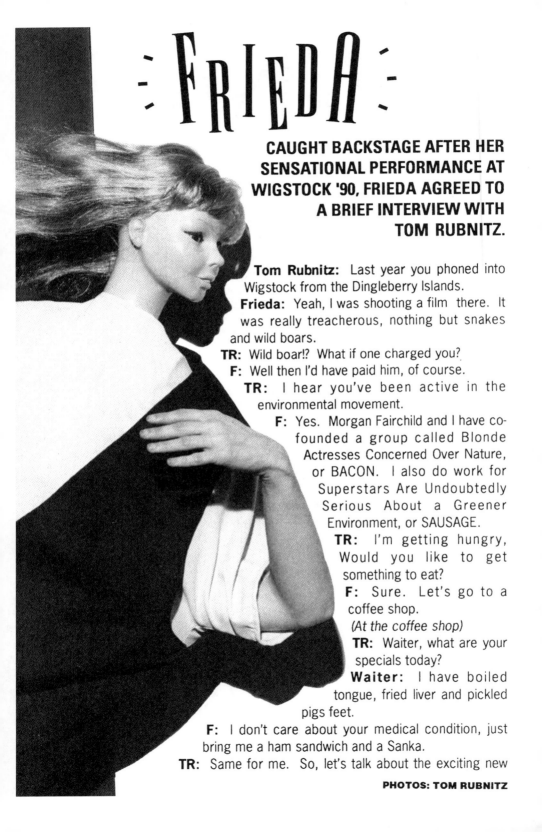

FRIEDA

CAUGHT BACKSTAGE AFTER HER SENSATIONAL PERFORMANCE AT WIGSTOCK '90, FRIEDA AGREED TO A BRIEF INTERVIEW WITH TOM RUBNITZ.

Tom Rubnitz: Last year you phoned into Wigstock from the Dingleberry Islands.

Frieda: Yeah, I was shooting a film there. It was really treacherous, nothing but snakes and wild boars.

TR: Wild boar!? What if one charged you?

F: Well then I'd have paid him, of course.

TR: I hear you've been active in the environmental movement.

F: Yes. Morgan Fairchild and I have co-founded a group called Blonde Actresses Concerned Over Nature, or BACON. I also do work for Superstars Are Undoubtedly Serious About a Greener Environment, or SAUSAGE.

TR: I'm getting hungry, Would you like to get something to eat?

F: Sure. Let's go to a coffee shop.

(At the coffee shop)

TR: Waiter, what are your specials today?

Waiter: I have boiled tongue, fried liver and pickled pigs feet.

F: I don't care about your medical condition, just bring me a ham sandwich and a Sanka.

TR: Same for me. So, let's talk about the exciting new

PHOTOS: TOM RUBNITZ

I've been in the laboratory working on

the scent for my new perfume, Gruyére.

video that Barbara Lipp, Tom Koken and I are making with you.

F: It's called "Wake Up, Smell the Sanka and Get Your Act Together 'Cause I've Got my Own Show to Do." We're about half way through and so far, so good. And my costumes are gorgeous, designed by Todd Oldham.

TR: Oh waiter, please bring us some turtle soup.

F: And make it snappy.

TR: Tell us what the video's about.

F: Oh it's about twenty minutes long. Actually, it chronicles my life in show business.

TR: What else have you been up to?

F: I've been in the laboratory working on the scent for my new perfume, Gruyére.

TR: Gruyére? Isn't that a cheese?

F: Oh really, I knew there was something alluring about it. Speaking of which, did you know that I have one of the largest cheese collections in the world?

TR: Cheese? Doesn't it go bad?

F: Oh hum, really? Oh gosh! That reminds me! I have a benefit for Citizen's Honoring Environmental Eco-Systems Everywhere and Hellbent Angry Motherfuckers.

**Before
you make
any
plans…**

DANCER

ACTOR

the Artistic Type

SINGER

15

PAINTER

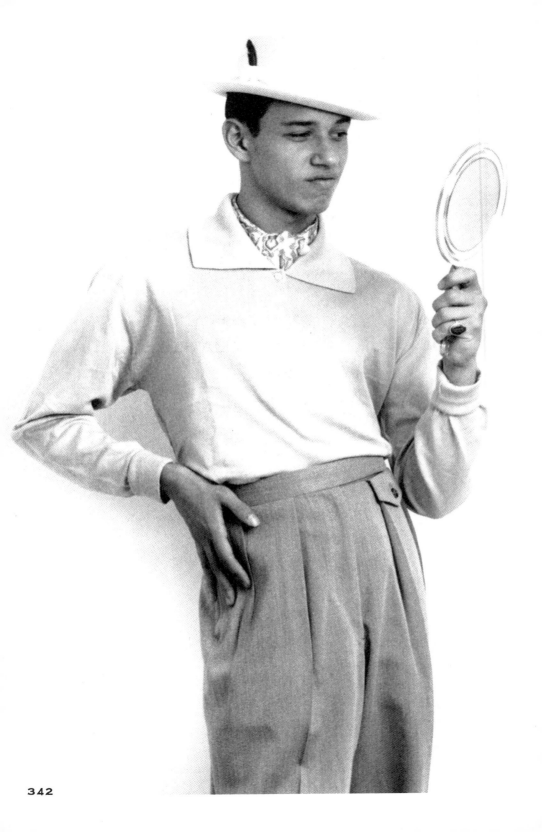

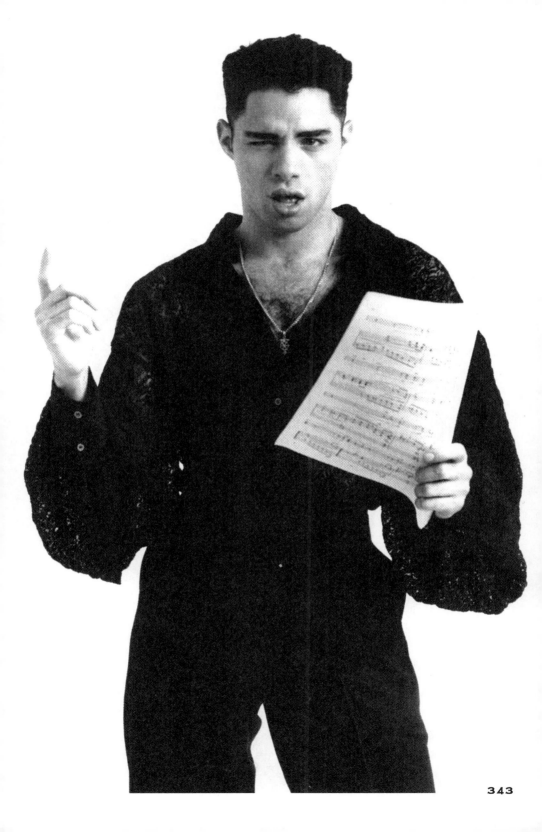

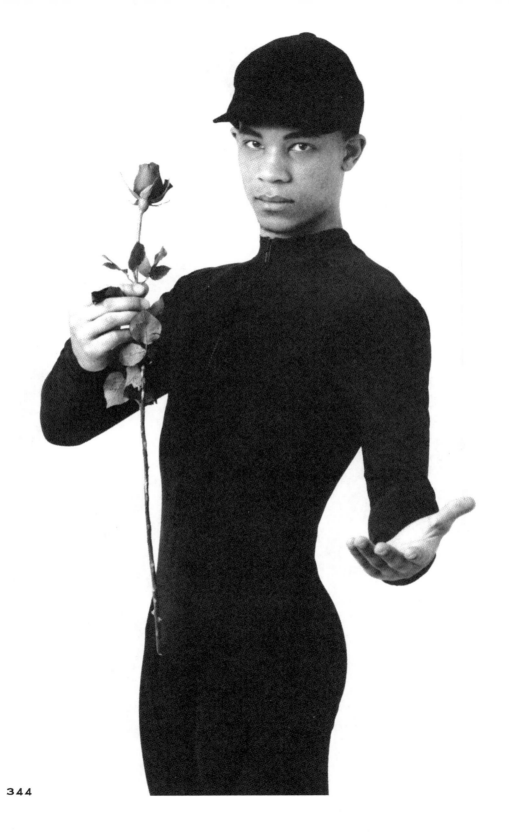

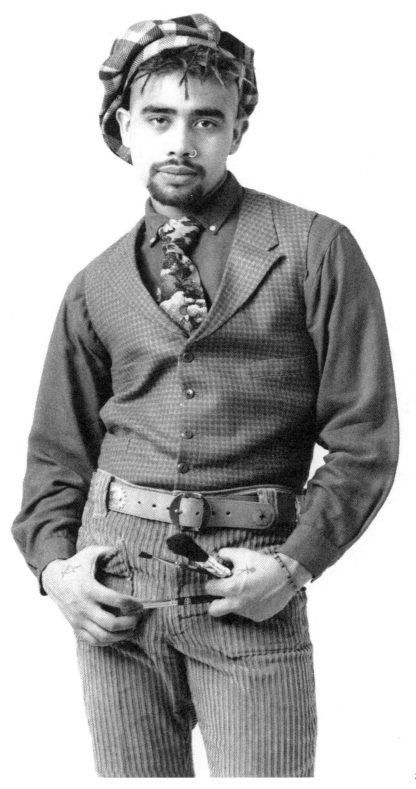

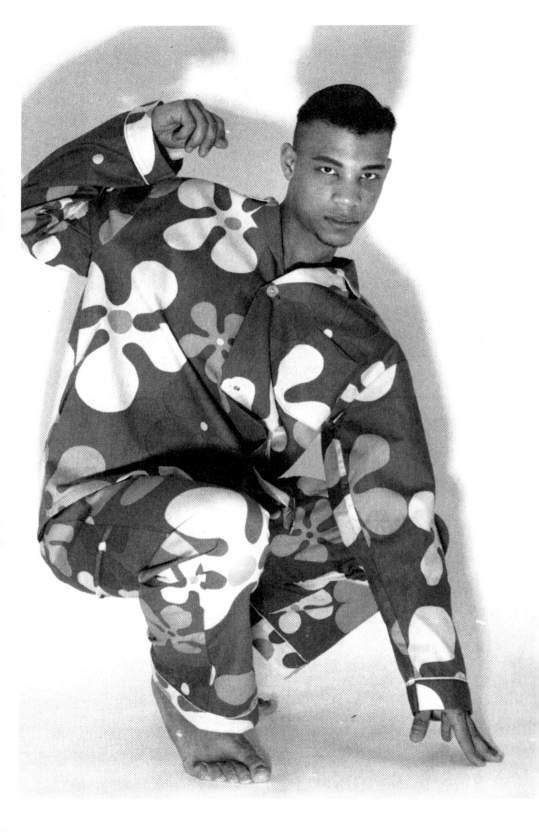

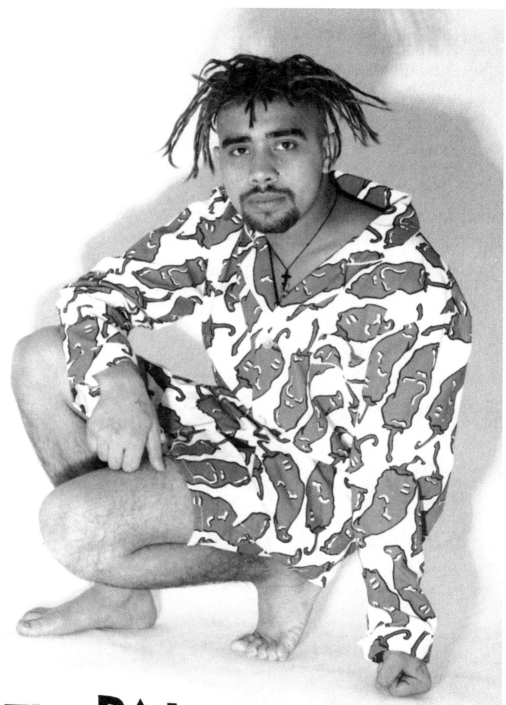

THE PAJAMA GAME

THE ARTISTIC TYPE

Pg.16—Hat from Screaming Mimi's/Ascot, Sweater, Slacks all from New Republic.
Model: **George G.**
Pg. 17—Black Lace Shirt from Screaming Mimi's/Slacks from New Republic.
Model: **George E.**
Pg. 18—Velveteen Riding Cap, Jumpsuit (available Spring 1991) from Patricia Field.
Model: **Creole**
Pg. 19—Shirt, Tie, Slacks from Screaming Mimi's/Vest from New Republic.
Model: **Erge**

THE PAJAMA GAME

Pgs. 20 and 22—Pajamas by Charles Goodnight. *Models:* **Creole and George G.**
Pg. 5 —Pajamas by Shady Character. *Model* **George E.**
Pg.21—Pajamas by Joe Boxer. *Model:* **Erge**

ALL PHOTOGRAPHS : MICHAEL FAZAKERLEY
PRODUCED BY MICHAEL ECONOMY

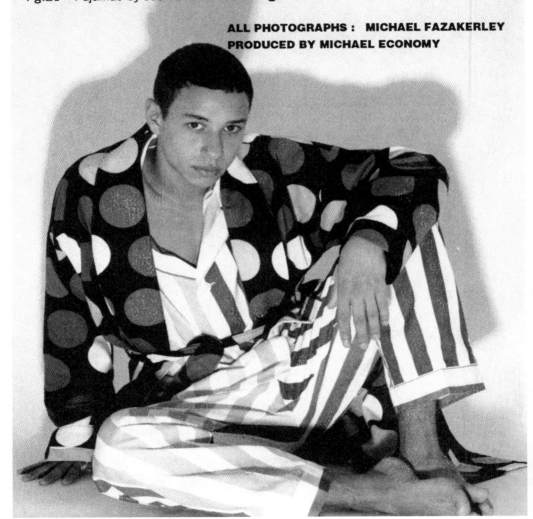

CHARLES GOODNIGHT
LOUNGEWEAR
1466 BROADWAY, NYC (212) 302-3770

DISCO TOUGH

EDWIGE BELMORE is truly one of the last viable products of Warhol's cult of celebrities. Crowned "Queen of Paris Punk" in 1977, she took the world of haute couture for a trip the reverberations of which lasted throughout the 80's. • Propelled by her mannish style to cult status, Edwige launched her musical career in Paris as one half of the duo Mathematiques Modernes. Already a star, she arrived in New York City and began promoting night clubs while showcasing her varying talents. Popular as hell with the girls (and the boys), she held the constituents of clubland in the palm of her hand; the crash was inevitable. • Now after a two year hiatus, the rehabilitated Edwige is back in town with a new sound! Club Kidz take heed, hers is a story few could hold a candle to!

AN INTERVIEW BY MICHAEL ECONOMY AND NATALIE STANFORD

Pansy Beat: So where have you been for two years?

Edwige Belmore: Ten years of night clubbing and working nights brings out a lot of stress, I guess I just retired. It is important to say that at one point something fell apart. Its important also that things are not irreversible. You know, I mean there is drug addiction and stuff like that. I got out of it with my will power and help, eventually. But really what you really need to do is to find yourself and that's what happened when I left and I went to a Yoga retreat for two years. That's where I was trying to find myself and re-define myself and feel comfortable with myself and that's why when I come back and I sing now, I sing twice as good. I'm not scared and I don't need drugs or alcohol when I sing. You know, I don't need it—anything—I mean I'm not new age and stuff like that, you know, I don't go to any spiritual meetings, blah, blah. I just found yoga. I found my teacher and I stick to that. You know, I'm not gonna go to every holistic center that comes around.

P.B.: Your recent come back performances at Grolier were certainly a success. The audience was well mixed, including many former fans, all humming to the accordion and genuinely howling after each number. How is it to be back in the spotlight performing again?

E.B.: Well, I must say that I was quite, you know, very nervous of course, because it was the first time that I was going to perform without any help of any drug and it was frightening. I was shaky and the minute I step behind the mike it's just like everything disappears. What I'm saying is that really all the nervousness and all that, happens always before. The minute you are on stage or behind the mike all the fright goes away. It really come out really really great.

P.B.: Your new performances are cabaret style again. What made you return to that style?

E.B.: That is something that is really on the side. I love to do that, I really like it but again, I was approached by the people at Groiler and they wanted me to do it. This is not my new stuff. This style with the accordion is so sort of typical, it's sort of campy, it's fun.

P.B.: So you were pretty much forced?

E.B.: Pretty much. But I realized by doing it that I love it. I love the people. love to see a face in the crowd.

P.B.: You did the "Beat Cocktail Lounge" at the American Foreign Legion, a little tiny space on Fourteenth Street and later at Carmelita's back in 1985. It was very intimate for that time. Big clubs like Palladium and Area were popular then and no one was doing that style of performance. How did you decide to revive the concept of the cabaret chanteuse back then?

E.B.: Really, this guy I was doing it with, Tony Catania, is actually the guy that got me into doing that. He came to me one day, I was singing at Danceteria for a party upstairs with Joey Arias and Robert Aron when he proposed to me to do a night on a weekly basis, like to have a club. It didn't matter how I sang, just that they came every week, and they loved it. Just to get together, that was the idea.

P.B.: You took Paris' nightclub fame and know-how and put it to work for you

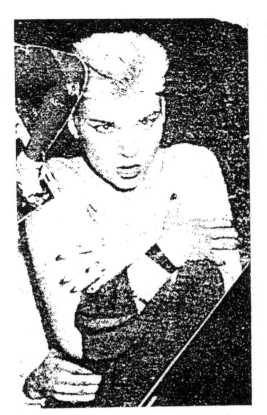

PARIS CROWN-QUEEN OF PUNK 1977

in New York. Your Mathematiques Modernes single "Disco Rough" won an award in Paris for most popular club record. You were celebrated door-woman of Le Palace in Paris and of architect Philippe Starck's club in Dallas. You were one of the most prominent figures in Paris and New York nightlife and a constant topic of interest in Warhol's *Interview* . Don't you think Warhol's concept of fame and celebrity actually fueled the fire that propelled our generation of 70's teenagers into the obsessive nightclubbing "cult of celebrities" craze?

E.B.: Yes, sure! Our generation really came out and went out in clubs in the late 70's and 80's. That's when nightclubbing was at its peak. We just lived in such an intense way. Nightclubbing was a lifestyle.

P.B.: Your punk "post" Jean Seberg look in the late 70's tipped off a host of lookalikes in today's pop pool. You were an inspiration and muse to artists, photographers and designers internationally. These creative people plugged parts of you into others who went on to become famous.

E.B.: I have things to say about that for sure. In 1977, when I cut my hair short and bleached it blond, Helmut Newton found me really fascinating and photographed me. Later, Andy Warhol also liked me. Designers would use me for their show because I was an outrageous figure. Mugler took me for his big 1977 show. I was frightened and horrified on a runway because I looked a certain way. Anyway, I always thought I was ugly my whole life. I thought it would be fun. But the thing is that in the fashion world, they would hate me. Like *Marie-Claire* and *Elle* magazines, I couldn't work as a model because I was too much. But then you see in 1980, someone like , who arrived in that boyish blonde hair Jean Seberg look which I didn't invent but I sparkled that into a trend. All of a sudden they

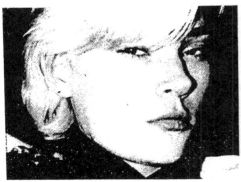

became huge models that made a lot of money. The thing is it always happens with the artists, some people are always one step in advance of others. They never actually get anywhere because they don't get recognized or they get recognized by just a small elite.

P.B.: Or they get put on a pedestal, held up as the new look. Others, however, capitalized on your image. Annie Lennox used your look in her debut and Maripol, the stylist responsible for Madonna's first look put bits and pieces of you into her. Perhaps not too obviously, but its in there.

P.B.: So what is inspiring you these days?

E.B.: Yoga has inspired me so much. It is a whole philosophy, a whole way of life. I took an intense course in yoga. I'm a certified yoga teacher. Teaching Hatha Yoga. I love to teach yoga. I teach every week at Sivananda Yoga Center on 24th Street. The really inspiring thing is when I have club scene people come to my yoga class. Everyone walks out so inspired, so elevated and feeling so good. I love that. All this energy I'm stirring in someone else wakens my own energy and its wonderful. And I keep going upstate to the Yoga Ranch.

P.B.: What other new projects are taking up your time?

E.B.: I have a manager now and we're putting together an album. We went to London to work with producer Jenny Healy. Eventually she wants to sell me to a record company. I'm working on new songs. I'm not a rapper. I'm not a rock and roll singer. I'm just a chanteuse.

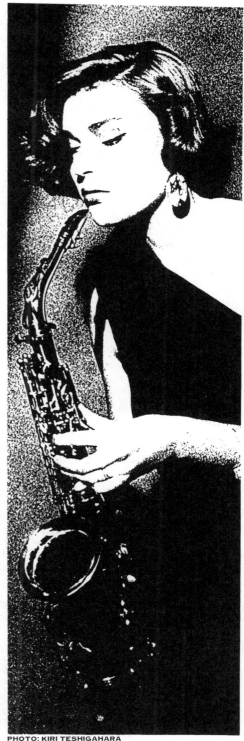

PHOTO: KIRI TESHIGAHARA

Faye Dunaway • January 14, 1941

Christian Dior • January 21, 1905

Carol Channing • January 31, 1923

John Travolta • February 18, 1954

Dinah Shore • March 1, 1917

Liza Minnelli • March 12, 1946

Aretha Franklin • March 25, 1942

Tennessee Williams • March 26, 1911

Cher • May 20, 1946

Peggy Lee • May 20, 1920

Patti Labelle • May 24, 1944

Cole Porter • June 9, 1892

Judy Garland • June 10, 1922

Jean Cocteau • July 5, 1889

Deborah Harry • July 11, 1945

Linda Ronstadt • July 15, 1946

19

PANSY BE

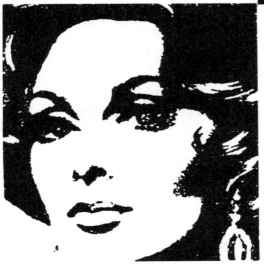

Yves Saint Laurent • August 1, 1936

Samantha Sang • August 5, 1953

Lucille Ball • August 6, 1911

Andy Warhol • August 6, 1927

Lesley Ann Warren • August 16, 1946

The Lady Bunny • August 16, 1971

Jacqueline Susann • August 20, 1921

Geoffrey Beene• August 30, 1927

Sarah Vaughan • March 27, 1924

Eileen Heckart • March 29, 1919

Billie Holliday • April 7, 1915

Ella Fitzgerald • April 25, 1918

Douglas Sirk • April 26, 1900

Ann-Margret • April 28, 1941

Anne B. Davis • May 3, 1926

Beatrice Arthur 8 May 13, 1926

CALENDER

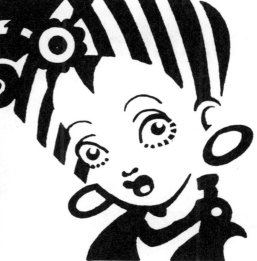

Sister Dimension • September 2, 2076

Patsy Cline • September 8, 1932

Bobby Short • September 15, 1926

Julie London • September 26, 1926

Oscar Wilde • October 16, 1856

Endive • November 21, 1950

Patty Duke • December 14, 1946

Jean Genet • December 19, 1910

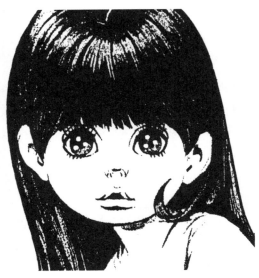

JANUARY

SUN	MON	TUE	WED	THU	FRI	SAT
☾ L.Q. 7	● N.M. 15	1	2	3	4	5
6	7	8	9	10	11	12
13	14	15	16	17	18	19
20	21	22	23	24	25	26
27	28	29	30	31	☽ F.Q. 23	☺ F.M. 30

MARCH

SUN	MON	TUE	WED	THU	FRI	SAT
☾ L.Q. 8	● N.M. 16	☽ F.Q. 23	☺ F.M. 30		1	2
3	4	5	6	7	8	9
10	11	12	13	14	15	16
17	18	19	20	21	22	23
24 31	25	26	27	28	29	30

356

MAY

SUN	MON	TUE	WED	THU	FRI	SAT
☾ L.Q. 7	● N.M. 14	☽ F.Q. 20	1	2	3	4
5	6	7	8	9	10	11
12	13	14	15	16	17	18
19	20	21	22	23	24	25
26	27	28	29	30	31	☺ F.M. 28

FEBRUARY

SUN	MON	TUE	WED	THU	FRI	SAT
L.Q. 6	N.M. 14	F.Q. 21	F.M. 28		1	2
3	4	5	6	7	8	9
10	11	12	13	14	15	16
17	18	19	20	21	22	23
24	25	26	27	28		

APRIL

SUN	MON	TUE	WED	THU	FRI	SAT
L.Q. 7	1	2	3	4	5	6
7	8	9	10	11	12	13
14	15	16	17	18	19	20
21	22	23	24	25	26	27
28	29	30	N.M. 14	F.Q. 21	F.M. 28	

JUNE

SUN	MON	TUE	WED	THU	FRI	SAT
L.Q. 5	N.M. 12	F.Q. 19	F.M. 27			1
2	3	4	5	6	7	8
9	10	11	12	13	14	15
16	17	18	19	20	21	22
23 30	24	25	26	27	28	29

JULY

SUN	MON	TUE	WED	THU	FRI	SAT
L.Q. 5	1	2	3	4	5	6
7	8	9	10	11	12	13
14	15	16	17	18	19	20
21	22	23	24	25	26	27
28	29	30	31	N.M. 11	F.Q. 18	F.M. 26

SEPTEMBER

SUN	MON	TUE	WED	THU	FRI	SAT
1	2	3	4	5	6	7
8	9	10	11	12	13	14
15	16	17	18	19	20	21
22	23	24	25	26	27	28
29	30		L.Q. 1	N.M. 8	F.Q. 15	F.M. 23

NOVEMBER

SUN	MON	TUE	WED	THU	FRI	SAT
N.M. 6	F.Q. 14	F.M. 21	L.Q. 28		1	2
3	4	5	6	7	8	9
10	11	12	13	14	15	16
17	18	19	20	21	22	23
24	25	26	27	28	29	30

358

AUGUST

SUN	MON	TUE	WED	THU	FRI	SAT
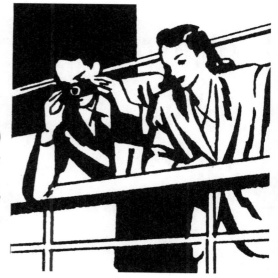 L.Q. 3	N.M. 10	F.Q. 17	F.M. 25	1	2	3
4	5	6	7	8	9	10
11	12	13	14	15	16	17
18	19	20	21	22	23	24
25	26	27	28	29	30	31

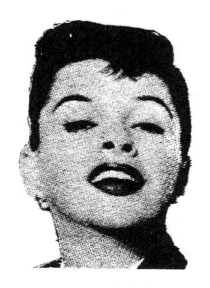

OCTOBER

SUN	MON	TUE	WED	THU	FRI	SAT
L.Q. 1/30	N.M. 7	1	2	3	4	5
6	7	8	9	10	11	12
13	14	15	16	17	18	19
20	21	22	23	24	25	26
27	28	29	30	31	F.Q. 15	F.M. 23

DECEMBER

SUN	MON	TUE	WED	THU	FRI	SAT
1	2	3	4	5	6	7
8	9	10	11	12	13	14
15	16	17	18	19	20	21
22	23	24	25	26	27	28
29	30	31	N.M. 6	F.Q. 14	F.M. 21	L.Q. 28

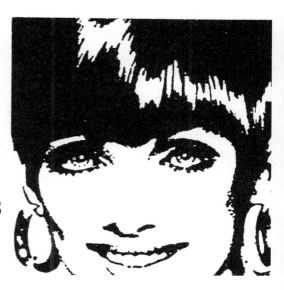

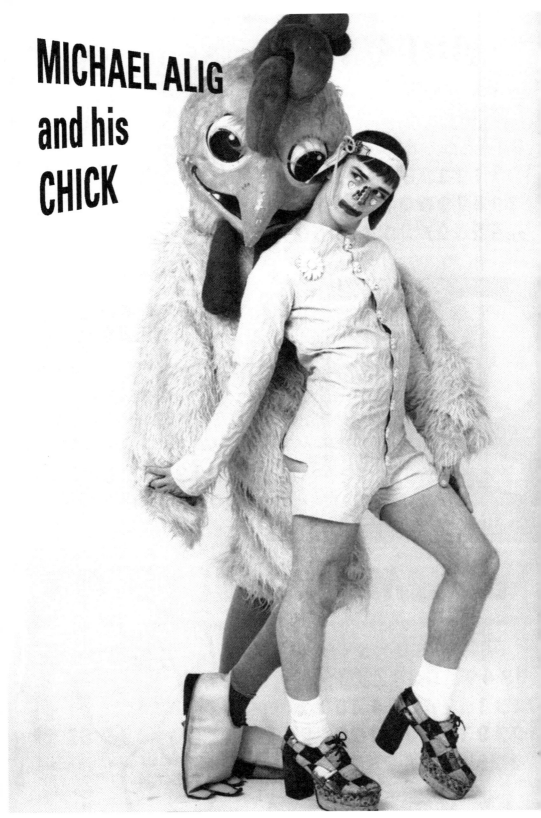

MICHAEL ALIG
and his
CHICK

Clara The Carefree Chicken, one of downtown Manhattan's most prominant club figures and Michael Alig, the true king of club kids and the genius behind DISCO 2000, chewed the fat for us, chicken fat that is.

Michael Alig: Where do you see yourself in ten years?

Clara: I see myself in a booth behind glass with a cocktail in hand and a strobe light flickering on display at the Museum of Natural History. I will be listed as an extinct species and the plaque will read: CLUBKIDUS NEWYORKUS.

M.A.: How did you get to the top of the club scene so fast?

C.: Basically I think all club promoters are after one thing from a bird like me. I had to pluck my way to the top, baby,. just like all the great ones!

M.A.: Were you surprised you weren't crowned this year's Queen of Manhattan?

C.: No, the whole thing was fixed. The scandal of it all is that there were no real women nominated for queen: six drag queens and a chicken! At least I am a real chicken.

M.A.: Who does your hair?

C.: I do, of course, I never trust anyone with my golden feathers and ruby red comb.

M.A.: Do you think people will try to copy your look?

C.: Copy! It's already happening! In fact, there has been all kinds of chicken sightings at bars and after hour clubs all over town.

M.A.: Who in the entire world would you most like to meet?

C.: Well between you and me, I've always wanted to meet Big Bird because he's such a sexy cock. I've heard they don't call him Big Bird because he's tall. WINK!

M.A.: Do you think I.C. the Bear and Hans the Dog are having a homosexual love affair behind everyone's backs?

C.: They must be because I've thrown myself all over them on separate occassions, to their indifference. No animal alive could resist my femme-fatal charms.

M.A.: Where are you going tonight?

C.: I thought you said we were having cocktails over at Colonel Sander's place?

MICHAEL ALIG'S OUTFIT DESIGNED BY ERNIE GLAM! PHOTOS: MICHAEL FAZAKERLEY

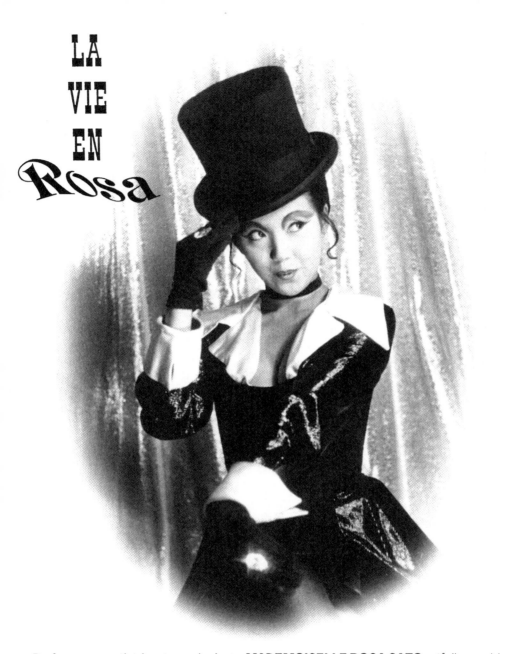

LA VIE EN Rosa

Performance artist/costume designer **MADEMOISELLE ROSA SATO** artfully combines operatic vocals with broken mechanical doll gestures sometimes set to a house beat. •Trained in Japan in her formative years by a retired member of the Vienna Boys Choir, Rosa's performances embody her concept: "Eroticism in the Stoic Doll." • She has appeared in a "New Order" video, sung with acid jazz band "Working Week" at London's I.C.A. gallery, participated in the Fashion and Surrealism exhibition at the Victoria and Albert Museum and performed at N.Y.C.'s now-defunct Love Machine. • This is one doll who refuses to live her life in the glass box called Japan. **PHOTO: AARON COBBETT**

DOG-MATIC READING

BY JUNE DENT

Cool weather brings on that literary mode when you pull on a patchouli-soaked sweater, head for some subterranean cafe, and read something that changes your life. This year, must-reading for in-the-know youthquakers is *Gutter Poodles*, the third annual compilation of short stories and essays by emerging writers.

If your idea of a literary challenge is plowing through *Vanity Fair* or *Pansy Beat*, then *Gutter Poodles* is for you—sharp, to the point, and perky as all get-out. In this year's issue, Michael Kaniecki poses the question: Is Karen Finley friend or foe? His explosive essay wonders why she became the icon of the anti-censorship movement, when she uses the right wing's questionable "us" versus "them" tactics. Kaniecki says he'd rather hold his enemy's hand than cut it off.

Also in the issue are short stories that concern, among other things: candy bar names, Mafioso exterminators, waitresses getting revenge, and cabbies after hours.

Some people find *Gutter Poodles* a howl. Some find it a fab alternative to the boring stories in *The New Yorker*. All people find it by sending four dollars postpaid to: C. Nazon, 187 Chrystie Street, New York, New York 10002.

ILLUSTRATION : CHIP WASS

PANSY COMPANIES

When we traveled downtown to register the name of our own dear little zine one year ago, we were required to check a list of other registered businesses to be certain there was no other "Pansy Beat Productions." We were delighted we were the first, and equally entertained with the number of other registered "pansies" we came across. In celebration of our first anniversary issue, we wanted to share the list with our readers. Some of the names may lead your mind to wander.

- •PANSY AMUSEMENT CORPORATION
- • PANSY BEADING CO.
- •PANSY CHEMICAL PERFUMERY AND SOAP CO.
- •PANSY CLOAK AND DRESS CO., INC.
- •PANSY COSTUME CO.
- •PANSY DECALCOMANIA COMPANY
- •PANSY DRESS SHOP
- •PANSY FELT NOVELTY CO.
- •PANSY HAT FRAME CO., INC.
- •PANSY HATS
- •PANSY LACE AND EMBROIDERY WORKS
- •PANSY MANUFACTURING CO.
- •PANSY PLEASURE CLUB
- •PANSY PLEASURE CLUB OF THE BOROUGH OF THE BRONX
- •PANSY PREPARATION CO., INC.
- •PANSY PUBLISHING CO.
- •PANSY REALTY CORP.
- •PANSY SHIRT WAIST CO.
- •PANSY SILK MILLS, INC.
- •PANSY SOCIAL CLUB
- •PANSY TRUCKING CO.
- •PANSY UNDER GARMET CO.
- •PANSY UNDER WEAR
- •PANSY WAIST CO., INC.
- •PANSY WEAVING MILLS

Elektra

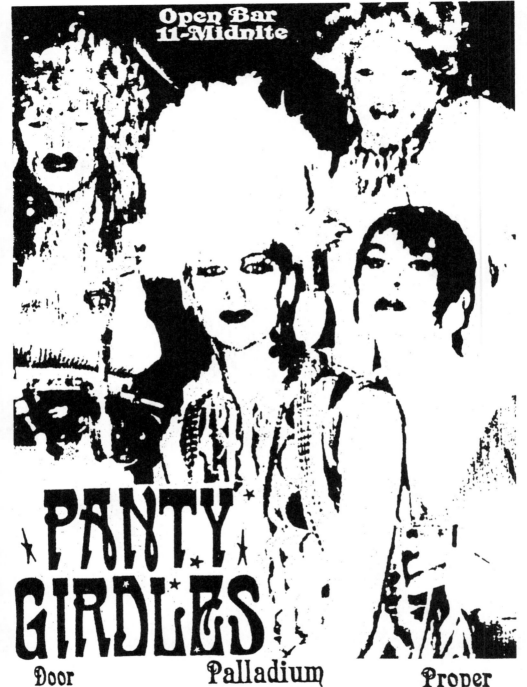

**Open Bar
11-Midnite**

PANTY GIRDLES

Door
Kate
Harwood

Palladium
BACKDOOR

Proper
ID to
drink

123 E 13th St., NYC (212) 473-7171

GROOVY CLOTHES

87 CHRISTOPHER ST., NYC
(212) 989-4976

ENIGMAS IN MY UNIVERSE

BY COLE SLAW

FOR THE PAST YEAR I BET ALL YOU DEVOTED READERS HAVE ASKED: WITH THE TYPE OF ENIGMAS COLE HAS, JUST WHAT MUST HIS UNIVERSE BE LIKE? SO I HAVE DECIDED TO GIVE YOU SMALL SAMPLING.

ERECTION DAY In Cole's Universe, there's no such thing as an Election Day. Instead, we hold Erection Days. The purpose and procedure are similar, but the outcome is oh so different. Naturally, penis size is the measuring factor. We have kept most of the same rules as Election Day but with minor adjustments. For instance: the rule that requires a presidential candidate be at least forty-five years of age has been slightly altered. We've replaced the word "years" with "inches". Hey, if a man's erection is forty-five inches (either length or diameter qualify), he deserves to be president. Perhaps you're asking: Just where the heck do women fit into this erectorial scheme? Easy, erected officials are allowed only to appoint women to all the various governmental posts. There is a women-only cabinet advising the President, an all-girl Supreme Court, etc., etc.

SWISHY WISHING Another difference in Cole's Universe is one does not wish upon a star. Rather, we swish upon a star. Forget all that 'first star in the sky' or 'falling star' hokum. Here, one only

ILLUSTRATION :
MICHAEL BARTALOS

has to prance a bit underneath a chosen baby sun with preferably a petticoat and then, and only then, will your swish come true.

HOLY HOLIDAYS! There are also a few changes in national holidays. The day after Halloween has been added. Actually, there is a holiday about every three weeks here in Cole's Universe. We still honor the traditional ones in our own sweet way. For example: "July 4th" is celebrated as "July 4th thru 17th" and "Labor Day" is now "Labor on Top of Me Day."

Some of the other holidays are: "National Beauty Parlor Day," in appreciation to all our cut-n-curl comrades. There's also "Children's Day" which is celebrated by letting kids run

the Pentagon for one special day a year. We also honor truck stops, spandex and clean air.

BETTER WORLD? Other differences between Cole's Universe and yours are: condoms come in cereal packages, *The New Yorker* prints a friggin' masthead, baseball players aren't allowed to wear underwear, bank lines are against the law and perfume carts exist instead of hot dog stands.

Additional cultural differences include: ballet is performed at breaks during hockey games, no one has ever heard of a mall and all large grocery stores have art aisles (yes, Andy's dream comes true in Cole's Universe).

Let me end by saying you are all welcome to come to my universe any ole time your heart desires. You just have to remember to bring a pink petticoat and a great big swish to have fun. And don't forget the camera!

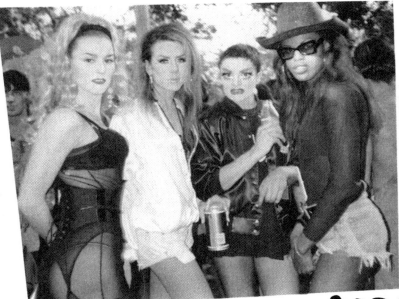

CODY
GUY
GLAMAMORE
CONNIE

Autumn in New York

OUCH!

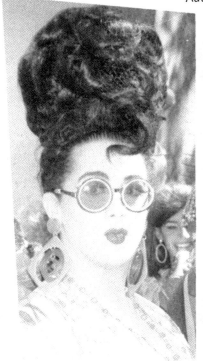

PERFIDIA

DEBBIE M.

LINDA SIMPSON

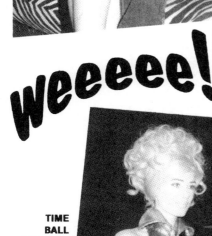

PHOTOGRAPHS: MICHAEL FAZAKERLEY

**TIME
BALL
WINNERS**

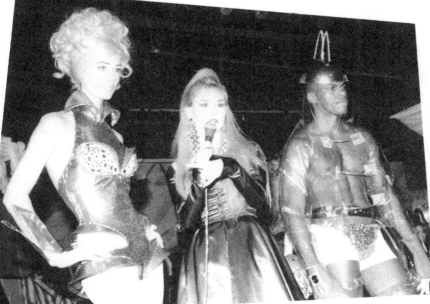

ENDIVE

MONA FOOT

ENDIVE

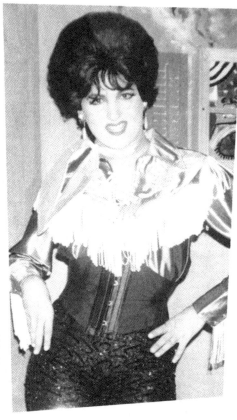

OINK!

**LULU WINS PATSY CLINE
LOOK-A-LIKE CONTEST
AT COWGIRL HALL OF FAME**

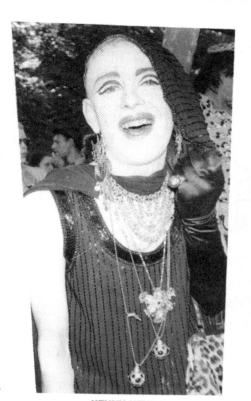

KENNY KENNY

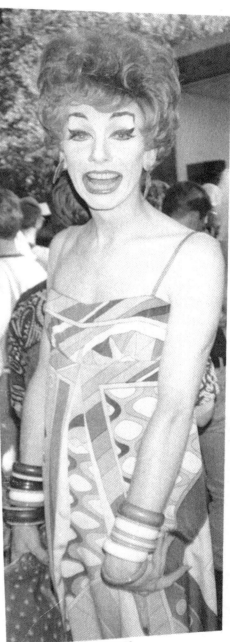

EEEK!!

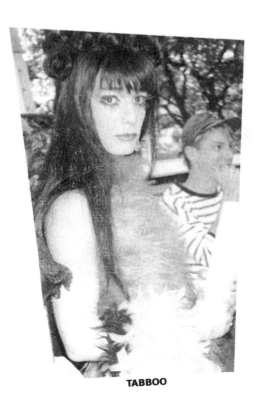

TABBOO

LYPSINKA

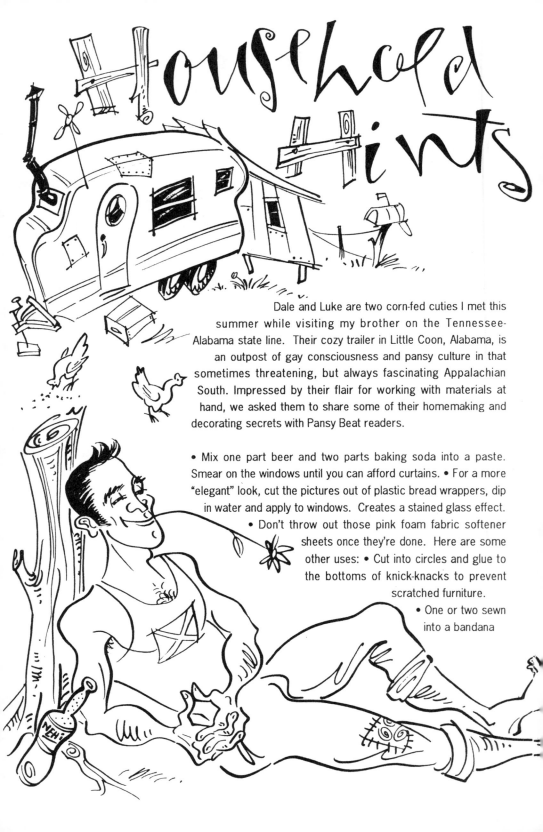

Household Hints

Dale and Luke are two corn-fed cuties I met this summer while visiting my brother on the Tennessee-Alabama state line. Their cozy trailer in Little Coon, Alabama, is an outpost of gay consciousness and pansy culture in that sometimes threatening, but always fascinating Appalachian South. Impressed by their flair for working with materials at hand, we asked them to share some of their homemaking and decorating secrets with Pansy Beat readers.

• Mix one part beer and two parts baking soda into a paste. Smear on the windows until you can afford curtains. • For a more "elegant" look, cut the pictures out of plastic bread wrappers, dip in water and apply to windows. Creates a stained glass effect. • Don't throw out those pink foam fabric softener sheets once they're done. Here are some other uses: • Cut into circles and glue to the bottoms of knick-knacks to prevent scratched furniture. • One or two sewn into a bandana

from Hillbilly Hunks

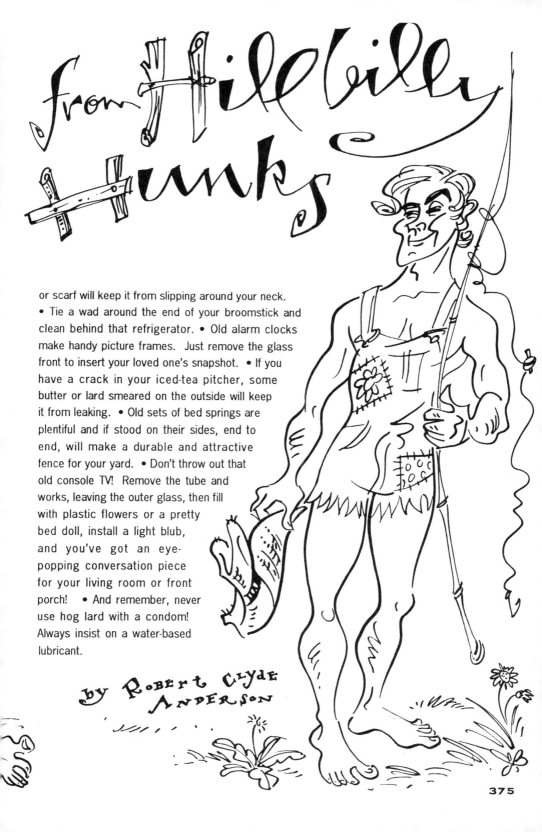

or scarf will keep it from slipping around your neck.
• Tie a wad around the end of your broomstick and clean behind that refrigerator. • Old alarm clocks make handy picture frames. Just remove the glass front to insert your loved one's snapshot. • If you have a crack in your iced-tea pitcher, some butter or lard smeared on the outside will keep it from leaking. • Old sets of bed springs are plentiful and if stood on their sides, end to end, will make a durable and attractive fence for your yard. • Don't throw out that old console TV! Remove the tube and works, leaving the outer glass, then fill with plastic flowers or a pretty bed doll, install a light blub, and you've got an eye-popping conversation piece for your living room or front porch! • And remember, never use hog lard with a condom! Always insist on a water-based lubricant.

by Robert Clyde Anderson

THE LYPSINKA COLORING BOOK

Sixteen pages of beautiful B&W cartoons of the fabulous Lypsinka for your coloring pleasure! Illustrated by Robert Clyde Anderson, this 8 1/2 by 11 sixteen page treasure is yours for the low, low price of $6.00. Price includes postage and handling. Make your checks payable to the illustrator and mail them to BIG FAT MOVIE STAR PRODUCTIONS, 264 Broome Street, 4th floor, N.Y.C. 10002.

PANSY BEAT IS AVAILABLE AT
THESE FINE SHOPS AND
BOOKSTORES

A DIFFERENT LIGHT
548 Hudson St.
989-4850

DETENTE
96 E. 7th St.
529-7323

PATRICIA FIELD
10 E. 8th St.
254-1699

ST. MARKS BOOKSHOP
13 St. Marks Pl.
260-7853

HUDSON NEWS * KIOSK
753 B'way at 8th St.
674-6655

SEE HEAR
59 E. 7th St.
982-6968

NIKO'S SMOKE & MAG. SHOP
462 6th Ave.
255-9175

published by
PANSY BEAT PRODUCTIONS
184 9TH AVENUE, N.Y.C.
10011
copyright 1990

PULL A HARD FACE,

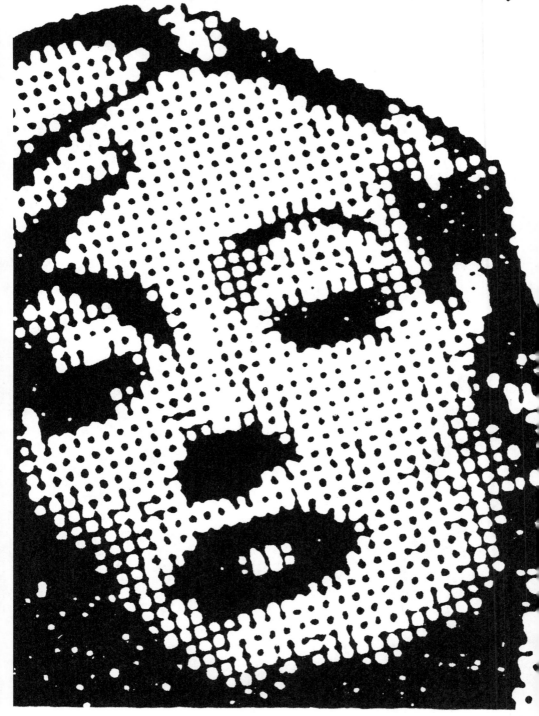

LADY

BY SISTER DIMENSION

Simply too much syrupy, heavy, yes even oozy, but gorgeous skin-tone base was being applied to Frank's newly shaved, blotchy but soon-to-be flawless facial skin. As the sponge, charged with the gradient ee-minous-nesity of High Beige, twitched fervently over our sweet "lady" Frank's cheek bones. Something stirred in his/her soul, sparking a mysterious emotion within, known only to keepers of the Sacred Pan-Stik. Yes, dear readers, Drag Queens.

Frank is a drag queen. Frank's only intention, his/her only wont, his/her only duty if you will, is to paint THAT face, get out there and quaff at the Fountain of Life. As micro-buddies of perfectly matte uplifting hydro-oxygen enriched translucent and yet gently beige (beige tonight, that is) powder poufed and darted this way and that, Frank's face began to flow with the finish of a newly minted porcelain plate.

"F-ff-r-rronds! F-ff-r-r-ronds of forest ferns!" Frank chanted to his/herself as he/she held his/her mascara brush in the air and wafted it in honor of the grand "ladies" before and all those just now being born. Charged with a feeling of the super-normal, he/she heroically applied the liquid lustre rapidly and perfectly to each lash of her soon-to-be legendary face.

In the tradition of the great Northern Renaissance painters of yore, he/she privately but beautifully applied lines, lines, lines actually only one line above each orb to bring to the eyes and, indeed, the whole face that so special effect that can only be screamed, "Drag!" For he/she who brandishes these wands of mercurial splendour, there is a moment that now arises, just after the eyeliner and before the eyebrows, a little moment perhaps but important, when a deep stirring of ancient pre-ordained micro-feeings pluck at the heartstrings of our beloved and aforementioned Frank, the "Lady".

GASP! With the last pencil stroke of nightmare black grease, the last traces of Frank's former self seemed to disappear as "Phoenix" hatched from her golden egg and chirped, "Drag!"

Phoenix now applied truckloads and carloads of imported colored powders and make-ups to create an infinite variety of 'effects; here shimmery, there preposterously matte. Like an accomplished orchestra conductor, she waved her baton at each different make-up, summoning a Grand Symphony of Beauty whose bewitching effect can, could, and does restore sight to the blind. Phoenix trumpeted her way through the Painted Forest, "Hear Ye, Hear Ye! I go forth in Spendour!" Until at last, with the last stiple of the lip-brush on her perfectly painted lips, she was completely WOMAN (for so she thought)!

As Phoenix made her Grand Prize March in the Club, someone remarked, "Who is that old hard-looking Queen?"

THE END

THING

▼

EXPRESS YOURSELF

Submissions of printable works are always welcome!
Please send copies only; we can't promise to return originals.

SUBSCRIBE

BUY IT!

We're available at **Guild Books**, **Unabridged Books**, and
People Like Us in Chicago. In New York and California we're
available at **A Different Light** locations.

CHRISTOPHER HILL *Illustrator* **JAN. 6, 1959 - OCT. 15, 1990**

page 34

MICHAEL ALIG FLIPS!

"I see myself in a booth behind glass with a cocktail in hand and a strobe light flickering on display at the Museum of Natural History. I will be listed as an extinct species and the plaque will read:

CLUBKIDUS NEWYORKUS. *"*

-- CLARA THE CAREFREE CHICKEN

MICHAEL ALIG AND HIS CHICK

When Michael Alig asked about advertising in Pansy Beat he immediately wanted the back cover and a page inside to promote his party Disco 2000. We quoted him the price and he laughed at how little it was and said "How much does it cost to print Pansy Beat altogether?" When I told him he said "Oh I can get that for you from Peter." And so he did. The interview was completely fabricated by Cole Slaw.

ARCHIVES

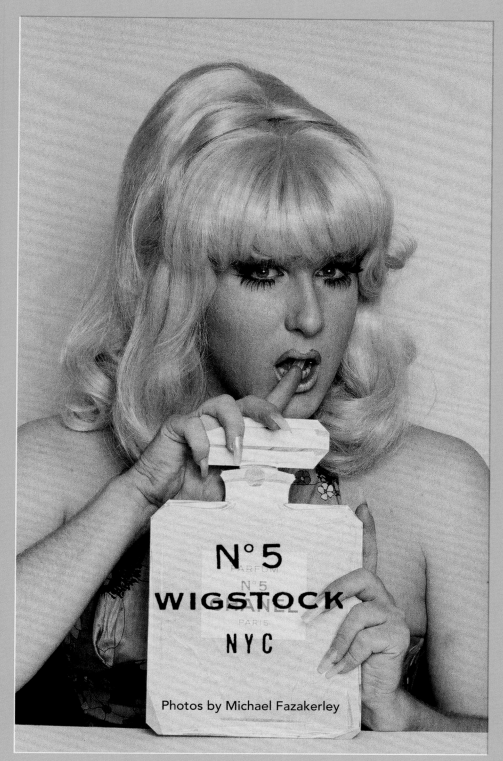

N°5
WIGSTOCK
NYC

Photos by Michael Fazakerley

YE OLDE LEGEND
OF
WIGSTOCK FESTIVAL

Fairies and Pixies throughout the land
Gather ye'self around and hear the lore so grand
Of Lady Bunny and her merry Band
Who celebrate Wigs, Peace, Love, and...

Thirteenty-score and two two hundred years ago
A lovely "Lady" hithered nigh!
Heee! Her sweet walk was noted
By Bluebirds singing in the sky.
On her flute she played a tune so sweet
That all who heard it rose to their feet!
(And ran away)
Her merry march was accompanied
By bewigged Folk of every description
And their luted voices sang a refrain
That all who heard it wish they'd restrain!
Lo! To Tompkins Square Park of yore they made their way
A high-falutin festival to create that day.
One by one they all had their say.
As they celebrated Wigs, and other things fey!

Sally! Nancy Mary! Miss Thing!
O! Pee! O! Get Over!
O! Tar-Poof! Let it ring!
A giantess cakes of Frantasy they baked
And left it in the rain!
That carefree spirit lives on today
In Wigstock Festival, something, something...
The End

**BY
SISTER DIMENSION
1990**

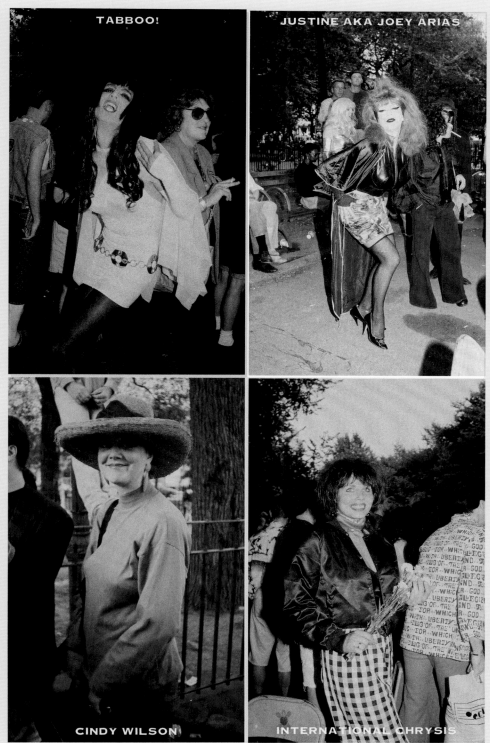

TABBOO!

JUSTINE AKA JOEY ARIAS

CINDY WILSON

INTERNATIONAL CHRYSIS

(B-52's)

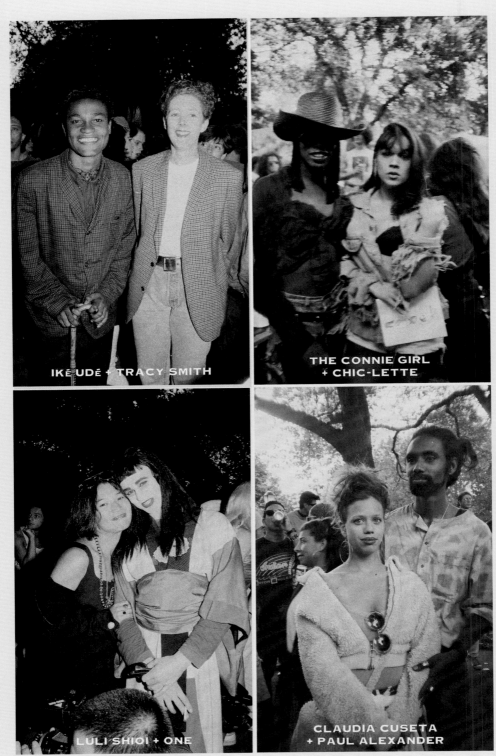

IKÉ UDÉ + TRACY SMITH

THE CONNIE GIRL + CHIC-LETTE

LULI SHIOI + ONE

CLAUDIA CUSETA + PAUL ALEXANDER

388

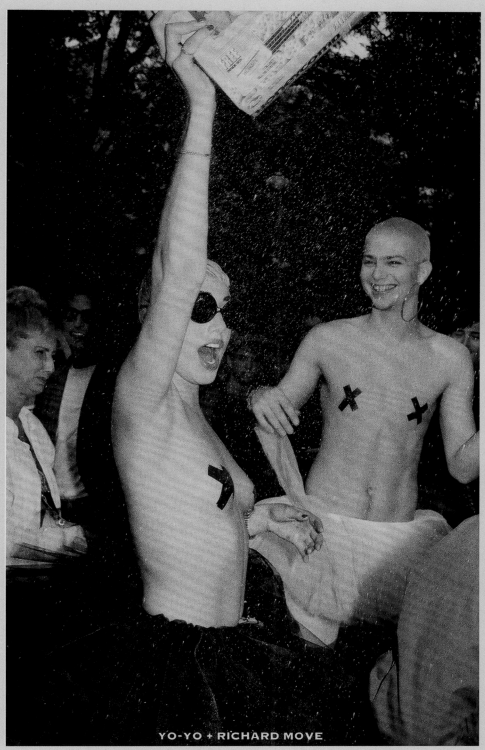

YO-YO + RICHARD MOVE

(aka Rebecca Weinberg)

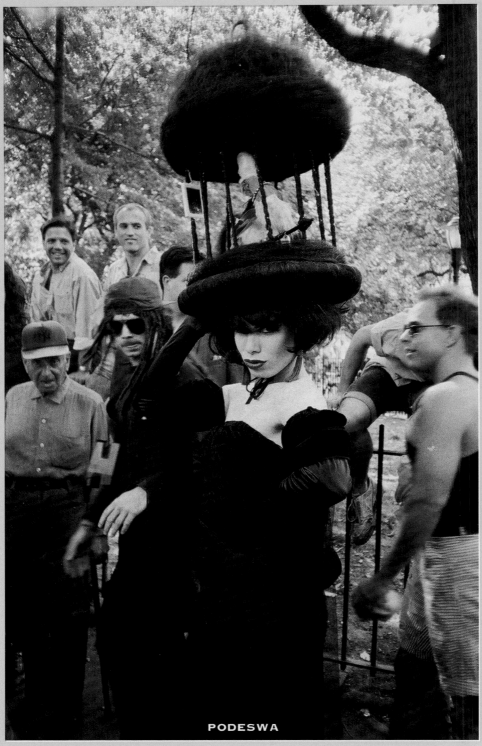

PODESWA

AARON COBBETT + BEAU

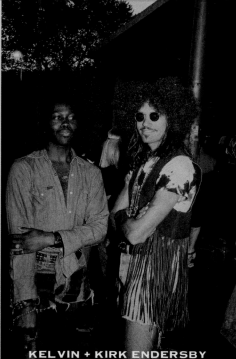

KELVIN + KIRK ENDERSBY

GREENELLA THISTLE + DUDE

BRENDA SEXUAL
+ GLENNDA ORGASM

(aka Duncan + Glenn Belverio)

391

RUPAUL CHARLES

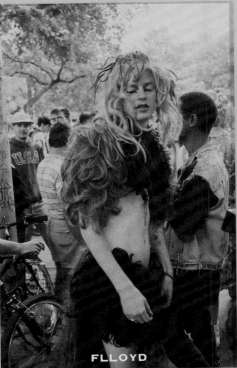

FLLOYD

DAHLEN + POSSE

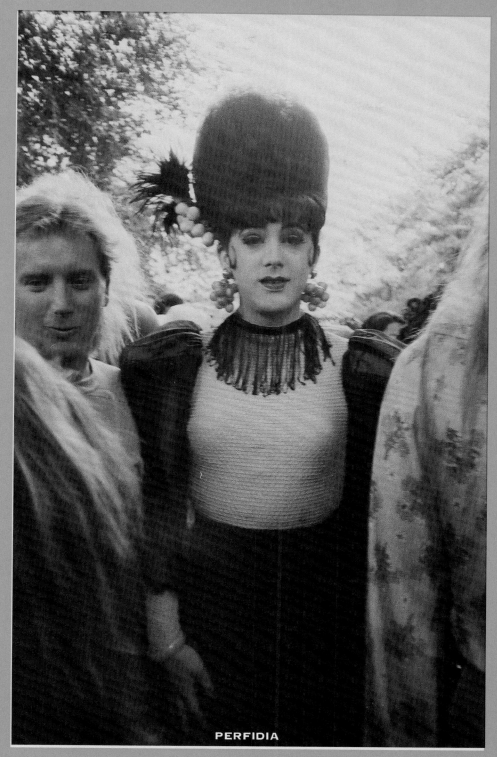

PERFIDIA

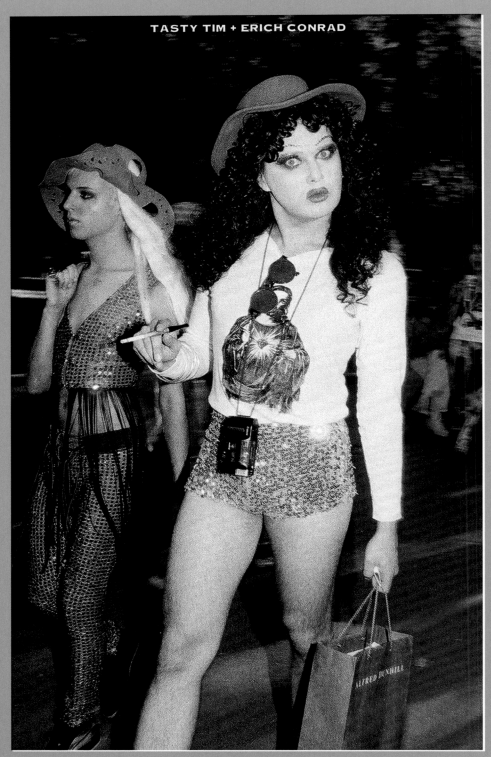

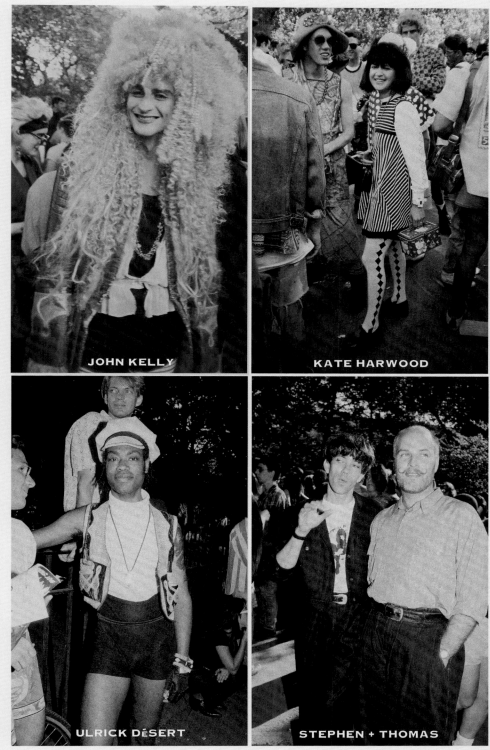

JOHN KELLY

KATE HARWOOD

ULRICK DéSERT

STEPHEN + THOMAS

KATY K

HYSTERICS

LORETTA HOGG

GEORGE WAYNE

MARIA AYALA
+ ALEX THOMPSON

MONA FOOT

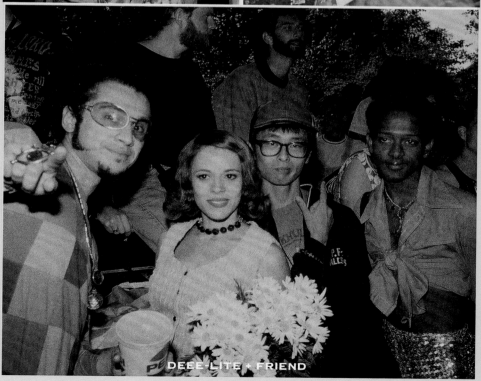

DEEE-LITE + FRIEND

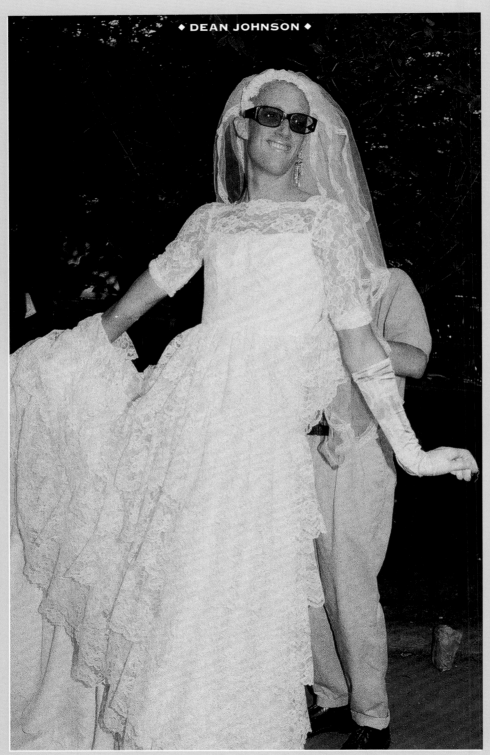

◆ DEAN JOHNSON ◆

Fag Rags Come of Age

The Gay 'Zine Scene Finds Its Audience

BY BILL VAN PARYS

There's a renaissance in American media, and Condé Nast has nothing to do with it. In fact, they probably couldn't have had less to do with it. The forerunner this time is precisely that which the mainstream press has gone out of its way to weed out and ignore: the gay-underground punk-publishing medium known as the fanzine.

"Being gay was like being invisible," Jeffrey Hilbert, editor of Los Angeles's *Sin Bros.* explains. "The representation we used to be able to find, either graphically or editorially, just wasn't there anymore. And the existing gay press was the same old tired nothing. When I got started with *Sin Bros.*, it was something *I* wanted to read."

Thanks to the discriminating literary tastes of Hilbert and his fanzine cohorts, the love that dare not speak its name is now having a hoot. In a layout reminiscent of '60s mod in New York's *Sister!*, topless club child YoYo delivers her message: "Repressed lesbians...shut up and look at my tits." In Chicago's *Thing*, "Niggerati" gives a queenly account of local black gay social events. A running commentary in *Sin Bros.* on the male sex industry examines the phenomenon of how porn stars never close bathroom doors while urinating.

The quality and format of fanzines vary as wildly as the tastes within the community itself, ranging from photocopied manifestos to esoteric designed-to-death brochures. And while 'zines exist for most every subgroup or interest, the bulk focus on gay men—which of course means erotica and camp aplenty.

THE SIMPSONS

At the forefront of this movement is *My Comrade/Sister!* Launched in 1987, the

A few of the *Sin Bros.*
Editor Jeffrey Hilbert (far right) *offers "titillating satire" of the gay fantasy world.*

often imitated New York publication represents both lesbians and gays (flip *Sister!* over and, voilà, *My Comrade*), reflecting "the new sense of community" according to editor Les Simpson.

Sitting in his tenement flat in cutoffs and a vest, Simpson betrays his stage persona of anchorwoman Linda Simpson, who is more commonly recognizable in a wig and pumps onstage at the Pyramid, a New York nightclub. But just as his appearance and coolly restrained demeanor might be a bit deceiving, so is the assumption that his magazine is no more than flip, superficial humor.

"*My Comrade* is liberating gay journalism from a really bland doom-and-gloom, lugubrious atmosphere," Simpson says. "It's like mainstream gay media has been reporting the news based upon the perceptions straight society has placed upon us—to be sad, to be defeated—rather than being joyous and celebratory. We're a bit more wild. *My Comrade* celebrates being gay."

Simpson's celebration plays to a wide audience these days. The last issue sold out 2,000 copies at a newsstand price of $3 a crack.

"People like it because it's got a really pro-gay attitude, and it's hip in the sense of pro-

gressive," Simpson explains. "It's so subversive right now to be gay and enjoying yourself. To say you love someone of the same sex is the most radical act you can do. It's completely insane. But the magazine's a little insane."

The fanzine combines camp, humor, and eroticism in a tabloidesque format to encapsulate the trash-connoisseur aesthetic of Manhattan's East Village. While the content varies from spoofs on gay personals ("For Fats and Fems Only!") to discussions of the taboo ("Why Is NAMBLA the Black Sheep of the Gay Community?") to hilarious "service" pieces ("A Gay Guide to Straights"), the one constant that emerges

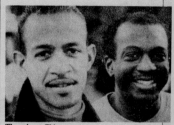

The misses *Thing*
Providing a "lightweight" overview of the black gay community

RICK CASTRO

"It's so subversive right now to be gay and enjoying yourself."

is the knack for poking fun in all the right places at both gay and straight society.

"Humor gives us the power to put things on our own level, to call the shots," Simpson notes. "It's not so much that we're anti-gay establishment, because we're pro-gay. There are various aspects of certain gay people's lives that might not be mine, but we're not here to undermine that."

This emphasis on humor is echoed by Michael Economy, editor of New York's *Pansy Beat*. "I'm concerned that the whole idea of being gay now goes hand in hand with being political," Economy says. "I wonder if people are missing the point. I'm all for the political part of the gay movement, but I don't want us to lose our sense of camp, our sense of humor. It's not that I'm against *OutWeek*; it's that I'd like to weight the scales. Besides, I'm sure we can disturb quite a few people out there as it is, just by our exaggerated sissiness."

Make way for Mary, Mr. Drummer.

"Growing up, we enjoyed being men but were always interested in what society dubbed as girl things," Economy continues. "I wanted to give an unashamed, unembarrassed viewpoint of people who are interested in sissy shit."

"Sissy shit" in *Pansy Beat* has encompassed interviews with Quentin Crisp; a profile on a founder of the Queens Liberation Front, drag pioneer Lee G. Brewster; illustrated pieces of both a service ("Are You Attractive to a Man?") and political ("A Spring Field of Pansies," featuring quotes from Oscar Wilde to Divine) nature; recurring features on Endive, a drag artist; and

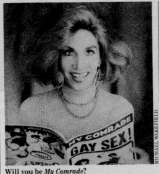

Will you be *My Comrade*?
'Zine editor and founder Les (Linda) Simpson

sultry sex-through-the-guise-of-fashion spreads.

Still, the illustration and design are the magazine's most impressive features, a reflection of Economy's and colleague Chip Wass's skills as two of Manhattan's more sought-after illustrators. But don't let the apparently calculated layout fool you; the magazine's intent is as whimsical as its origin.

"The whole magazine just sort of ended up happening by accident," Economy says. "The reason we started was, Endive called me up a year ago and said, 'Listen, I want to be on the cover of a magazine.' And she's really pushy."

CREME DE LA CREME

Pansy Beat is not the only fanzine that exists primarily to feed the self-promotion appetite of an egocentric drag queen. Los Angeles is home to the 'zine most resembling its punk predecessors, the outrageous *Fertile La Toyah Jackson Magazine*.

Actually, the commentary voice in the 'zine is that of Kayle Hilliard (a.k.a. Vaginal Creme Davis), who puts the comments of "soft-spoken" Fertile, a fellow member of the drag act Afro Sisters, in editorial form. Hilliard, who describes himself as "a queen's queen queen," draws upon his years of experience in Los Angeles entertainment circles as fuel for his fanzine.

"I go out all the time," says Hilliard, "and

get paid to go to industry events where they want color. They're not very creative, and they see these drag queens and say, 'Look, how funny! They're in drag.' So they talk very freely in front of us. People tell me their innermost secrets, because I'm sort of Whoopi Goldberg-ish—like Whoopi on *Star Trek*. They don't know that I write a magazine. And I listen and remember *everything*."

The popularity of the magazine, now in its fifth year, is soaring among both gay and straight audiences to the point where it has even been picked up by the store Tower Records. Hilliard notes that he receives at least 30 mail orders a day ("and they send me cash, honey") not only from all major U.S. cities but from as far away as Israel, which "gets me excited, because, you know, I *really* love Jewish men and Israelis especially. They can be neurotic and irritating, but I don't care."

Predilections aside, Hilliard has an idea of why the magazine has taken off. "I think it's because no one has heard the black, queenly voice," Hilliard says. "That's a new voice for America to hear, even though it's rooted in a lot of culture. It's a voice of no pretense, and I think that's what people are craving, because life has no validation anymore. So they want someone to come along

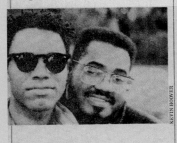

Those frisky *Fertile* fellows
Kayle Hilliard, a.k.a. Vaginal Creme Davis (foreground): *"I'm sort of Whoopi Goldberg-ish."*

"No one has heard the black, queenly voice. That's a new voice in America."

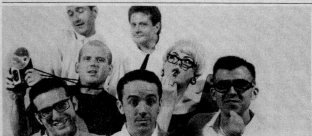

SETH GURVITZ

Prowling the *Pansy Beat*
"An unashamed, unembarrassed viewpoint of people who are interested in sissy shit."

and put all the cards out on the table and just give it to them in no uncertain terms."

In the fanzine, Fertile minces no words: "All these upscale people, doing their upscale thing. I'd like to get all dressed up

Fertile La Toyah Jackson Magazine
7850 Sunset Blvd., Suite 110, Los Angeles, CA 90046

My Comrade/Sister!
326 E. 13th St., #15, New York, NY 10013

Pansy Beat
390 Ninth Ave., New York, NY 10011

Sin Bros.
c/o W.K., P.O. Box 618, North Hollywood, CA 91603

Thing
2151 W. Division St., Chicago, IL 60622-3056

in my Comme des Garcon, walk in with my subatomic machine gun, and kill all these people connected with these places. Sounds mean, but somebody has to do it."

The magazine offers a knowing critique of the Los Angeles glamour scene as well as a substantial share of reporting of both fictitious celebrity dirt and the imagined sexual escapades of the editor: "Vag had quickie sex with actor Robert Downey Jr. but didn't even know who he was until someone told her later. Robert Jr. is a premature ejaculator. . . ."

Fertile found any queries about legal troubles resulting from her reporting preposterous.

"There's no problem with lawyers," she says. "You can only be sued if things are false."

The glamorous image of Los Angeles, the image that provides Vaginal Creme Davis fuel for her fodder, also provided the impetus for Hilbert to launch *Sin Bros.*

"I call West Hollywood the lavender ghetto," Hilbert says. "It's the fantasy world where everybody's gay and beautiful and has a Jeep and a tan. *Sin Bros.* is a reaction against that materialistic mentality, that you have to be this beautiful model thing and not worry about anything but your next tanning appointment."

The result is a fanzine of what Hilbert calls "titillating satire," a combination of real and spoof reviews, mock poetry ("Haiku-koo"), satire ("Undercover Angel in Hair-Extension Hell"), and arousing visuals ("I think half-naked men are real eye-openers; I use them wherever I can"), all dedicated

to the pursuit of individualism.

"*Sin Bros.* is a voice for a gay alternative," Hilbert says. "We're not all the same, and we want to show that you can be gay and still have this weird identity of your own."

A BLACK GAY AESTHETIC

A lack of representation of the black gay underground in Chicago compelled Robert Ford to start *Thing*. Somewhat more sober in its tone than other fanzines, *Thing* is primarily intended to provide a "light-weight" overview of the black gay community, focusing on music, film, and fiction.

"There's a different sensibility to black gay people," says Ford. "Vogueing and house, which came out of the black gay underground, are part of a larger black gay aesthetic that doesn't get seen much."

Another distinguishing element of *Thing* is industry advertising. But will *Thing's* underground status be threatened by accepting ads from Elektra? Ford thinks not. "I don't think there's anything wrong with the advertisers trying to latch on to something popular," he says. "A lot of the dance music is bought by the kids who go to the clubs, and how do you reach them? We may be faced at some point with a moral decision – if Arista approached us with an ad for Snap, I might have to think twice about that."

The dilemma of having to turn down advertisers is one most 'zine editors would welcome. Advertising, which usually comes from local bars, restaurants, nightclubs, and retailers, just covers printing costs. 'Zines depend on newsstand sales to begin covering the other expenses, yet they come nowhere close to compensating the writers, artists, and designers who basically donate their talents to the exhausting tasks. Day jobs remain the norm, and fund-raising parties at clubs help finance their projects.

Financial hardships aside, the consensus is that the effort is rewarding. There is satisfaction in getting work published and giving the community a laugh in increasingly difficult times.

But as Simpson points out, there is one aspect of fanzines that stands head and shoulders above the rest of the publishing world: "In America, any moron can do a fanzine." ▼

★ **'ZINE FOR TEEN QUEENS:** If you still need more pulp for that long subway trek, pick up *Pansy Beat* and see what kind of looks you get while reading it. It's like *My Comrade* with three other drag queens who write, edit and star in it. Actually *Pansy Beat*'s writing is choice and will have you laughing so loud that people won't even come near you for change. Available at: **A Different Light Bookstore, 548 Hudson St.**

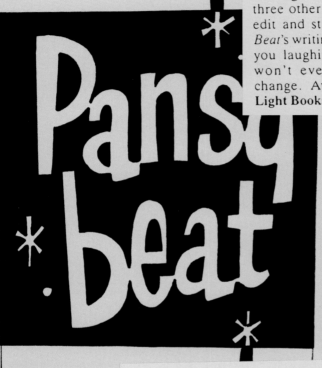

With the emergence of magazines like *My Comrade* and *OutWeek*, the pansy beat is becoming a road well-traveled. But the latest issue of our favorite drag-rag—particularly the fashion-photo exposé on the Connie Girl's efforts to become Barbie's black sister—affirms what we've long suspected, that this magazine is a fierce to be reckoned with.

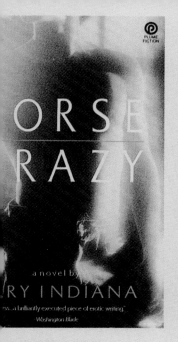

TREAT ME LIKE SHIT
AND I'LL LOVE YOU FOREVER

of us, if we're honest, has had at least
twenty obsessive love affairs. You
be where the guy is too gorgeous and
string you along. Well, until now no
captured the modern version of this
ning infatuation like *Village Voice* art
ndiana. His book *Horse Crazy* [Plume;
extraordinary in the way it captures
, unreciprocated, mad passion. Of
ever met Gary in person, you wouldn't
. By comparison, Truman Capote was
al person. Anyway, here's a tidbit from
eat novels of the decade:

aid, "your hands are shaking. Relax. You
ike? Kiss my. . . collar. Not my neck, honey,
gory doesn't want his skin touched today.
Twenty kisses. One, two, three, four. . . kiss
the way down, down, kiss just along there,
ff, twenty kisses . . . kiss that button. Oooh,
d. That's so nice. Now the belt. Stay away
kle area, you can only kiss the side there,
is, kiss the loop. Now the knee, just the left
irty times. . . very nice, sweetie, real nice.
o the other knee too. You know something,
, you're all warm and soft like an angel. Your
n angel's hair, it's so smooth . . . kiss the leg
the way down, now kiss my socks, kiss all
t, kiss under the toes, twenty kisses . . . do
at's so beautiful, you're really my slave,
 funny because, do the heels now, thirty
eel, if people only knew you're a complete
w around, up to the ankles, people would
d, I bet people think I'm your dumb little
 your tongue, sugar, taste the whole sock,
ny toes in your mouth. People think I'm your
ou're my little slave. You're an angel slave.
st beautiful angelic slave I've ever had."
, if your local bookstore doesn't carry
e, try A Different Light, 548 Hudson
York City. 212-989-4850. Toll free,
002.

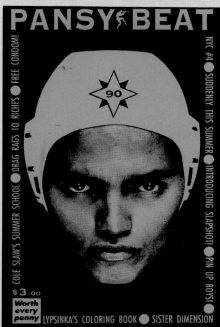

THE JOYS OF
BEING SWISH

Are you sick of big, thick penises that aren't rouged?
Do you want to barf when you see these hunkering,
hairy numbers swaggering about the streets?
Do you go crazy looking for Madonna bras that
will fit your titless torso, Well, *kvetch* no longer,
hons! *Pansy Beat* is here to stay. ■
This absolutely *fabulous* little magazine
has been created for those of us who are
drag queens at heart. (Of course, you don't
need limp wrists to purchase this delicate
rag, just good taste, $3.00 and a store
that actually sells it.) The current issue
has a Lypsinka coloring book section,
adorable young men modeling madras
outfits, and lots of important dating
advice. For example: Do you tell a man
he is beautiful even if you find him
only average looking? This habit hurts
no one and makes a lot of men 'swell'
with pride. ■ Besides original articles,
great ads, a free condom, and clever
repartee, *Pansy Beat* has some of the best
art direction in town. So if you can't find
it in your local candy store, send three
smackaroos (plus $1.35 for postage and
handling) to: *Pansy Beat* Productions,
189 9th Avenue, #2B. N.Y.C., NY 10011.

MANHATTAN ON THE ROCKS

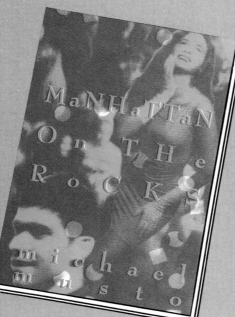

That's the name of the new first novel from *Village Voice* columnist Michael Musto. He writes about the milieu of downtown social climbers at a time when downtown was trying to be uptown and the ills of New York were first exploding in the consciousness of party people. We follow the main character, Vinnie DiBlasio, pub-

lisher of a downtown magazine, as he crawls through the scene. Musto trashes everyone—uptown socialites, posing artists, fashion victims, ostentatious activists, social climbing homosexuals—even himself. "Just remember," he says, "that I made my character worse than anyone else in the book." If you live in New York, beware, you may recognize yourself in this *roman a cléf*. Published by Henry Holt and Company, $18.95.

PANSY BEAT

And now the latest entry in the Downtown ultra underground magazine sweepstakes, featuring Lypsinka protege Endive and exclusive interviews with Lady Bunny along with important feature stories on things like whether you should wear bottom false eyelashes. *Pansy Beat* is the creation of Michael Economy who says, "We hope to take you on a whimsical journey down a pansy-strewn lane, leading to our peculiar brand of offbeat obsessive humor, colorful local celebrities, and sometimes even a lil' bit of social con-

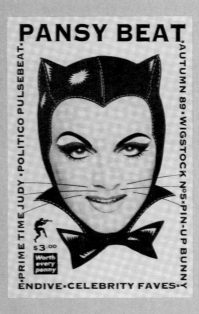

sciousness. So clap yo' hands and stomp yo' feet, let's get movin' to the Pansy Beat!" You can contact *Pansy Beat* at 237 West 18th St. #1-FE, New York, NY 10011. The mag costs $3 at newsstands and is worth every penny.

ALL MAN 35

This page and previous page clippings from *ALL MAN*, 1989 and 1990

Into the fray of wacky, pseudo-underground, hipper-than-hip, gayer-than-gay, raw publications comes *Pansy Beat*, which, at $3.00, claims to be "worth every penny." Following in the footsteps of *My Comrade/Sister*, *Pansy Beat* covers the perverse, the obscure, the bizarre and the all-too-familiar place we call "downtown," except it's perhaps a tad more anarchistic (activantes are quoted inside saying such cute things as, "Blow up Washington, D.C.!").

Says *Pansy Beat* in it's premiere issue: "We hope to take you on a whimsical journey down a pansy strewn lane, leading to our peculiar brand of offbeat obsessive humor, colorful local celebrities and sometimes even a lil' bit of social consciousness."

—*M.S.*

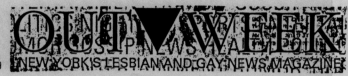

OUT▼WEEK October 22, 1989 NEW YORK'S LESBIAN AND GAY NEWS MAGAZINE

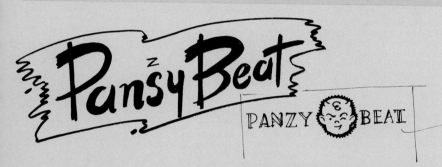

COPPER PLATE GOTH
POSTER BODO
COCHIN BLAC

MY COMRADE

WINTER 1990

Let's see, what was that other magazine we wanted to mention? Oh yes, <u>Pansybeat</u>, New York's newest underground gay magazine.

Adorable, it is simply adorable. In fact, a magazine of such caliber as <u>Pansybeat</u> is exactly what we've been hoping for. Now MY COMRADE <u>really</u> looks good!

Oh, we're just kidding <u>Pansybeat</u>. We really did love your first centerfold of Bunny in those cute platform shoes she always wears, and that essay or whatever it was by **Cole-Slaw** was just too-too nutty. Love all the sexy guys (ZERO), and as far as those side-splitting "articles" by **Endive** - well, good gay humor like that just ain't easy to find (Thank God). Make my day, Endive, make my day.

Goodness, a lively little downtown New York Underground publishing scene has developed lately. There's <u>R.O.M.E.</u>, <u>MY COMRADE</u>, <u>Project X</u>, <u>Aqua</u>, <u>SISTER</u> and our lovely newest little addition - <u>Panseybean</u>, er, beat.

Deee-Liteful Threesome

New Music Trio Comes Up From the Radical Drag Undergound

BY ADAM BLOCK

The gay dance club scene that once spawned Donna Summer, Grace Jones, and Madonna has lately launched the most scintillating new combo of the '90s: Deee-Lite.

This unlikely multinational trio boasts a de-gorgeous debut single, "What Is Love?" (backed with "Groove Is in the Heart"), which recently soared to the top of both the British and American dance charts. That triumph coincided with the trio's unpaid appearance last month at New York's dragfest Wigstock—a treat for the gay elite who first nurtured the group.

Deee-Lite coalesced in the midst of Manhattan's radical drag underground—a hotbed of tolerance and creativity. In 1985, DJ Dmitry, a Soviet expatriate and classically trained pianist, was playing guitar for the short-lived band Shazork!, fronted by drag celebs Lady Bunny and Sister Dimension. American-born go-go dancer and singer Kirby Kier was making the group's outrageous sci-fi silver-lamé costumes.

Two years later Dmitry and Kier were performing together when Towa Towa, a recent arrival from Tokyo, slipped the two a tape. The technowhiz funk fan "helped us overcome our fear of technology," Kier admits. Still struggling with his English, Towa Towa became the group's third member, and Deee-Lite began de-grooving.

The group fashioned its music out of an infectious collision of soul, funk, disco, and house—a layered, shifting quilt that marries Sade's cool soul to the wacky camp of the B-52s against the trance beats of acid house.

"We've all been very influenced by the gay scene," Kier admits. "I learned everything that I know about show biz from drag queens," she laughs.

Asked if any members of Deee-Lite are gay or bisexual, Dmitry responds, "I don't think it's anyone's business. I don't think that it's important or that anyone should care." Could these be three raging heteros, petrified of being found out? That would be refreshing.

Deee-Lite's openly gay posse is enormous—from their manager, former *Billboard* music columnist Bill Coleman, to Taboo, the downtown drag legend who does their calligraphy. Kier sees working with gay artists as a way to "promote social awareness and fight bigotry."

The band hired Michael Economy, editor of the gay 'zine *Pansy Beat*, to do a comic-strip portrait of the group for their new disc, *World Clique* (Elektra). They cast Wigstock luminaries Taboo, Glamamour, and Miss Guy in their first video. And they hope to collaborate soon with the French gay photographers Pierre and Giles.

Deee-Lite arrives in the midst of the AIDS crisis, and to the group's credit, there is an appropriate echo of dread seeping into their effervescent mix. "We knew Keith Haring, Ethyl Eichelberger, and so many great people," says Kier. "We've lost so many, but that has helped propel us toward the positive. We've done benefits for AIDS groups and for homeless PWAs. We're not escapists. We're very aware of the horrors and problems out there."

"And we escape," Dmitry adds, "into hope."

The band has plans for a one-hour stage show and a video of their second single, "Power of Love." The single is due out in mid November. This month they'll be on a ten-city tour of the United States, followed by five weeks in Europe. The group hopes to be back in Manhattan by Dec. 8 to play the Gay Men's Health Crisis AIDS danceathon.

Deee-Lite's commitment to fighting AIDS is only one measure of how much their gay fans are appreciated. They're certainly the only act on a major label to take out ads in underground gay 'zines like *Fertile LaToyah Jackson*. But their ultimate aim is to inoculate the mainstream with tolerance, irreverence, and delight.

"We really want to play fully integrated clubs," Dmitry notes, "gay, straight, black, and white—[to help] lose the distinctions."

"It just seems that the coolest clubs always have a lot of gay people in them," Kier grins. "I don't think we're really camp, though," she muses. "Not in that sense of being an in-joke. We want to be universal and inclusive.

"That's why we called our album *World Clique*—to celebrate the ultimate anticlique: the whole world. That's who *we* want to play with." ▼

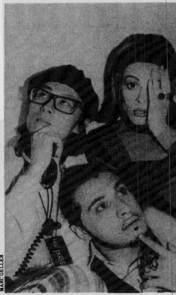

MARC GELLER

Three on a party
Deee-Lite "learned everything from drag queens."

"Deee-Liteful Threesome" by ADAM BLOCK for *The Advocate*, 1990

UNSEEN DELIGHTS

ONE DAY IN JANUARY 1989, I was handed a phone number by the owner of Carpet Fashions, an East Village shop where I created window displays. He said the couple who left the note looked like a 70s pimp and a hooker. So, naturally, I was curious. When I called the number, a woman answered and said her name was Lady Miss Kier. She said she loved my drawings and insisted we meet. She wanted me to come to a party she was throwing at Union Square Ballroom that very night. ESG was scheduled to perform. I was flattered, but I was heading to Japan the next morning for a job. I knew I shouldn't go, but ESG was one of my favorite bands. I couldn't resist that beat.

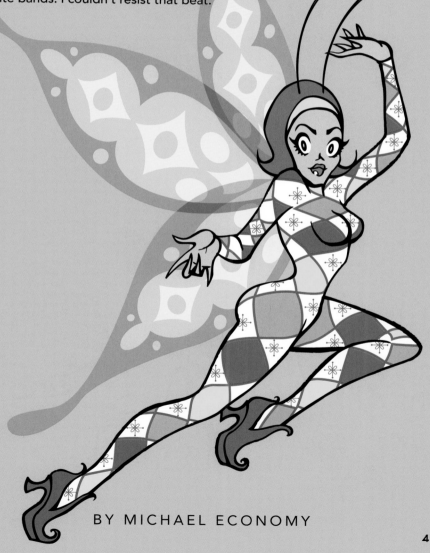

BY MICHAEL ECONOMY

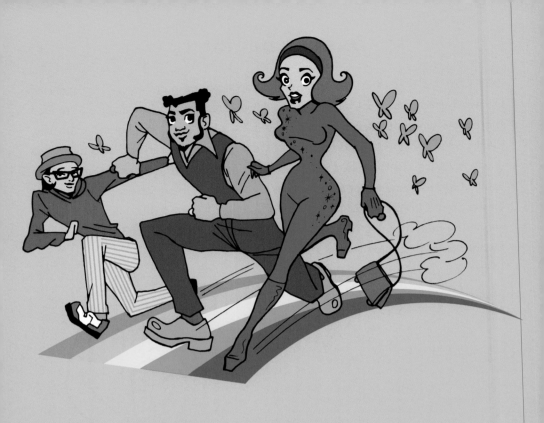

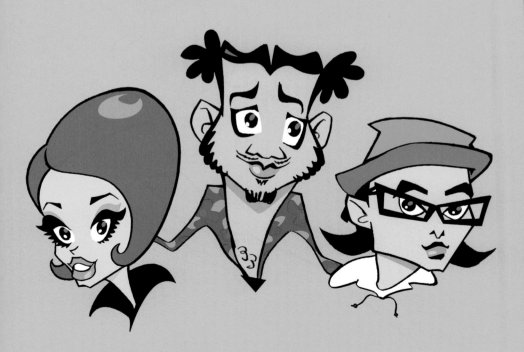

I got to the party just before midnight. I was early, and only three or four people were on the dance floor. Among them was a young girl dressed like a sexy old lady. She was wearing a fake Chanel suit, flesh tone stockings attached to a visible garter belt, with red cracked patent leather Mary Janes. She had on a wig festooned with big plastic curlers. I knew it had to be Kier. After I introduced myself, she pulled me over to the turntables to meet Super DJ Dmitry, duded up in an ensemble of funky finery. We were joined by Jungle DJ Towa Towa. At this point the party was in full blast, and while we were dancing, Kier told me the three of them would be signing a record deal as Deee-Lite and she wanted to be introduced to the world as cartoon characters. She wanted me to work with them to make that happen. The night was so fun that by the time I got back to my mouse-trap East Village apartment, I wished I wasn't leaving for Tokyo.

It was more than a year before any of those things came to be, but Kier was true to her word and her vision. And before any of the things she had whispered in my ear on the dance floor came true, we introduced the world to the cartoon band Deee-Lite in *Pansy Beat*'s very first issue.

See pages 150 and 151

Kier's impeccable instincts led her to combine my artwork with the inimitable Stephen Tashjian, aka Tabboo!'s authentic hand lettering.

Here are some illustrations I created for Deee-Lite at the time. They were never submitted to Elektra Records.

delicious
deLovely
deLectable
Divine
Degorgeous

De With it
Degroovy
Deee-Lite

46 East 3rd. Street,
NEW YORK 10003
212:254:0508

28th. October '89

Thank you,
 dear Mr. Economy,
 for the copy
of Pansy Beat; I enjoyed reading it and
thought it gay in all senses of the word.
I wish your magazine lots of luck and a
huge circulation.
 Please feel free to
quote me as saying anything that will help
your publication.

 Yours sincerely,

 C QUENTIN CRISP

MICHAEL ECONOMY (EDITOR)

Michael's artwork has appeared on soda cans, album sleeves, perfume bottles, Times Square billboards and TV screens. He has collaborated with fashion designer Anna Sui for over two decades. In the late 90's, Economy co-created and art directed the Los Angeles-based apparel line Mighty Fine. A collection of his work entitled "I Heart Me" was published to coincide with an exhibition of his work hosted by Parco Gallery in Tokyo. ★ iheartme.com

MICHAEL FAZAKERLEY (PHOTOS)

Michael studied photography at the Fashion Institute of Technology and started his career assisting in the studio of famed celebrity and fashion photographer Francesco Scavullo. In the early 90s, Fazakerley began documenting the Club Kids, scheduling all-night portrait sittings out of his small Chelsea apartment. The series is likely to be the definitive collection of the era. He relocated to Fort Lauderdale, Florida in 2004. The first retrospective of his work will be hosted at The Stonewall National Museum & Archives in Wilton Manors in the Autumn of 2018. ★

CHIP WASS (ASSOCIATE EDITOR)

Chip is an award-winning artist who creates animations, illustrations, character designs, and logos for a wide variety of advertising, publishing and broadcast clients. His work is noted for its ironic style and wit. Chip's clients have included Disney, Cartoon Network, *The New York Times*, Nick-at-Night, Nickelodeon, *Entertainment Weekly*, ESPN, and Barnes and Noble, among others. He's currently finishing an illustrated novel, and it feels like sometimes lately he's the oldest man on the dance floor. ★ chipwass.com

JAN WANDRAG (DESIGN)

Jan is a South African-born designer and photographer who lives in Manhattan with his husbro David. He has an MFA from SVA in New York. Jan has worked with Slava Mogutin on a variety of projects and regularly collaborates with Billy Miller, publisher of *Straight To Hell* magazine. Other artists he has worked with include Collier Schorr, Nath Ann Carrera, Gio Black Peter, and Desi Santiago. Jan has published three photo books. He is working on a book about protest called *Our Streets*. ★ janwandrag.com

★ ★ ★ ★ ★ ★ ★ **OUR BOOK TEAM** ★ ★ ★

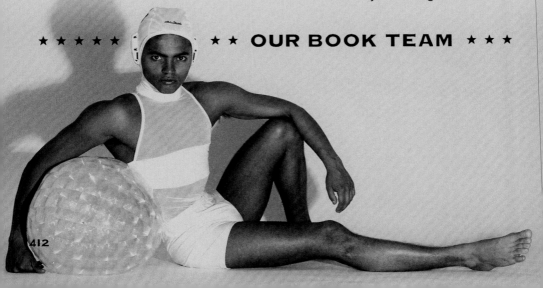

$ $ $ $ $ $ $ $ $ $ OUR ADVERTISERS $ $ $

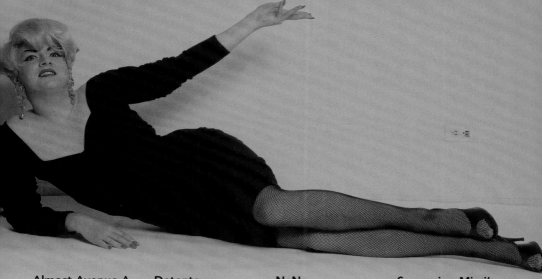

Almost Avenue A

Auntie Em's Farm

Banshee XXX

Camouflage

Cantarella

Charles Goodnight

Cheeks

Chip Duckett

Deee-Lite

Detente

Disco 2000

Full House

Hysterics

Kanae

La Palace De Beauté

Lee's Mardi Gras

Lotto

Mingus Salon

NaNa

Panty Girdles

Paper White

Patricia Field

Pyramid

Reckless

Red Zone

Roger Roth Inc. And Dave

Roxy

Screaming Mimi's

Sister Blister

Stella Dallas

Tease Curls Not Queers

The Community Center

Thing magazine

Yaffa Cafe

Special thanks to the advertisers that stuck with us for all five issues:

A DIFFERENT LIGHT

ALPHABETS

LITTLE RICKIE/PHILLIP RETZKY

NEW REPUBLIC/THOMAS OATMAN

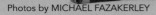

Photos by MICHAEL FAZAKERLEY

◆ ◆ ◆ ◆ ◆ ◆ THANK YOU ◆ ◆ ◆ ◆ ◆ ◆

GIANT THANK YOU and extra-special shout out to **HYOUNG-UNG KIM** whose generosity and support made this book possible.

Also, to **JAN WANDRAG** who brought so much more to this project than just his amazing design sensibilities and to **CHIP WASS** who, as always, brought balance to my mania.

Special thanks to **BILLY ERB, MISS GUY, DOUGLAS MAO** and **BILLY MILLER/S.T.H. EDITIONS**.

Thank you, to **CAROL HAYES** for introducing me to Richard Saja.

And thank you, to **MICHAEL FAZAKERLEY** who collaborated with me to create all the original photos for *Pansy Beat*.

-- M.E.

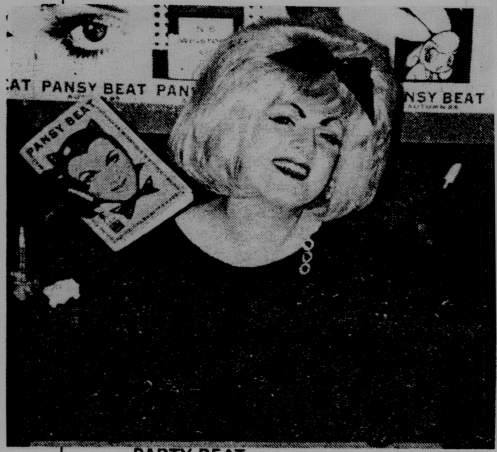

PARTY BEAT
Endive at Trax

414

Photo: UNKNOWN

AARON COBBETT

AKIMITSU NARUYAMA

AKIMITSU SADOI

ALAN HAMILTON/
ENDIVE

ALBERTO ORTA

BILL PEAKS

BILL VAN PARYS

BURT

CARL MICHAEL
GEORGE

COLE SLAW/
TERRY LAWSON

CONNIE FLEMING

CREOLE

DAN LECCA

DANNY

DAVID YARRITU

DEEE-LITE

DMITRY BRILL

DONALD CORKEN

DUKE TODD

ELIAS

ERGE

FRIEDA

GARANCE

GEORGE E.

GEORGE G.

GIORGIO VOLTAIRE

GLENN BELVERIO

HAYLEY MOSS

JAIME ROLDAN

JAVIER FIGUEROA

JAYME THORNTON

JOEY

JOEY HORATIO

JOSÉ LUIS GARAY

JOSIAH SCHUMANN/
JOSIAH HOWARD

KENNY KENNY

KIRI TESHIGAHARA

K-ZAHARA

LADY BUNNY

LADY KIER

LARRY TEE

LAURIE PIKE/
JUNE DENT

LEE KIMBLE/BARBARA
PATTERSON-LLOYD

LEN WHITNEY

LINDA SIMPSON

LISA CROSBY

LYPSINKA

MADEMOISELLE
ROSA SATO

MATTHEW KASTEN

MATTHEW WALDMAN

MAURICE VELLEKOOP

MEL ODOM

MICHAEL ALIG

MICHAEL BARTALOS

NASHOM WOODEN/
MONA FOOT

NATALIE STANFORD

PIERRE ET GILLES

RICHARD ALVAREZ

RICHARD HENKE

RICHARD SAJA

ROBERT CLYDE
ANDERSON

RYAN LANDRY

SACHIO KAMIA

SHIGEYASU HIYAKAWA

SISTER DIMENSION

STEPHEN TASHJIAN/
TABBOO!

STEVE LAFRENIERE

TREY SPEEGLE

TODD OLDHAM

TOWA TEI

★ IN MEMORY OF ★

ADAM BLOCK

CHRISTOPHER HILL

CHYNA BLEAU

DONALD SUGGS

EDWIGE BELMORE

JOHN BADUM

LEE G. BREWSTER

LEIGH BOWERY

NAO NAKAMURA

PHILIP TENER

QUENTIN CRISP

TOM RUBNITZ

WALTER CESSNA

EPILOGUE

WAY BACK IN 1989 I hitched a ride with a friend to Santa Fe, NM from NYC ostensibly to study ceramics and simplify the complex life of a young 20 something. Somehow and in a very short amount of time I had enrolled in a Great Books of Western Civilization program at St John's College studying Plato, Aristotle Euclid et al. The high desert of NM was a territory completely alien to me both physically and culturally and I began to rely on my twice yearly trips to NYC to keep abreast of what was happening culturally in the rest of the world. Back then, the East Village was a vibrant locus of individualism and it was in the small 'zine shop See/Hear that I first encountered the charming and cheeky *Pansy Beat*. Here was something that spoke to my soul: a chap book not hung up on conventional expressions of taste, trend and, most especially, gender. Not only did *Pansy Beat* traffic in a beautiful present where, unmolested, the Connie Girl could prance down the street carrying a tasty treat (made by Endive!) for some hot young hooligan, it also recreated the past in its own image, envisioning a history where the love-that-dared-not-speak-its-name pointedly screamed it from on high - and with a lisp at that! *Pansy Beat* was seemingly more fun and flirty than political, but lurking beneath all the sequins, glitter, flowers and feathers was a subtle subversion, a signal that things were changing and nothing felt self conscious or forced when acceptance was the new world order of the day. Given that the communication on the inter tubes was still in its infancy, I circulated each new issue to all of my friends in the Southwest, spreading that joy around like mono in a middle school. And then, of a sudden, *Pansy Beat* was sadly and inexplicably gone forever. I periodically revisited the issues and these days the set I've had for the past 25 plus years is definitely showing both its great age and its prescience of what contemporary mainsteam culture could tolerate and embrace - not unlike the inimitable Lady Bunny. For the 4 glorious years of self-imposed exile in the hallowed adobe towers of the Southwest, *Pansy Beat*, along with her butch queen brother *JD's* and sister-wife *My Comrade*, was my tether to the vanguard in LGBTQ etc. life to which I would soon return, smarter and, hopefully, more employable. In retrospect, they now serve as a time-capsuled reaction to an intolerant world which happily no longer exists. And yet, this newfound freedom, a promise delivered so recently, is again under threat by a truly evil empire. It's my hope that a younger and more connected digital generation will rise up singing and celebrate their own greatness and diversity in a similar fashion to the way *Pansy Beat* did: with grace, humor, style and subversion.

BY RICHARD SAJA